DESIGN
BY
NATURE

USING UNIVERSAL FORMS AND PRINCIPLES IN DESIGN

MAGGIE MACNAB

New Riders | VOICES THAT MATTER™

Design by Nature
Maggie Macnab

New Riders
1249 Eighth Street
Berkeley, CA 94710
510/524-2178
510/524-2221 (fax)

Find us on the Web at www.newriders.com
To report errors, please send a note to errata@peachpit.com
New Riders is an imprint of Peachpit, a division of Pearson Education

Acquisitions Editor: Nikki McDonald
Associate Editor: Valerie Witte
Production Editor: Danielle Foster
Developmental Editor: Anne Marie Walker
Copyeditor: Anne Marie Walker
Proofreader: Patricia Pane
Composition: Kim Scott, Bumpy Design
Indexer: Joy Dean Lee
Cover Design: Charlene Charles-Will
Interior Design: Charlene Charles-Will
Color correction for section-opening images: Mimi Vitetta

ISBN-13: 978-0-321-74776-1
ISBN-10: 0-321-74776-3

9 8 7 6 5 4 3 2 1

Printed and bound in the United States of America

For my children, Evan and Sommer,
and for Mark.

ACKNOWLEDGMENTS

There is no way to thank the many people who contributed to this book or to express in words how grateful I am for their creative, kind, and good spirits in doing so. To everyone whose creative work and inspiring words are in *Design by Nature*—and to everyone who has contributed during its development with their support—thank you from the bottom of my heart.

I am particularly grateful to my acquisitions editor, Nikki McDonald, who saw the potential of the topic, even though my ideas were quite rough initially. To Anne Marie Walker, development editor, and Valerie Witte, project editor, who were immensely patient and always on task while guiding this work to unfurl much like a new leaf meeting the sun for the first time. To Charlene Charles-Will and Kim Scott, book designers extraordinaire with finely attuned attention to detail and aesthetic; and to Danielle Foster and Hilal Sala for minding the many p's and q's of production. I am very grateful to Peachpit Press for being willing to take a chance on the topic and the author.

To the contributors, one and all—from unknown student to celebrated designer, to anonymous street artist, to the many mentors I will never meet—it is your work that makes this book. Whether intentionally created with nature in mind or not, your extraordinary creations, stories, and passion for a life well lived are reminders of why design is a calling and worth doing to your very best ability. You have not only set the benchmark of aspiration, but your commitment inspires all who experience it as the creative, problem-solving process in action. It is why humanity is here. Thank you for the ever-present reminder.

To my parents, Arden and Sandy, for teaching me that nature is sacred. And to those closest to my heart: my children, Evan and Sommer, for the honor of being your mother; and to my love, Mark Fay Coble.

And always…*always* to nature.

ABOUT THE AUTHOR

Maggie Macnab grew up in Santa Fe, New Mexico, with her parents, Sandy, an architect, and Arden, a poet and teacher, and her younger brother Jesse. Her interest in nature and its creative potential was encouraged by her father who gave her a microscope at age nine to see the invisible, read her science fiction shorts as bedtime stories, taught her to observe and draw nature, and took her camping and horseback riding in the high deserts of New Mexico. She learned early on to appreciate nature in all of its many guises in beautiful and mysterious places such as Chaco Canyon, the Sangre de Cristo Mountains, Big Bend National Park, Puye Cliffs, and the Santa Fe River on Upper Canyon Road.

Maggie left school at age 16 with one credit outstanding toward graduation, determined not to spend another year in the public educational system, and began training in commercial art (the predecessor to design) in Albuquerque in 1973 as a production artist. She learned hands-on with hot metal and emerging computerized typesetters, printers, and ad agencies in Albuquerque and Austin. Maggie started her freelance business in Albuquerque in 1981, subsequently winning national awards and receiving recognition in national design magazines and books from 1983 on. She raised her two children, Evan and Sommer, in the Sandia Mountains.

Maggie teaches design theory at the Digital Arts Program at the University of New Mexico/Albuquerque and for Santa Fe University of Art and Design. She is for the most part self-taught and has pursued education in her own way, never looking back. Maggie lives in Santa Fe with her partner, Mark Coble, and a dozen chickens.

FOREWORD

by Debbie Millman

The moment I saw the chapter titled "Infinity Captured" in the Table of Contents in Maggie Macnab's first book, *Decoding Design: Understanding and Using Symbols in Visual Communication* (HOW Books, 2008), I knew I was in for a treat. Having long been curious about the connection between science and design, I instantly recognized that her book resolved my recurrent questions and stored the answers I had been searching to find: why symbols and patterns resonate on an instinctive level, how images "speak" to us, and why my heart fluttered whenever I saw evidence of the golden ratio in everyday life. *Decoding Design* now has a noble partner to further its intellectual and philosophical reach, and it is a remarkable companion.

Design by Nature is a revelation. It is both a book and a bible of sorts: It investigates and illuminates the symbiotic relationships in nature, art, science, economics, philosophy, technology, and design.

Design by Nature begins with the beguiling subtitle, "Memory: Remembering What We Know," and it is chock-full of Proustian epiphanies and exercises on reclaiming intuition and creativity. The book also investigates the notion of connectivity and quantum mechanics in a gorgeous chapter that also includes a treatise on "Emptiness as a Philosophical and Visual Design Application," which is simply masterful.

Throughout *Design by Nature*, Maggie demonstrates how the design process embodies and defines the human species. She reveals how we have transformed energy and matter into tangible and useful inventions. And she proves how, at its best, design allows us to perceive and refine large patterns into fundamental meanings and relationships.

Before I read *Design by Nature,* I asked Maggie what her intention was in writing it. She responded by telling me, "Intention generates the reality of life." Her hope was that "the book would inspire people to remember that while we are here on this planet, we can participate in the process of living by creating meaning with beauty."

Design by Nature thoroughly succeeds in doing that, and then some. Frankly, *Design by Nature* makes you feel glad—and grateful—to be creative, to be inventive, and to be alive.

CONTENTS

SECTION ONE MEMORY: REMEMBERING WHAT WE KNOW

CHAPTER ONE

AESTHETICS ENJOY THE RIDE 5

CHAPTER TWO

EFFICIENCY GO WITH THE FLOW 35

CHAPTER THREE

NATURE'S ETHICS EVERYONE'S BUSINESS 67

SECTION TWO MATTER: UNDERSTAND AND CREATE

CHAPTER FOUR

PATTERNS NATURE'S DYNAMICS 105

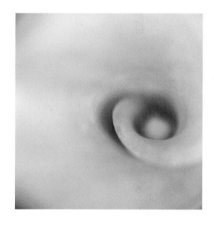

CHAPTER FIVE

SHAPES NATURE'S VOCABULARY 141

CHAPTER SIX

THE ELEMENTS NATURE'S SENSUALITY 169

SECTION THREE MOTION: THE EXPERIENCE ENHANCED

CHAPTER SEVEN

STRUCTURE BUILDING BEAUTY 201

CHAPTER EIGHT

SYMMETRY A BALANCING ACT IN TWO OR MORE PARTS 227

CHAPTER NINE

MESSAGING A MEANINGFUL MEDIUM 251

INTRODUCTION

At five years of age, I stood above the clouds at sunset atop a mountain with my father. He told me to never forget the moment. I never have.

I consider myself lucky to have had parents who regarded nature as the primary source of truthfulness. In our family, nature was never secondary to the inventions, interpretations, or interventions of human making. Rather, it was meant to enhance, guide, and inspire what humans create. My mother, who expressed nature in the words of a poet—and my father, an artist and architect who had a creatively gifted mind and generous heart—gave me opportunities from the beginning to experience life as deeply connected to the earth and sky. My father taught me that nature was beautiful, powerful, and mysterious—and always to be respected. Nature was the source of all that is and an infinitely creative and patient mentor. I've drawn images and information from nature from the moment I could hold a pencil. Disenchanted with what institutionalized education had to teach me, I left high school a year early and worked my way into what seemed a natural fit. I became a designer so I could use my visual skills to figure things out creatively. My career began with advertising design and evolved into teaching—and now book writing—all of which I continually learn from.

Like most designers, I designed what "felt right" early on without completely understanding where the ideas came from or how the connections were made. Time and teaching have made those connections for me. I've learned to be consciously aware of how I source intuitive understanding to create designs that are aesthetic, functional, and meaningful. Conscious observation is all it takes—that, and being as patient with yourself as nature is with its own process.

Design by Nature will remind you of the knowledge you already have by *really looking* at everyday relationships. By recognizing the principles, patterns, and processes of nature, you can create intuitively elegant and aesthetic design at will rather than by chance. Because nature happens around and within you continuously, you know its processes by heart. And by understanding how to relate message to image, you create value—or design that tells an authentic and useful story—enhanced by your creative understanding of the common experience. This is crucial to communicating across language, culture, and belief. Nature is the one touchstone all human beings relate and respond to.

This book will start you on your way to developing a more finely tuned awareness and appreciation of nature, with exercises that help you experience how nature's problem solving can be applied to design. The tools are simple: All you need is a compass, a straightedge, and drawing software if you want to create digitally, along with a heart that is receptive and a mind that is responsive to what it observes.

As a human, you are meant to be a creative problem solver. Loving every aspect of your work while also satisfying the project's scope and requirements—and making a living that is constantly challenging and enriching—are not unattainable goals, nor are they meant to be. The most reliable, available, and truthful mentor is right outside your door. Nature has an answer for any question you ask if you just relearn how to hear its answer.

Maggie Macnab
Santa Fe, New Mexico
August 2011

MEMORY

REMEMBERING WHAT WE KNOW

一冊の本

一九九六年七月十日第三種郵便物認可 二〇〇三年五月一日発行（毎月一日発行）第八巻第五号（通巻第八十六号）

2003
5

朝日新聞社

1

AESTHETICS

ENJOY THE RIDE

You might wonder why the opening section of a design book is called "Memory: Remembering What We Know." Being born through the wisdom of nature, everyone on earth comes into the world equipped with a toolbox of natural abilities. Some of them are physically apparent, and some come to you as if out of the ether. You have a brain that analyzes the world around you and thinks inventively to create what it needs; two hands that are adept at using and making things; an array of senses that gauge, measure, observe, and absorb all that you interact with; and a heart that directs you in what "feels right" for who you are.

KEY CONCEPTS

- Aesthetics are both relevant and necessary to effective design.
- Intuition is essential to creativity.
- Synchronicity opens possibilities that may not otherwise exist.
- Wabi-sabi is an Eastern approach to a natural, unmanaged aesthetic.
- Grunge is a Western approach to a distressed, manipulated aesthetic.
- Simplicity is reduction; emptiness is expansion.

LEARNING OBJECTIVES

- Understand the relevance of aesthetics to functional design.
- Appreciate the relationship of simplicity and emptiness to elegance and multiple-use applications.
- Use your inherent creative abilities of intuition and synchronicity to support your design's fluency and reach.
- Appreciate the creative expression inherent in the natural process of a design's evolution in wabi-sabi and grunge.
- Understand the difference between the concepts of simplicity and emptiness.

ncluded in your innate inventory are intuitive signposts to help direct the way. Fundamental pieces of "memory" are embedded from the earliest experience of your ancestors and from your personal experiences collected during the first years of life. These experiences join with the unique composite of your genes to give you an individual perspective of beauty, teach you how to assess and respond, and advise you on how to make decisions based on what you believe to be right or wrong. This first chapter focuses on aesthetics, or the appreciation of beauty, and how it is integrated into effective design. This chapter will help you remember what you already know.

Truth and Beauty

"Who ever said that pleasure wasn't functional?"

—Charles Eames

The appreciation of beauty is universal. There was a time in history when beauty was regarded as the highest evidence of a fundamental truth. If something was sensually pleasing, it was understood to display an intrinsic quality expressed outwardly.

Think of a lovely peach fresh off the tree (**Figure 1.1**). At the center of this piece of fruit exists all its future generations in the compact form of a pit. The fruit is the short-term nourishment for the incubating seedling or—more likely—becomes nourishment for the lucky animal or human that happens along at the right time to eat it.

The peach is the outward expression of all the future peaches that will be produced if the pit grows into a tree. The essence of the fruit provides direct energy to whoever eats it in the form of nutrition, vitamins, fiber, and sugar energy. All of its benefits are implied in the sensual perception of the fruit: its beautiful color; luxurious, fuzzy feel; delightful sweet scent; and delectable flavor. Everything about it is appealing because it is good for you.

Aesthetics have universal and personal appeal. Most people can agree on a beautiful proportion. But at the same time, one group can consider an item or a style to be beautiful while another is repulsed by it (**Figure 1.2**). It is not a logical choice, but rather a sense derived of diverse subtleties in personal and cultural experience and preference. Beauty is considered an *emergent* property—a quality spontaneously generated from within, not created by external decoration or a superficial addition of some sort.

1.1 *The fruit of the peach tree expresses pure goodness in the sensual experience embodied by its look, smell, feel, and taste (opposite). Visual Language, www.visuallanguage.com.*

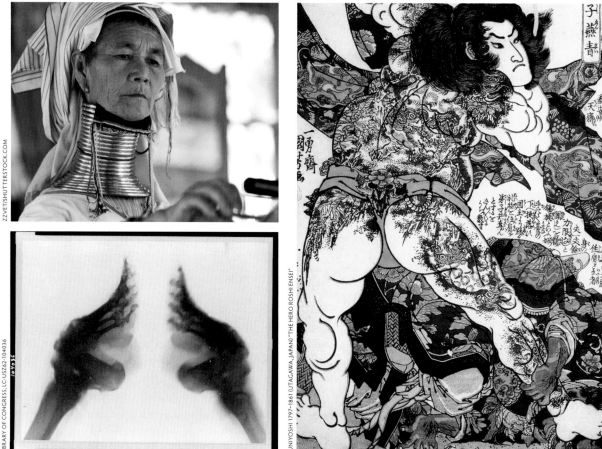

1.2 *In the eye of the beholder. Primitive to modern cultures have practiced various body modifications to enhance beauty that look quite bizarre to some but are considered beautiful by others: neck stretching (Padaung tribe of Thailand), foot binding (Chinese), and full-body tattooing (Japanese).*

Beauty Is as Beauty Does

Murray Gell-Mann, the theoretical physicist who invented the term "quark" for one of the most elementary particles ever identified, sees beauty as a criterion for selecting a correct theory and discovering a universal truth. How do aesthetics support truth? Gell-Mann explains it as an appreciation and recognition of a fundamental property that is carried from the inside out. Like successive layers of an onion, each progressing skin layer contains similarities to the one prior. Similarity brings *fluency* to information; that is, the ease with which it can be processed and understood.

Isaac Newton used the same idea of common relationships between scales to understand how gravity functions—from why an apple falls to earth to how that same force influences planetary orbits. In Newton's time, the idea of a principle remaining essentially the same from earthly to universal scales was such a radical notion that he felt he would be seen as an "extravagant freak" for the theory in public. This theory of "common scaling" is called *self-similarity* in scientific terms and has become an active area of theoretical study in recent years. The basis of a theoretical application called *complexity theory*, self-similarity anticipates megapatterns from initial—or beginning—conditions. Self-similarity is helpful to demonstrate everything from the most effective routes to evacuate thousands of sports stadium fans in the event of a bomb, to how ants find food individually and then cooperate as a single communal system to return it to the nest.

DID YOU KNOW? **Metaphors (multidimensional meanings) are the basis of organizing conceptual thought by creating multiple relationships and solving many problems at once. They are as effective with visuals as they are words.**

The most elegant discoveries are simple in nature because simplicity is at the heart of the complex. Complexity arises from simplicity: You were the equivalent of a tiny two-dimensional circle once upon a time. In the case of the onion, a fundamental law of similar structure and shape is carried throughout its successive layers. This simple redundancy is displayed elegantly as the same approximate form repeating in different layers, at different scales, or in other dimensions (more on self-similarity and scaling in Chapter 9, "Messaging: A Meaningful Medium").

Intuition and Creativity

"The intuitive mind is a sacred gift, and the rational mind is a faithful servant. We have created a society that honors the servant and has forgotten the gift."

—Albert Einstein

Intuition is an immediate insight of understanding without reflection or rational thought processing. Because it is difficult to investigate and quantify, intuition is regarded by most modern cultures as unreliable, unscientific, and irrelevant to the real world. Most educational training teaches you to override your intuition and places rational thinking (which drives materialism) in higher regard. But in

many other cultures, and increasingly so in modern Western culture, intuition is regaining its status of being practical in a different way. It is the nature of intuition to spark and guide creativity, and it is an essential ingredient for anything new in the "real world" to happen at all.

As is obvious, *creativity* is the act of making or inventing an entity that didn't exist before. Intuition sets the stage for the freedom of creative thought to occur; as such, it's a good strategy to prepare for it. Creativity is a personal process, and there is no formula that can force it—by nature it is spontaneous. But that doesn't mean you can't encourage it with preparation. Consider a ballet dancer. The dancer must have all of the physical supports in place to execute the dance: eating right, resting well, and practicing the dance moves and timing diligently. When the sequence and timing of the movements are embedded in muscle memory, the brilliance of creativity takes over and becomes spontaneously fluid—which is best known as art. Design, like dance, is about more than mechanics (**Figures 1.3** and **1.4**). Although technical skills smooth the execution, intuition lubricates the flow of creativity and has equal importance to technique and skill. Clearly, skill and intuition combine to form the most creative and inspired result.

The word intuition comes from the Latin *intueri*, roughly translated as "the teacher inside." Intuition, as the American architect, inventor, and futurist Buckminster Fuller said, "is having integrity with oneself." After a difficult period in his life in the late 1920s, with no money, no job, and his daughter dying from polio, Fuller considered committing suicide at the edge of a lake. Later, he recounted a voice coming to him and saying, "You do not belong to yourself. You belong to the universe." Maybe you've heard this voice during a particularly critical moment in your life. There is no doubt when you hear it that it is truthful, or at least wiser, than you might be in that moment. Because Buckminster Fuller wrote a book titled *Intuition* in his later years, I wouldn't doubt he knew his intuition was giving him a simple and profound instruction for his life's path. He went on to dedicate his life to finding out what he might do to benefit humanity. In a 50-year-long experiment of how the universe works, Fuller developed 28 patents, authored 28 books, and received 47 honorary degrees. His most well-known invention, the geodesic dome, has been produced hundreds of thousands of times worldwide. But his true impact lives on in his continued influence upon generations of designers, architects, scientists, and artists who use his principles to approach living through design in a more graceful way.

Let's look at a couple of personal stories of intuition and creativity.

1.3 *This design was inspired by my appreciation of music expressed in the form of dance. The flow of the design is reminiscent of the intuitive process used to design it (as well as the subject matter), whereas the execution's success resides in the skill of combining technique and tool, in this case, Adobe® Illustrator®.*

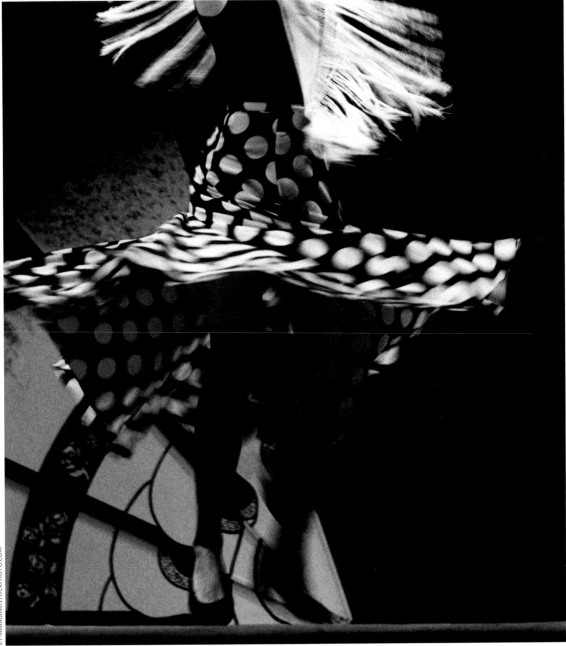

1.4 *Flamenco dance evolved out of Moorish dance influences during the Renaissance. The exclamation "olé!" was derived from the exclamation "Allah!" shouted when a Middle Eastern dancer inspired the beauty of God in the audience.*

JOEL NAKAMURA : GUEST DESIGNER STUDY

ILLUSTRATOR : UNITED STATES

Award-winning artist Joel Nakamura is known for his unique style: a blend of folk art and sophisticated iconography rendered in a neo-primitive technique. He is chosen for many of his commissions because of his knowledge of tribal art and mythology, and for his ability to convey stories and information in an intricate and engaging manner. Joel's ability to access the mythological and convey it in universal terms is based in his intuitive access via his openness to the common human story.

1.5 *Joel finds his inspiration in quirky human art and stories that are often perfectly combined in antique children's toys. Multiple Visions: A Common Bond. Installation 9-8-Circus Scene.*

A GARDEN OF EARTHLY DELIGHTS

A circle of white rabbits surrounds a single clown with a sinister smile (**Figure 1.5**). The leader of the rabbits is wearing a red vest and hat. We don't know why this little drama is taking place. The collection doesn't change, yet seems to be always changing, because I always seem to find some new, strange, diorama drama that is fascinating and amusing. The museum is one of my favorites in the world and is one of my muses.

I have been visiting museums since my childhood. My parents were both art educators, so our family was always off to the latest art exhibit. At first I was a reluctant participant, but I grew to truly appreciate museums. I think it's this background in experiencing art in person that gives me a creative edge. I find myself grateful to have stood for hours in front of Hieronymus Bosch's Garden of Earthly Delights (**Figure 1.6**) when I was 10 years old.

As I got older, my inspirational sources moved into popular culture. I may be the only artist to quote Charles Bronson, anti-hero actor, as a creative influence. In the 1970s movie *The Mechanic*, Bronson plays a hit man. Each time he receives his assignment, he pins up all the information about his victim on a board, puts on some classical music, and looks at his collection of Bosch paintings. I liked the idea of immersing oneself in information until some kind of plan or concept begins to take shape. I was only in junior high school when I saw the movie, but I would plan my homework, term papers, and projects this

1.7 *Joel's work is displayed in galleries and is also used for commercial purposes.* Dream Catcher ©1998 Joel Nakamura.

1.6 *Hieronymus Bosch often depicted a bizarrely intricate and sinful humanity in his paintings (c. late 1400s–early 1500s), an early inspiration for Joel's illustration work.*

way. Later, I would continue this process into art school and my professional career. I have an extensive library of books about art, artists, mythology, and more. Books are a great way to stimulate ideas or take me in a different direction. The Internet is also a good tool, but it lacks the visceral connection I get from surrounding myself with a pile of books.

My process has also evolved. I used to edit the sketches I would send clients. Now I send everything. I'm often surprised by the direction or sketch that's chosen. Clients enjoy seeing the number of doodles and my total creative output. When it's time to actually paint the work, it's a long, intensive process (**Figure 1.7**). A great help to keep up my stamina while working is listening to audio books. One of my favorite authors is Michael Connelly, who writes about an LA detective named Hieronymus Bosch.

It is not very often that I find myself in a creative slump. When I do, the Folk Art Museum is my go-to place. And of course, there's always Hieronymus Bosch. ■

STEFAN SAGMEISTER : GUEST DESIGNER STUDY

DESIGNER : UNITED STATES

Stefan Sagmeister, owner of Sagmeister Inc. and author of several design books, has created graphics for clients including the Rolling Stones and Lou Reed. His work is timeless and of the moment, reflecting his intimate but thoughtful approach that inspires his intuitively creative design.

OBSESSIONS MAKE MY LIFE WORSE AND MY WORK BETTER

I rarely obsess about things in my private life. I fail to care about the right shade of green for the couch, the sexual secrets of an ex-lover, or the correct temperature of the meeting room AC. I don't think I miss much.

However, I do obsess over our firm's work and think that a number of our better projects came out of such an obsession.

On September 13, 2008, Sagmeister Inc., began the installation of 250,000 Eurocents on Waagdragerhof Square in Amsterdam (**Figure 1.8**).

Over the course of eight days and with the help of more than 100 volunteers (**Figure 1.9**), the coins were sorted into four different shades and carefully placed over a 300-square meter area, according to a master plan.

After completion, the coins were left free and unguarded for the public to interact with. Less than 20 hours after the grand opening, a couple of local residents noticed a person bagging the coins and taking them away. Protective of the design piece they had watched being created, they called the police (**Figure 1.10**).

Spontaneously creative displays—particularly in the public realm—are often not appreciated for very long. It would seem, although loved by onlookers and participants, and appreciated by those in need of a few extra cents, the police deemed the exhibit inappropriate. ■

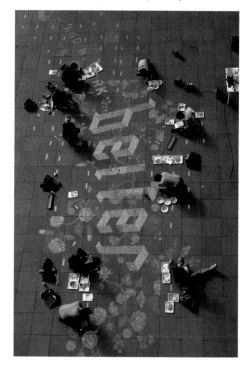

1.9 *Volunteers working on the design's development in a public space.*

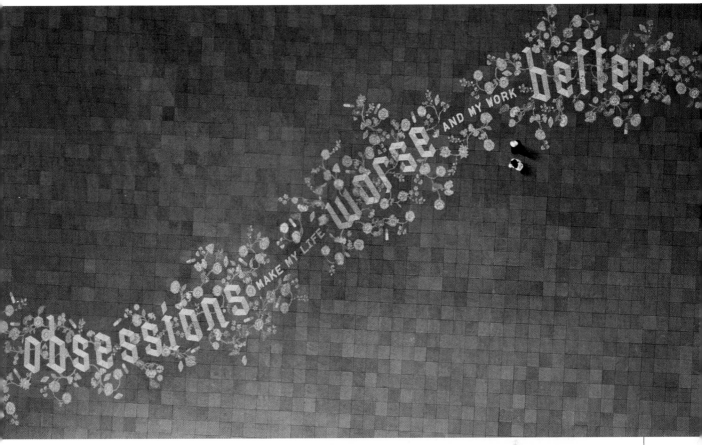

1.8 *A collaborative design of hundreds of thousands of Eurocents, addressing "obsession's" impact on the quality of life (above). Art Direction: Stefan Sagmeister; Design: Richard The, Joe Shouldice; Photography: ©2008 Jens Rehr (all images this spread).*

1.10 *After stopping the "criminal," the police—in an effort to "preserve the artwork"—swept up every remaining cent and carted them away.*

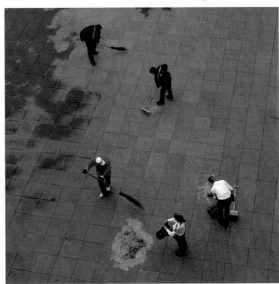

Synchronicity

A *synchronicity* is a meaningful coincidence. Synchronistic events manifest ideas in real-world experiences. The Swiss psychiatrist Carl Jung coined the phrase almost 100 years ago as a description of the law of attraction and manifestation. You've probably experienced it: You think of someone and that person calls you within minutes of the thought; you continue to see the same number or image in different situations; the funnies have a theme running through unrelated comic strips that aren't tied to current events. These events come in all levels of relevance, from circumstances that led to a tragedy or prevented one, or from a simple curiosity to some of the most brilliant realizations that turned theories into usable practices. Maybe you've experienced it in the process of design. Have you ever worked on a design problem with no progress, and then something you weren't looking for—something unexpected outside your research and in the most unlikely place—suddenly appears and either leads you to or is perfect as the solution? Granted, this doesn't happen often, but it does happen from time to time. These are the gifts of synchronicity. Pay attention to and appreciate them when they occur.

You spend a lot of time following a thread: an email conversation, a sequential line of thought, and a step-by-step task list. There's a reason for that: It gets the job done. Tasks become more manageable when broken down into bits. Just think of the number crunching your laptop does when it's figuring out all of the complex connections it has to make to transform your inspiration into a final piece of design.

Or look at the source code on any HTML Web page, and you'll see the framework of letters and symbols that string technology together. When programmed well, the "skin" appears fluid and effortless as a final result, due to millions of tiny connecting configurations that are responsible for its creation. Thousands of pieces of code bring a comprehensible Web site into being or can create amazingly complex digital illustrations (**Figure 1.11**). Unless you're a Web developer, you don't delve into these details, much in the same way you don't think about the physical organization of cells, muscles, and skeleton as the underlying structure of who you are. You take your skin at face value.

People are connected by more than physical parts, as quantum mechanics is beginning to describe. This is the difference between the machines that are designed and the amazing composite of matter and energy that people are. You can't actually trace or find all of the bits, or understand how they connect you to the intangible that inspires you, but somehow they find each other, connect,

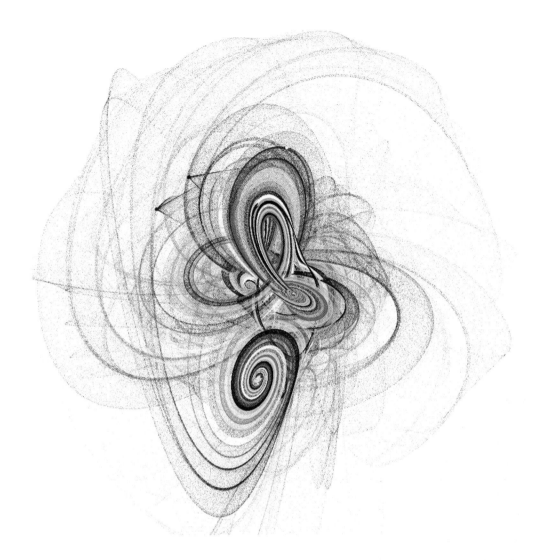

1.11 The Sand Traveler *is created with an open source programming language called Processing, and it is made up of 1,000 traveling particles, each in pursuit of another. Over time, patterns of travel are exposed as sweeping paths of color that coalesce into a synchronistic expression of organized art. Jared Tarbell, 2004.*

and result in something miraculous that was previously invisible. Coincidence is very much a part of everyday life, but it takes awareness to notice it. With the understanding that everything in the world is connected with varying degrees of separation, coincidence could be considered a word that simply describes a connection more remote than others.

When you are sensitive and proactive with synchronicities, they connect you in unexpected ways with alignments that are important to you. As designers, one of the most gratifying things you can do is apply your skills to work that is personally meaningful. In the following story, David Berman tells of how his personal family history, his passion for design and ethics, and an unexpected commemorative project in his home country of Canada came together and synchronistically combined circumstances in a dramatically poignant result.

DAVID BERMAN : GUEST DESIGNER STUDY

DESIGNER : CANADA

David Berman applies strategy, design, ethics, creative branding, and communications to business problems. He has over 25 years of experience in design and strategic communications, including Web design and software interface development. As an internationally acclaimed expert speaker, facilitator, communications strategist, graphic designer, typographer, and ethics chair, his thought-provoking speaking and professional development engagements have brought him to over 10 countries in the past few years.

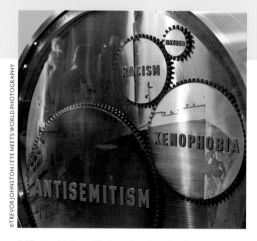

©TREVOR JOHNSTON / EYE MEETS WORLD PHOTOGRAPHY

1.12 *David chose the typeface DIN for the commemorative monument, created by the Deutsches Institut für Normung (or DIN in English: The German Institute for Standardization), for legibility and consistency in prewar Germany.*

A SYNCHRONISTIC PROJECT

In June 2010, I had been invited to speak at the Bauhaus School in Dessau, Germany. Erik Spiekermann had insisted that if I were ever near Berlin, I should visit him. Dessau is just over an hour from Berlin, so I called Erik from my studio in Ottawa before leaving Canada to make sure he'd be in town. Serendipitously, not only would he be in town, but I would arrive the day he was speaking at his TYPOBerlin conference. By the time I got there, they had put me on the program!

After speaking at the conference, I rented a bike to tour Berlin and see the Jewish Museum Berlin. The museum is a stunning piece of architecture by world-renowned architect Daniel Libeskind, within which is documented the very difficult history of the Jews in Germany. It was a powerful, profound, and sorrowful day: My grandparents were all European Jews, and our family tree has many severed branches.

Two months later, back in Ottawa, I discovered a heartfelt letter to the editor from Daniel Libeskind in the *Ottawa Citizen*. Daniel had won the competition to design the first monument to the ill-fated passengers of the MS St. Louis. The MS St. Louis was the German ship that was turned away from North American ports in 1938, along with its cargo of 937 Jewish refugees from Nazi Germany. By sending those 937 passengers back to Germany, the Canadian government had condemned many of them to death. It's a dark story that had never been commemorated.

I was captured by the story, which included a sketch of Daniel's vision for the monument that would be erected at Pier 21 in Halifax, Nova Scotia, where those passengers could have started new lives. After seeing the typography, I thought that the architectural concept was brilliant, but the graphic design needed help. Inspired to act, I crafted a short email and sent it to the man designing the Freedom Tower (the proposed monument to commemorate the Twin Towers in New

York City) explaining my desire to donate my assistance as a designer, a typographer, a Jew, a Canadian, and a design advocate to help repair the world.

Two days later I received a call. They had checked my work and asked to meet with me. Daniel had expressed his desire to include a list of the passengers' names on the monument. I suggested that the back of the monument be filled with a typographic wheel of names. "Send sketches," said Daniel, and so it began.

Trevor Johnston, a Pulitzer Prize-winning infographics specialist and a friend for decades, volunteered to help. My mother, a community archivist, arrived on my doorstep with a stack of books for design research, including the passenger list. We set all 937 passenger names in inch-high lettering to be etched in relief on stainless steel. That was a larger challenge than doing the graphic design for the front of the monument, because spelling precision was paramount.

I wanted to choose a typeface that was appropriate in terms of the tone of voice but would also poetically

help fulfill Daniel's artistic vision (**Figure 1.12**). I chose a late 1930s German typeface—a cut of the DIN typeface usurped by the Third Reich and redrawn by Albert-Jan Pool for Erik Spiekermann's FontShop. DIN carries connotations of the bureaucratic machinery of the era. To further dramatize the sense of that period's tone, the red of the Nazi party flag was used. (See more about the redrawing of this font in the "Albert-Jan Pool" sidebar.)

To honor the passenger list in a special way, I used a more humanist typeface—Erik Spiekermann's Meta Serif (**Figure 1.13**). (See more about Erik's design for Meta in Chapter 2, "Efficiency: Go with the Flow.")

On a windy January day in Halifax, Trevor and I attended the unveiling of the monument at Pier 21. After the speeches, Daniel and Canada's current Minister of Immigration proudly unveiled the sculpture. Dignitaries, designers, and guests gathered around the monument reading and examining. For the first time, I was able to run my hands over the lettering of the names—a very powerful experience. A woman next to me was doing the same, touching one specific name. She looked up at me and said, "You put these letters here? I came all the way from Boston. This is my uncle's name I'm touching. Thank you." Thank you, Bauhaus. Thank you, Erik. Thank you, Daniel. Thank you, Trevor. Thank you, Mom and Dad. Thank you, synchronicity.

Synchronicity brought me into this project by allowing my professional ability to attract an opportunity—as is so often the case when we trust our principles to align with what we care about most.

When we offer up our professional experience and abilities, guided by our principles, we attract the opportunity to be of true service. By making ourselves vulnerable, we invite synchronicity. And because we can, we must. ■

1.13 *An elder appreciating bittersweet memories at the commemorative memorial.*

ALBERT-JAN POOL : GUEST DESIGNER STUDY

TYPOGRAPHICAL DESIGNER : THE NETHERLANDS

Albert-Jan Pool is a Hamburg-based Dutch type designer who studied at the Royal Academy of Arts in The Hague (Netherlands), and has owned his studio, Dutch Design, since 1995. He wrote Branding with Type *(Adobe Press, 1995) with Stefan Rögener and Ursula Packhäuser, and is working on a doctorate thesis on the history of constructed sans serif typefaces in Germany. In 2011 the New York Museum of Modern Art (MoMA) extended its applied arts collection to include digital typefaces, amongst which is FF DIN.*

A HISTORICAL STORY ABOUT THE MS ST. LOUIS MONUMENT'S GERMAN TYPEFACES

In 1905, the Royal Prussian Railways defined a new master drawing for their lettering (**Figure 1.14**). Its original purpose was to unify the descriptions on the freight cars; soon it was adapted for all sorts of lettering, including the names of railway stations on platforms. Its sans serif forms were drawn with lines and arcs on a simple grid. Simple letterforms like this were quite common back then. In France, Germany, and Austria, the forms were developed by teachers who trained draughtsmen, such as engravers, lithographers, and sign painters, from the 1840s forward. After WWI, the foundation of the Weimar Republic enforced the process of the unification of the patchwork of German countries into a single German state. Consequently, all state railways were merged into the Deutsche Reichsbahn in 1920. Both the young republic and the German industry envisioned that standardizing could be an important means to revive the postwar economy. The German Institute of Standardization (DIN), founded in

1917, soon took a leading role in promoting, devising, and establishing such standards. Walter Porstmann, a DIN employee who had invented the standard series for paper sizes (A4, etc.), advocated the "single alphabet" (lowercase forms only) and envisioned the development of a universal typeface with which eventually all languages of the world could be written. In 1922, the DIN Committee of Typefaces took up its work but left Porstmann's ideas for what they were. Mainly on behalf of Siemens and Reichsbahn representatives, it was decided that the typeface of the former Prussian Railways would become the basis of a series of easy-to-construct lettering models "for the untrained." Not knowing that Bauhaus designers would manage to design far more elegant typefaces using grids of similar simplicity a few years later, the committee finished its DIN typefaces. Economical and political problems delayed its official release as DIN 1451 until 1936. Although the DIN 1451 typefaces have seldom been used for representative lettering, or in advertising or propaganda, they were used for general purposes, such as signposts, traffic signs, and wayfinding signage. They continue to influence the unofficial typographical identity of Germany today.

In the early 1990s, designers rediscovered the vernacular or "non-designed" typefaces, such as DIN 1451 (**Figure 1.15**). Erik Spiekermann asked me if I would do a redesign of the DIN 1451 typefaces to be issued by Font-Shop as FF DIN. I carefully reworked them and turned them into a family by providing lighter and bolder weights as well as italics. ∎

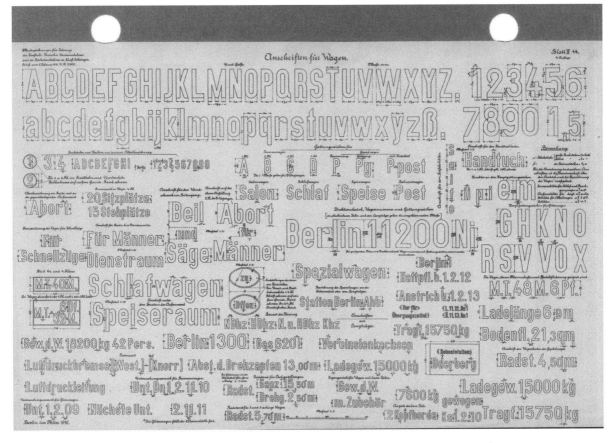

1.14 *The Master drawing from 1912 by the Royal Prussian Railways. The letterforms are identical to the first version from 1905. This typeface is known as the official model for DIN Engschrift, which was developed between 1926 and 1936.*

1.15 *A preliminary version of DIN 1451 from 1931 showing DIN Fette Engschrift (DIN medium condensed) ©DIN, Germany.*

Wabi-sabi and Grunge

Wabi-sabi is a Japanese term for an aesthetic that appreciates the beauty of ordinary objects no matter how imperfect, incomplete, or humble they are (**Figure 1.16**). It is an acceptance of the truth of life's impermanence. Although the idea of decay or incompletion has a negative connotation in Western culture, Zen Buddhism sees this inevitable predicament as a transcendence of worldly concerns; therefore, it has the positive perspective of liberation. From a philosophical standpoint, wabi-sabi is the recognition of worldly things exactly as they are in the present moment with no judgment or excessive thought about what they used to be or might become. It is an awareness and acceptance of life's endings and beginnings.

This is a foreign idea to most Westerners, whose values are determined by reliability, predictability, and materialism. Although the Japanese version of wabi-sabi is an acceptance of irregular beauty and is a state of letting it be, the Western version comes from another perspective. A dominant cultural interpretation of the Eastern-styled wabi-sabi outlook is grunge. Grunge—or messy, chaotic design— breaks the rules (**Figure 1.17**). It is a trend response that rebels against cultural mores when they become too restrictive. From surfer to punk, grunge design has been used as a visual antithesis to materialism and superficial values. The difference between these two cultural outlooks is significant: Grunge tears down or interrupts in a reactive way, whereas wabi-sabi simply appreciates the reality of the living process. Beliefs gauge the status of internal and external values, and determine which has dominance. Modern cultural values have a tendency toward active and offensive action, whereas many traditional cultures, particularly in the Eastern hemisphere, tend toward passivity and acceptance. Both have their appropriate place. You have the ability to choose which one to use as a design aesthetic depending on the circumstances.

1.16 *Wabi-sabi principles are often incorporated into freeform structures like pottery. But these principles can encompass anything that is human-generated and takes on a spontaneous shape; for instance, releasing leaves or petals to fall into an unplanned pattern when they land in a garden.*

1.17 *Northwestern United States grunge designer Art Chantry reinforces his client base of musicians and artists with funky grunge techniques and visual shock tactics (opposite). Design: Art Chantry.*

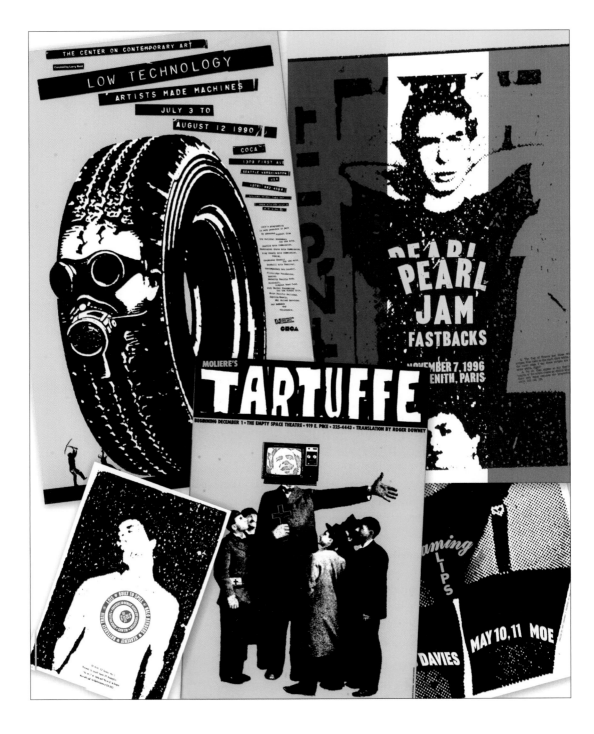

Emptiness and Simplicity

Simplicity is not the goal. It is the by-product of a good idea and modest expectations. —Paul Rand

When an embryo begins its process of cellular division to create organs, a neural stem and body, it starts as a flat circle before spontaneously folding and curving into a shape best described as a container (**Figures 1.18** and **1.19**). Within this protective vessel, cells migrate to their appropriate positions to form the parts necessary to emerge as a new life-form. Emptiness is a requirement of life to develop.

As a human, you emerge from this container of emptiness as an impressionable, perceptive, creative, sensual, and problem-solving species. Your innate abilities are called emergent properties. They come into being as needed, just as your cells coalesce and transform into the necessary body parts at exactly the right time.

In emptiness, forms are born. When one becomes empty of the assumptions, inferences, and judgments he has acquired over the years, he comes close to his original nature and is capable of conceiving original ideas and reacting freshly.
—Stewart W. Holmes and Chimyo Horioka, Fifteen Zen Tenets

Your given abilities are sourced within. They are already part of who you are. You can enhance these integral aspects of yourselves with training and education, but every human comes into the world equipped to exist within, expand upon, and contribute to the world *just as they are*. Your inherent abilities "emerge" through the experience of living and your *personal* interaction with nature. At their most useful, these gifts are complemented and expanded—rather than managed and compressed—by learning, beliefs, practices, and experiences. When a personal quality is complemented by an outside source, it allows you to contribute from the center of who you are by extending you into the world through your work; when managed, it becomes filtered through a perspective generated from a source outside of yourself that may or may not agree with your own.

The homogenization of individual abilities and perspectives through a common filter creates redundancy and noise, because it is *simplified* into a singular response. Instead of giving options that come from subtle and different

1.18 *A fly egg showing gastrulation, an early embryonic process that takes place in most animals. This process transforms the embryo from a relatively simple shape (ball or sheet of cells) into a multilayered structure. Image recorded by Dr. Willy Supatto (Biological Imaging Center, CalTech, left and right).*

1.19 *The collective behavior of hundreds of cells simultaneously migrating to create a furrow that will become the container within which body parts form. The egg itself is made up of about 6,000 cells at this stage. Image recorded by Dr. Willy Supatto.*

perceptions, one answer is offered. This reduces complexity but doesn't necessarily provide the most effective response to a problem. The more possibilities offered, the better the chance to address the issue. When you design solutions based on a response that stems directly from the issue rather than a simplified one-size-fits-all answer, the probability exists to discover a more workable, more aesthetic, solution.

Emptiness and simplicity are related concepts that contain subtle but significant differences. In the Eastern hemisphere of the interconnected earth, the idea of emptiness is one of emergence. It is a Zen concept of possibility. Its power lives in the potential of becoming. By contrast, emptiness in a Western context is perceived as lonely, despairing, or alienated.

Emptiness as a Philosophical and Visual Design Application

A perfect example of how to integrate emptiness and simplicity into design has been accomplished by Kenya Hara, author and creative director for Muji, a Japanese household retail company. Kenya uses the principle of emptiness in a variety of design solutions he creates for products, advertising graphics, and industrial

applications for the company (**Figure 1.20**). Muji is based in Japan with stores in several other countries. The name *Muji* is derived from a phrase that means "no-brand quality products." The company's philosophy is founded on recycling, minimal production waste and advertising, and a simple shopping experience. Muji's philosophy is part of the developing anti-branding movement and has a subtle but significant difference to the idea of simplicity.

Hara describes Muji's advertising as "not dispatching information from one entity to another, but facilitating the mutual exchange of information. In effect, Muji's advertising and products offer an empty vessel for the audience to supply the meaning themselves." With minimal branding and packaging, users provide their own interpretation, which emerges from a highly personal interaction (**Figures 1.21** and **1.22**). This strategy includes a range of responses from different sensibilities: old/young, male/female, professional/homemaker. As Hara says,

1.20 *Using the unobstructed view of the Mongolian horizon split perfectly between heaven and earth, this Muji poster communicates* everywhere *and* all, *or the receptivity of emptiness and equanimity, or "evenness of mind."*

MUJI

"Some customers buy Muji products because they like the ecological sensitivity of the company, the low cost, the urban aesthetic and simple design, or just because the products do the job described." Muji's philosophy includes them all. It is a philosophy that has risen out of necessity: The Japanese have long practiced a conscientious and open-design aesthetic in all they create to accommodate limited resources and space, which is reflected in Muji's advertising design. It's minimal, unobtrusive, and relaxed.

"Emptiness" as a design principle in Western culture is less common. Western culture is obsessed with specifics: bottom lines, literal interpretations, and hard results. Most Western commercial transactions are quite pointed in their direction—that of end purchase—and most advertisements are a gross overture to that result. But there have been instances of minimalist design that express an appreciation of the ideas of emptiness and its simplicity, such as those produced

1.21 *A Muji house ad provides a background of emptiness so as not to impose the advertiser's assumptions on the customer. It becomes a "fit" for anyone who cooks. "House" (left side, written using one Japanese character); MUJI (right side, written using four Japanese characters).*

1.22 *A Muji clothing ad. "What happens naturally" (left side, written with 11 Japanese characters); MUJI (lower-right side, written with four Japanese characters).*

by TBWA\Chiat\Day Los Angeles for Apple Computer. By identifying Apple's core philosophy with the rebels and geniuses that changed the world by "thinking differently" (**Figure 1.23**), the campaign established Apple as the ideology of the future. Apple was perceived as saving the day by making technology accessible to anyone. This move repositioned it well above its competition and far beyond the status of "product" by connecting the user into a world of possibility.

Simplicity

Although similar in its presentation, simplicity is a different concept than emptiness. Simplicity reduces information rather than acting as an invitation to the viewer's response. Simplicity distills information to its essence and provides an answer with a single conclusion. Necessarily sparse, it contrasts with emptiness by distilling information to its absolute rather than allowing for multiple interpretations. Emptiness is always simple, but simplicity is not necessarily empty, in the context that it contains an expectation of response or a directive.

1.23 *The phenomenal success of the TBWA\Chiat\Day "Think Different" campaign (1997) turned Apple in a new direction with a brilliant example of integrating the principles of emptiness, simplicity, and aesthetic. ©Apple Inc. Use with permission. All rights reserved. Apple® and the Apple logo are registered trademarks of Apple Inc.*

1.24 *As a literal example, a sign conveys an either/or simplicity that directs a response. It is literal, direct, and can't be mistaken for anything else.*

1.25 *A symbol conveys both/and ambivalence to allow a personal interpretation or choice. Symbols are usually broadly understood to represent a generality just as the yin yang represents opposites while also leaving room for the viewer's personal interpretation.*

Each has a different use. When you're driving toward road construction at 45 MPH, you don't want to guess what to do. There isn't time for that. A simple sign that tells you exactly what is expected of you is necessary in this situation (**Figure 1.24**). Road signs are simple and direct, and are specifically for the purpose of providing information quickly. They give an instant and clear answer: right, left, stop, go. A symbol is also simple (**Figure 1.25**), but it doesn't direct you to a definitive answer; rather, it invites *your* response, so it is not necessarily an answer but a question in and of itself.

Advertising has been doing this since its inception: When you want to establish a relationship with your viewer that invites their interpretive response, use ambiguous, symbolic language. When you want to give viewers a directive, clearly tell them what to do. An example of this using the same product for different end means is a car advertisement that tempts you with the freedom of the open road, the sexy lines, the indulgent extras; essentially, an escape from your day-to-day. On the other side of the coin is the car commercial that pushes the discount, the low annual interest, and the fast-talking "buy, Buy, BUY RIGHT NOW before this deal is gone." See the difference?

Putting It into Practice

It's important to put your own structures into place to provide a space for creativity to occur. The following 11 supports prepare the mind for design and are general guidelines that you can use and modify in ways that work for you.

1. Accept. Accept that you can't control everything. At best, you have a little influence, and that is all. When you release resistance, creativity is more apt to flow.

2. Observe. The only way to become really aware is to really look. Creativity is a heightened sense of flow between the observer and the observed.

3. Breathe. While you're observing, notice your breathing. Breath is your built-in equalizer. Use it to bring yourself back to center. This is a good tool for when you feel upset or off-kilter, but it is also useful to consciously connect with your perception of the external world.

4. Emerge. Go with your natural tendencies. Allow flow before deciding what is "right." Don't judge the unexpected; honor it.

5. Detach. Detach from a problem to get out of the middle of it so you can rise above it for a broader perspective.

6. Perspective. The way you see a problem isn't the only way to see it. Broaden your sights. Turn it upside down. Mirror it. Take a walk. Forget it. Remember it in a new way.

7. Practice. Practice what you learn. You won't get better at a new skill by waiting for it to improve itself, you must practice it. Skills are important supports to help funnel and focus creative flow.

8. Begin. Begin somewhere. Increments are doable. It doesn't matter where you start. Just start.

9. Meditate. I don't necessarily mean meditate literally. But do assess. Look back on your day and review it. Part of it worked to your advantage. Part of it didn't. Cut yourself some slack. We're all learning. If you didn't figure out the most brilliant design today, revisit it tomorrow with fresh eyes. Don't give up.

10. Live. Life is chaos. Back to Rule #1. The only constant is the moon. If there was no change, there would be no reason to learn, to love, to live.

11. Enjoy. Life is short, create it lushly. Design carries into every aspect of your life. Create your life around what you bring to it. You happen to the universe; the universe doesn't happen to you.

(a)

(b)

(c)

(d)

(e)

SIGN OR SYMBOL?

How might simplicity or emptiness be applied in a logo design? There are hints: one is direct, the other a suggestion. One leads you to a point, the other gives you a point to start from. Signs condense simply, whereas symbols provide the space to expand. Of the logos to the left (**a–e**), which fall into a category of a sign type of definition, and which invite your interpretation like a symbol? What sorts of businesses would prefer one over the other. Why?

INTUITION AND SYNCHRONISTIC DESIGN

Problems aren't negative occurrences. They're opportunities to flex your creativity and problem-solving skills, and to connect with the deepest parts of yourself. This exercise will bring more awareness to how you source information through and beyond yourself to come up with a solution that has the most possibility. The most important part of this exercise is to *pay attention to how the inside relates to the outside.*

1. Think of a design problem you're working on or a personal issue.

2. Draw an image that helps to represent the problem for you. The image should create a relationship between you and the problem.

3. Tell yourself that you want help in finding a resolution or relationship with this issue/project and that you are open to any ideas that will present a viable solution.

4. Over the next few days, be conscious of what is around you, what comes up in dreams, or what happens in situations when you are not actively thinking about the problem. The tangible external manifestations will arise spontaneously if you take care to notice them. Particularly, pay attention to anything that comes up more than once, even if it doesn't seem to be related.

5. If an image, number or another instance of a common tangible "thing" recurs in separate and unrelated events, delve into what that relationship might be. Experience your emotions as you explore (they give clues, too). Are you anxious? Comforted? What is the relationship between the problem, you, and the recurring event or object? Is the relationship related to a past experience?

6. Understand that sometimes an unrelated issue blocks a resolution to the current one. It is particularly important that you respect whatever your subconscious reveals and try to interpret its relationship to the current problem.

SIMPLICITY AND EMPTINESS

This exercise will help to bring the concepts of simplicity and emptiness into consciousness. It's called an "exercise" because it takes a conscious intention, a practice, for awareness to occur.

1. For a day, keep a small notebook with you that is easy to carry and pull out when needed. I recommend taking the time to draw because this acquaints you in a deeper way with what you are observing. (If you must, use a phone camera or other accessible device, but the point of the exercise is depth; it is not about speed or convenience.)

2. Whenever you see a visual "bit" of information—a sign, a logo, a billboard, poster, public art piece, or some other succinct visual message—make a visual note of it. Draw it (or photograph it). Capture whatever strikes you as being the most relevant components of the message.

3. Review your work later—that evening or within the next day or two. Has this piece of information supplied you with an "answer" as a directive, or has it invited you to create your own answer? Was it based in simplicity or emptiness?

4. Do you have a preference for simplicity or emptiness—that is, does a directive work better or does the ability to have your own interpretation work better—and why? Is your preference driven by the circumstance of the message or by a personal inclination?

5. How was the piece of information appropriate (or inappropriate) to the overall message?

EYEKU: WRITE A HAIKU AND ILLUSTRATE IT

Haikus are minimalist Japanese poems that are written in the moment and about the simple wisdom in everyday occurrences. Eyeku (**Figure 1.26**) was a design I created when I wanted to capture the idea of a symbol and a word combined. John Lennon wrote, "Life is what happens to you while you're busy making other plans." Life isn't what we expect. So? Laugh. Swear. Write a haiku. And walk on.

A haiku follows a pattern of moras. A *mora* is a phonetic unit that determines emphasis or timing. English translations can vary this rule, so there are loose interpretations of how to write one. The typical pattern of timing is 5 moras/7 moras/5 moras for a haiku. But there are many variances. They can be vertical (short verses in four or five lines), circular (never ending), a spiral shape, or the standard of three lines in 17 syllables. The basic guidelines include the following.

1.26 *Eyeku is visual plus word in balance. Designer: Maggie Macnab.*

1. Make it simple. Write about something anyone can relate to, something that is part of an everyday experience.

2. See something new in the simplicity. This is the *aha!* of a haiku.

3. Illustrate your haiku with a brush and paint or ink. Make the strokes spontaneous. You may need to do several to create one you love. That's OK; spontaneity doesn't come easily to most people, but practicing it can free you to be more in the moment. This is about self-trust.

4. A variation on the traditional method would be to use digital artwork and typography for a visual haiku, which is called a *haiga* (**Figure 1.27**). You can manipulate the letters, change the structure of the sentence formatting, and incorporate photography or digital painting.

5. If you're working in a group, pass your haiku forward and let someone else illustrate it. You illustrate someone else's. Compare your expectation with the result.

Here are some examples:

Haiku master Matsuo Basho (1644–1694)

> Falling sick on a journey
> my dream goes wandering
> over a field of dried grass.

(He died shortly after this; it was considered his last haiku.)

by Allen Ginsberg

> I quit shaving
> but the eyes that glanced at me
> remained in the mirror.

1.27 *Haigas as vector illustrations, ©2010 Alexandre Egorov, Switzerland.*

(a) The mother and baby bears are drawn stylistically, but are clearly referencing the animal: This is a sign. **(b)** This logo indicates medical care for pawed animals, probably domesticated dogs or cats. This is primarily a sign, although because of the implied rather than direct reference to a specific animal or treatment, it also has symbolic qualities (remember Aesop's fable "Androcles and the Lion"? See Chapter 2, "Efficiency: Go with the Flow"). **(c)** The visual forms the word. This is a sign, with all of the creepy-crawliness it implies. **(d)** Clearly a sign, with no doubt of its black-and-white intent. **(e)** This is an ambiguous symbol. The "h" and "p" letterforms rotate around a negative-ground plus symbol (in and of itself an ambiguous suggestion). You can see there is meaning to be had, but you are left to your own interpretation without more information.

第壹號　第六號　第拾一號

第貳號　第七號　第拾二號

第叁號　第八號　第拾三號

第四號　第九號　第拾四號

第五號　第拾號　第拾五號

2

EFFICIENCY

GO WITH THE FLOW

The phrase "go with the flow" hardly brings the word efficiency to mind, but that is just what nature does to optimize energy. Don't mistake going with the flow with being laid back: It only appears that way because nature's skill is unsurpassed when it comes to economy. The difference between human thinking and nature's process is simple: People deliberate and detail the steps to proceed, whereas nature transforms actively and constantly.

KEY CONCEPTS

- Nature is completely economical in its use of materials, and design benefits from understanding how to use minimal information for maximum understanding.

- There is a "value" to fit all circumstances of the design experience.

- Design impacts all aspects of human existence.

- Creativity and intelligence are different, but complementary, functions of the brain.

- Diverse problem-solving skills and creative processes are essential to good design.

LEARNING OBJECTIVES

- Understand nature's general process of efficiency and how it relates to design.

- Learn how well-thought-out design emulates multiple problem-solving processes in nature in terms of economy, value, recombination, and consistency.

- Become familiar with different styles of problem solving as demonstrated by other designers.

- Review a case study of problem solving as a group process within a community.

Efficiency and aesthetics are fundamental qualities of nature. Being efficient is defined by the ratio of time and effort expended for the work being done, and nature is brilliant at balancing need with response. Nature equalizes design solutions that neither gain nor lose energy in the process of change. It does this by adjusting itself to work within multiple circumstances, continually adapting to what exists *now*. Throw in a few random mutations for variation, and you have the recipe for infinite possibilities and configurations. There is just one requirement: Change must be functional to be sustained (**Figure 2.1**). A characteristic of functionality is flexibility. In nature, designs that can't or won't respond to changing circumstances are eliminated quickly in extinctions or absorbed over time in an adaptive response.

In this chapter, you'll learn from different styles of creative problem-solving skills and how to integrate economical and flexible visuals into your designs to help you create more imaginative and useful visual communications.

The Economics of Nature

Ecology and economy are rooted in the same word from the Greek οἶκος, or "house." They are the study of (-ology) and management of (-nomy) the "house." When management outstrips study (the conscientious observation of what works and why), imbalance occurs because you have forgotten to observe closely and understand what you see. One of the fallibilities of human design is a lack of thorough and rigorous study. Everyone loves a shortcut. But finding shortcuts to benefit the short term can often cost more in the long term. Breakdowns in systems, functions, or materials that aren't built to sustain over time are wasteful and cost more to fix. When a design becomes by and large accepted, it takes on the status of "real." Realness equates to "true" in most people's minds. The interchanging of "real" with "true" has been used by all human systems, including governments (**Figure 2.2**), religions, and corporations.

When you don't closely consider your designs of systems, products, or even your beliefs—or don't leave them open for future evolution as things change—the potential for those systems, products, and beliefs to become unworkable are probable. Overmanagement creates breakdowns. When you anchor to human-designed ideas without flexibility, you aren't able to change when things around you do. That nature is completely economical is its most basic quality, and it is derived of flexibility. Nature continually re-creates itself in unanticipated scenarios *in the moment*, balancing what existed in the past with what will exist in the future. It is always appropriate in its response.

2.1 *The scutes of a tortoise's exoskeleton (which is actually its outer skin) compress into an ultra efficient visual pattern that also serves as strong protection from predators (opposite). Photo: José R. Almodovar Rivera, University of Puerto Rico.*

A long-lived brand (for instance, Coca-Cola or Levi's, discussed in Chapter 9, "Messaging: A Meaningful Medium") is an example of having the flexibility to change around the edges—as a stylistic response to current trends—while the core of the brand is consistently represented over time: This mimics the flexibility of an oak tree's branches bending in the wind. The core remains intact and solid, while the more external parts go with the flow of the currents around it. "Going with it" is an effective way to respond to resistance or change. Energy that isn't pushing against a stronger energy is conserved for more productive processes like growing—be it an oak tree or a company.

Economical design uses only what is needed to serve the message. Effective visual messages that integrate stylistic additions facilitate the fluency of that communication for its particular culture and era.

Value-driven Design

Nature is completely self-reliant because it works within resources that are immediately available. It is always of the moment because it is "value-driven." The word value is used all the time, but rarely is its simple and straightforward definition considered. *Value* means *a fair exchange*, which is the business of nature. Never too much or too little, nature trades evenly. Energy is neither lost nor gained in the process of transfer: It is simply reordered. Nature lives by a resource-based economy. If the resources don't exist for a new development, then the development won't exist. It's a basic system, and it works.

The simplest solution can work beautifully in graphics, as well. You have a world of options at your fingertips, but too many choices can get you off track from finding the right solution. Remember how nature works when you're feeling overwhelmed. Look for the most accessible and usable option. It might be redundant, but there is reason for that: It's worked before in another situation that had some sort of fundamental similarity. Finding and making this connection within the essence of your design creates a relationship with the viewer. The principle of drawing parallels between ideas or things that appear unrelated (**Figure 2.3**) is one I use often, most particularly in designing logos. More than technique, it is a connectivity that identifies the *aha!* that engages your audience.

Visual communication that uses the principle of being value-based provides several inherent benefits to all concerned:

• An exchange of information equal in quality to the value of the viewer's time

• An equal exchange of the client's money for the designer's time

2.2 *Small disagreements can result in arguments; large ones can result in war. The constant repetition of a message combined with visual symbols and relationships can transform an ideology into reality (*For the glory of Ireland/*Hely's Limited Litho, Dublin, 1915). Library of Congress, Prints & Photographs Division, WWI Posters.*

- An equal exchange in the design appropriately and accurately expressing the message

- An equal amount of satisfaction-to-effort ratio for the designer in the final result

Optimal design provides information that is useful, beautiful, or in some way improves the experience of all involved. Closely aligned with this is common sense. Everyone has it, but it is often overridden by messages that encourage and seduce with false need.

2.3 *Art deco sentries guard the portal into the justice and equality of the Bisbee, Arizona, Cochise County Courthouse. Function is most effective when joined with beauty because beauty helps to describe the value of the function. This design is protecting the sanctity of justice by returning order (or balance) to opposing parties in a courtroom through an agreed-upon process. This is suggested by the economical deco style of the design and its symmetrical side-by-side use on the entryway.*

PETER BRONSKI

ECONOMY IN LOGO DESIGN

MACNAB DESIGN : USA

In 1981, I started my design business. Freelancing was a relatively new phenomenon, and I was one of the first designers (called commercial artists back then) to leave the ad agency business and venture out on my own in Albuquerque. I was far more interested in using design for creative problem solving and in direct one-on-one client interaction than I was in advertising culture. I knew if I could find my own clients, my creativity would be less restricted by a top-heavy hierarchy directing the process. I've never looked back.

(a)

One of my first projects was a logo design commissioned for a local veterinarian hospital (almost all work was local during the pre-Internet and pre-computer days). Because I've always been an animal lover, I was thrilled about the project and was excited to do projects that were meaningful to me.

My first sketch was silly and I knew I wouldn't use it—the vet wouldn't even see it!—but it addressed the first thought that came to mind as a pet lover—my affection for my pet (**a**). In the many years I've designed logos, I learned the first rule early on: *Get started!* Your first concept may not be the right one; it may not even be close to the final creation, but you must encourage the process with participation to get anywhere with it. Often, you'll find that your beginning ideas point to a viable direction you'll end up going in; it's impossible to see when you're in the process, but it's quite clear when you follow its genesis backward.

(b)

Because this particular vet saw only small animals (dogs and cats), that aspect of the service set me on the path of a paw print (**b**), a commonality of both animals. Knowing it had good potential as a universal sign for pawed animals, I decided to think on it for a while, because alone it was far too general.

While distracted by another project a couple of days later, I suddenly remembered an Aesop's fable from my childhood about a terrified slave named Androcles pulling a thorn from a lion's paw, a gratuitous act that eventually saves them both from death. Ultimately, both are captured and face each other again center stage at the Coliseum. Unable to kill Androcles, the lion licks his hand, shocking the emperor, and both are freed.

(c)

(d)

There are several morals to this story:

- What goes around, comes around.
- Treat others as you would like to be treated.
- Take care of those less fortunate.
- Honor the wisdom of animals; honor nature.
- Compassion is expansive; fear is contractive.
- When love overrides fear, expect miracles.

The heart of this story encompasses the basic truths of living consciously and humanely in the world. It has been repeated in multiple forms to fit the culture and era because it scales universally by being relevant to any place at any time. Remembering this fable gave me the instant realization of the perfect visual addition to capture these basic messages about the simple act of caring about another species that shares the world with us (c).

Because of its ability to communicate universally, the logo took first place in logo design from the American Advertising Federation for the United States (1983). It was also published in several high-profile design magazines (including *Communication Arts* and *Print*), giving national exposure to my business in its earliest days. With no Internet connectivity at the time, it was a significant coup for a young designer.

The economy of scale principle is an efficient method for designs that must weather the long term, such as a logo must as a key branding component. Introducing this kind of relationship into a succinct piece of visual communication substantiates it by connecting it into a universally understood truth. Trend doesn't bend the core of the design, and its universality makes it flexible enough to retain its meaning decade to decade and from culture to culture. The logo was in active use until 2005 when the animal hospital was sold (d).

Economize the graphic by using it as an opportunity to tell a story. Connecting to a universal truth does much of the message's footwork by creating an immediate relationship with the audience. It's engaging, memorable, and satisfying to depict a little reality in advertising. ■

Design's Purpose

Design's value and purpose can be evaluated by the way it is meant to serve: It connects you with memory through ritual and symbolism, provides the aesthetic experience of decorative art to utilitarian objects, gives access to information through its refinement and organization, and helps you to engineer tools and systems that have workable function. None of these aspects are exclusive from one another; design qualities often overlap in their use. In fact, the very best designs are completely economical, appropriately match the design to the message, are aesthetically pleasing, and provide a valuable service of facilitating information as knowledge or product as tool. At its best, design leaves the user better than before.

The natural world is the greater context from which you derive meaning, and you translate it as functional design. There is much you can learn through a process that has evolved over nearly 4 billion years, much that you already mimic, and much that would benefit you to relearn. You have always had the talent to understand how nature works around you, source the appropriate materials, and access the energy you need to create and live.

Nature needs only a few energetic principles to create designs for all of the possibilities it encounters. These principles are expressed in a few basic patterns and shapes that create the immense variety in nature's handiwork. Natural patterns and shapes represent some of the basic functions of the work of the universe: They move, store, and connect energy. You use these same forms in human meta designs of civilization: Roads move resources from one place to another; storage containers designed to be strong, light, and stackable hold those resources; and connections help transport them from one place to another (highway interchanges, road to rail, rail to ship) and to transform them (digital code transforms ideas into a cipher that in turn transforms as a visual interpretation people can understand). Regardless of context or the culture in which these visual patterns and shapes are used, they recur repeatedly and contain intuitive messages that remain constant because they manifest eternal natural processes in physical form (**Figures 2.4** and **2.5**). Nature's design purpose informs your design purpose. Patterns and shapes also occur in the two-dimensional forms of graphic design and artwork, and are the efficient and immediate way to communicate basic information with fluency the world round. Section Two, "Matter: Understand and Create" goes into more detail about them.

Problem Solving: Different Strokes with Effective Results

Design is an act of inspired creativity with practical, real-world results. Most designers use a "whole-brained" approach that distills complexity into an elegant simplicity without losing the essence of the information. You are trained to bring opposites into agreement as complements. By its very nature, you approach problem solving from an encompassing point of view. You must sort the essential from the extraneous and make it functional, beautiful (to encourage engagement), and relevant. The purpose of designed work is to make the complex or disorganized accessible. There is no "right" way to solve a problem; if the solution works, it's the correct one. But there are many styles of problem solving and two different approaches to the various styles that are basic to human nature. One is a holistic, nonlinear, and creative thinking approach that invents multiple possibilities not necessarily related to each other, and the other is a more linear, sequential style that accomplishes tasks one step at a time toward the end goal (**Figure 2.6**).

"The most innovative designers consciously reject the standard option box and cultivate an appetite for thinking wrong."

—Marty Neumeier

2.4 *Mehndi, or henna tattooing, is a ceremonial art form that originated in ancient India. The designs contain spirals, paisleys, and other organic forms. The spiral is the form of unfurling new life, which is the shape commonly used for marriage and springtime celebrations. (See Chapter 5, "Shapes: Nature's Vocabulary," for how these shapes relate to self-similarity and scaling in nature.)*

2.5 *The scrollwork, butterflies, and spiraling flowers of vector-based technology popular in current culture imply the underlying message of organic and sustainable growth.*

2.6 *Somehow in the mind's intricate thinking process, humans navigate a maze of options and usually come up with good solutions—some of which are quite unexpected. Credit: Jabuguin/istockphoto.com.*

Creative Ideas Used Skillfully

All animals re-create future versions of themselves through offspring, but only humans can create for the sole purpose of self-expression, no matter how short-term that expression may be. With the ability to emote creatively comes a knack for problem solving. Individual perspectives create all sorts of styles with all the quirks, dead ends, brilliant new ideas, and duds that result from the process of trial and error. One fact is certain about good design: It must be connected in a real and vital way that inspires the viewer to take action (action can be latent, too, such as remembering it later). When you connect to nature, you connect to a source that contains the vitality that everyone recognizes and craves as living beings.

Designers have a propensity to think visually and creatively, and most balance creative thinking with practical outcome. You have to. This is essential for work that uses creativity in the real-world application of functionality, in everything from work to play. Designers marry image to word. And because of the necessity of using creativity and practicality, most have well-developed skills in both approaches. "The power we have as designers," says Cheryl Heller of Heller Communication Design, "is that we are generalists. Designers have the ability to see systems and patterns." As it turns out, this ability not only creates good design, but it is exactly the skill set needed to help solve problems. Designers need to make connections and see the overall picture. When you are able to assess information and anticipate future impacts objectively, you can see and understand the whole picture.

There are some fundamental differences between creative and critical thinking processes. Many of these differences also align in the same way the brain processes a symbol or image and the way it processes written language. **Table 2.1** compares what each style does best. It's clear that we need both, and that they each contain different skills that can be used in different circumstances.

DID YOU KNOW? **More than 40 million people have taken the Keirsey test (developed by educational psychologist Dr. David Keirsey), which categorizes personalities into four temperaments: guardians, artisans, idealists, or rationals. To learn more about your personal problem-solving tendencies, you can take a basic version for free at www.keirsey.com.**

Creatives on the Creative Process

From a pointed process of linear efficiency to a more relaxed "go with the flow" attitude, there are as many styles of creative problem solving as there are people. You probably use a combination of at least some of these approaches, and perhaps you'll see a few new ways to broach a problem than you have before. Many of these creatives jump-start their process with an eclectic approach that provides several options; a few go directly into linear steps. Choices provide options, which can be a help or a hindrance.

TABLE 2.1 **Brain Solving: Lateral vs. Linear**

CREATIVE THINKING	LOGICAL THINKING
Generate an idea	Analyze a thought
Divergent ideas	Convergent ideas
Lateral (networking out and through)	Hierarchical (top down)
Possibility	Probability
Perception	Judgment
Hypothesis forming	Hypothesis testing
Subjective	Objective
An Answer	Answer
Open-ended	Closed
Associative	Linear
Speculating	Reasoning
Intuition	Logic
Both/And	Either/Or

Adapted from Fisher, R. (2002). Creative minds: Building communities of learning in the creative age. Paper presented at the Teaching Qualities Initiative Conference, Hong Kong.

AN INDUSTRIAL DESIGN CASE STUDY FROM ASKNATURE.ORG

In Japan, the Japanese 500-series bullet trains could travel 300 km/hour (200 mph), but the sound levels exceeded environmental standards. One source of noise was an atmospheric pressure wave forced in front of the train as it traveled through a narrow tunnel, creating a sonic boom at the exit. The bullet-shaped nose was part of the problem. Another source of noise was the pantograph, a protrusion that extended above the train to receive electricity from wires overhead. The structural adaptations of the Shinkansen train helped to minimize these concerns.

Eiji Nakatsu, an engineer with JR West and a birdwatcher, used his knowledge of the splashless water entry of kingfishers and silent flight of owls to decrease the sound generated by the trains.

KingFisher Photo: Charlie Hamilton Jones/UK; The Shinkansen 500 Series at Shin-Osaka Station: 663highland/Japan

Kingfishers move quickly from air, a low-resistance (low-drag) medium, to water, a high-resistance (high-drag) medium. The kingfisher's beak provides an almost ideal shape for such an impact. The beak is streamlined, steadily increasing in diameter from its tip to its head. This reduces the impact as the kingfisher essentially wedges its way into the water, allowing the water to flow past the beak rather than being pushed in front of it. Because the train faced the same challenge, moving from low-drag open air to high-drag air in the tunnel, Nakatsu designed the forefront of the Shinkansen train based on the beak of the kingfisher. The more streamlined Shinkansen train not only travels more quietly, but it also now travels 10 percent faster and uses 15 percent less electricity.

Visit www.asknature.org, a project of The Biomimicry Institute, to see more examples of nature's problem-solving strategies and learn how they can be applied to create sustainable and healthier human technologies and designs.

SEAN KERNAN : GUEST DESIGNER STUDY

PHOTOGRAPHER : UNITED STATES

Sean Kernan began his creative life at a young age in New York City. After graduating from the University of Pennslyvania's writing program, he fell into the theater and then discovered photography. Never having been taught photography in a formal setting, he has become a renowned teacher and inventive photographer. His work has been shown in museums in New York City, Greece, and Egypt, and has appeared in The New York Times Magazine, Communication Arts, Graphis, *and* The Atlantic Monthly.

SET YOURSELF ASIDE

The problem with thinking of yourself as a problem solver is that you wind up with a lot of problems.

2.7 *Sean Kernan's cover photo for The Secret Books.*

Design is, I think, not a purely artistic exercise, because we start at the place we need to get to in mind. But we are creative in the way we get there. So our best impulse is to always start by heading for the border and beyond. (Do you know that old joke: How many designers does it take to change a lightbulb? Why does it have to be a lightbulb?)

This is the impulse to be cultivated, and I do so by getting away from my office, my life, and my past. I travel if I can, and take a walk if I can't. I also try to move as I think and work. Something about being kinetic releases me from old thoughts.

Then I look at what I've done as though someone else has done it, which detaches me from the question of how well I have fulfilled my intentions. The trick is to get past my intentions, and then to recognize when I have and when it works (**Figure 2.7**).

If this all seems like an exercise in setting myself aside, that's exactly it. ■

A DIFFERENCE BETWEEN CREATIVITY AND INTELLIGENCE?

AN INTERVIEW WITH REX JUNG, PHD

Rex Jung, Ph.D. (University of New Mexico), is a leading scientist and author of over 40 scientific publications in the emerging field of positive neuroscience— the study of what the brain does well, particularly in the areas of intelligence and creativity. I asked him about just how creativity "manifests" in the brain, how creative thinking is different than intelligence, and how the two work together to better solve problems.

Q: *Have you all identified an actual process that supports creative thinking? Or are there "styles"?*

A: There are four basic "styles" of creative thinking, if you will, based on a theory by Arne Dietrich, a major theoretical thinker in creativity research today. In his theory, there are two axes—one a processing mode and the other a knowledge domain. On the processing axis, you have either deliberate or spontaneous modes. For deliberate, think of anything that is done with intention. For spontaneous, think of "flow" or improvisation. In the knowledge domain, there are emotional or cognitive styles. The scientist works in more of a cognitive domain (as does the engineer, or designers, or architects in certain stages of a design), whereas the painter or musician works in more of an emotional domain to elicit emotional responses from the audience. So with these two axes, you have four main styles: deliberate/cognitive, deliberate/emotional, spontaneous/cognitive, and spontaneous/emotional. No one is pigeonholed into one of these but can move back and forth depending on what aspect of their creative process they are in (generative vs. refining).

Q: *From a scientific viewpoint, how is creative thinking different than logical thinking?*

A: Logical thinking lives predominantly in the deliberate/cognitive domain. It is part of the creative process but not the exclusive purview of creativity. It is necessary but not sufficient. We have found a network of brain regions associated with logical thinking (i.e., intelligence) in which bigger, faster networks are the order of the day in linking information between the parietal and frontal lobes; in contrast, we are finding that broadly distributed, slower

2.8 *MRI measurements of white matter connect strength between different brain regions (in green), and regions in orange/red show higher creativity is associated with lower connectivity. The blue shows a personality variable related to creativity (openness to experience) that is related to lower and deeper white matter connectivity. The left figure cuts through the brain front to back; middle, through top to bottom; and right, from ear to ear.*

networks are associated with creative cognition, particularly within frontal brain regions.

Q: *Have you found actual physical structures in the brain that perform various functions in creative problem solving?*

A: Yes! We have found frontal lobe structures associated with increased creative achievement; biochemistry associated with increased divergent thinking ability; and that decreased white matter fidelity in specific areas was linked to creative capacity. All point to the more recently developed frontal brain regions, and most show that "less is better" when it comes to creative thinking.

Q: *What are some of the unexpected things you've discovered in your research regarding intelligent vs. creative thinking?*

A: Primarily that intelligence and creativity are not the same thing: The smarter you are does not necessarily predict how creative you will be. And, this notion is supported by the complementary networks of the brain—one fast and efficient, the other slower and more distributed (**Figure 2.8**). The brain is a very "expensive" organ to run, using some 80 percent of the oxygen we take in.

Q: *So, is one better than the other?*

A: The advantage intellectual activity has over creative activity is the high-speed efficiency of being routed through existing neural connections. Much like a superhighway, the structures are already in place and thoughts are expedited through them. By its nature, creative thinking is a slower and probably "more expensive" use of brainpower because novel ideas create new neural connections. So the ~~amount~~ number of neural connections may tell you how fast and much you can think, but it doesn't necessarily address how many new ideas you might come up with. Intelligence and creativity are complementary aspects of the human brain. ∎

ELLEN LUPTON : GUEST DESIGNER STUDY

DESIGNER AND EDUCATOR : UNITED STATES

Ellen Lupton is a writer, curator, and graphic designer. She is director of the Graphic Design MFA program at Maryland Institute College of Art (MICA) in Baltimore, where she also serves as director of the Center for Design Thinking. The books she has authored include Thinking with Type, D.I.Y.: Design It Yourself *(co-authored with her students from MICA), and* Design Your Life: The Pleasures and Perils of Everyday Things *(co-authored with her twin sister, Julia).*

2.9 *Ellen's first inspiration—this painting by 16th-century artist, Giuseppe Arcimboldo—came from the client's directive.*

DIGESTIBLE INFORMATION

How do you view your clients? Sometimes the process between designer and client breaks down over issues of time, money, taste, or endless rewrites and mind changes. You've all been there. But you also all know that successful outcomes usually result from a good relationship between designer and client, where there is mutual respect and a free exchange of ideas.

The primary item a good client brings to the table is a good project. Here is a recent great opportunity: Create a poster for a documentary film about visionary chef Tony Geraci, who has set out to reform the school lunch program in Baltimore. Designing a film poster is a dream project for many designers. It's up there in the stratosphere with book covers and museum identities. My clients were the film's director, Richard Chisolm, and its producer, Sheila Kinkade.

Sheila had just seen an exhibition by the Italian painter Giuseppe Arcimboldo (1527–1593) at the National Gallery. Arcimboldo created amazing portraits from fruits and vegetables (**Figure 2.9**). She wanted a veggie portrait of Tony, the film's hero. Knowing this would be extremely difficult to pull off, I loved the idea of including paintings in the poster. As the conversation evolved, we talked about filling the background with fruits and veggies. An early design featured broccoli and string beans emanating from the chef's head like an edible halo. (**Figure 2.10** shows another use of Arcimboldo's classical art in a

design solution.) Then Richard and I began discussing how to make the poster more active. Boxing posters were mentioned because they are a powerful and familiar graphic genre that speak to conflict and fun.

For the final poster (**Figure 2.11**), we commissioned photographer John Dean to shoot a portrait of Tony in a boxing pose, which gave the poster more physical punch. ▪

2.10 *A similar idea created by iconic art director George Lois for* Esquire *magazine in 1971.*

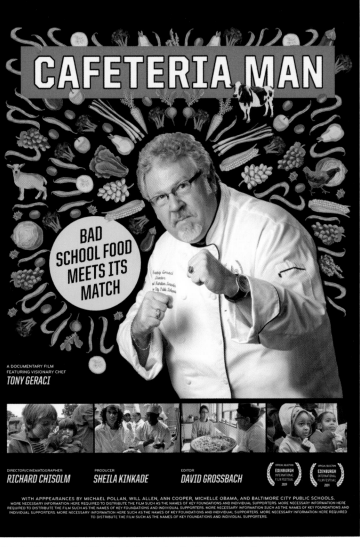

2.11 *The final result of food as information for the movie poster.*

ERIK SPIEKERMANN : GUEST DESIGNER STUDY

TYPOGRAPHICAL DESIGNER : GERMANY

Erik Spiekermann is an information architect, type designer, and author of books and articles on type and typography. He founded MetaDesign in 1979, Germany's largest design firm. Projects included corporate design programmes for Audi, Skoda, Volkswagen, Lexus, Heidelberg Printing, and wayfinding projects like Berlin Transit and Düsseldorf Airport. He started FontShop in 1988, a company for production and distribution of electronic fonts. He was recently awarded the National German Design Award for Lifetime Achievement. This is a story about his creation of Meta PT55 and its subsequent extended family as a highly legible and flexible font alternative to Helvetica.

2.13 *The counter (inside shape) is not parallel to the outside shape but is slightly squared off and creates contrast between outline and counter or between black marks and white space. This is the contrast that we read rather than simply the outlined shapes of a letter.*

REINVENTING "THE HELVETICA OF THE 90S"

Meta, in its first incarnation as PT55 (**Figure 2.12**), was designed for forms and telephone books—or, small type on bad paper. The brief was for a typeface that was neutral, not fashionable, yet also unmistakable and characteristic. Exaggerated contrast between outline and counter shapes achieves good legibility (**Figure 2.13**), whereas highly distinctive curved and flared "pseudo-serifs" open up connecting corners and add "noise." At small sizes, a little bit of noise is perceived as warmth.

When tools for type design and production became available on the desktop, the old artwork was dug up and redigitized on a Macintosh. It was named Meta and used

2.12 *The very first pencil sketch of FF Meta.*

2.14 *Development sketches of the Meta ampersand.*

exclusively by MetaDesign in Berlin until FontShop International released the face as FF Meta in 1991.

After the tools became available to design and produce fonts on the desktop, FF Meta became the most influential sans of the digital revolution. The phrase "Meta is the Helvetica of the 90s" was coined by Robin Kinross. He made that remark about Meta's sudden ubiquity rather than as a physical comparison. In fact, the two faces couldn't be more different. Because Meta's character shapes were originally designed for use under adverse conditions, its idiosyncrasies are deliberate details to better distinguish characters from one another **(Figure 2.14)**. There are applications where this might be more important than in books where we read what we expect rather than having to identify a name or a number. Helvetica, on the other hand, was designed to be the face for people who didn't want to think about choosing a typeface ever again. A jack-of-all-trades that ended up being master of none. Meta is the singer-songwriter to Helvetica's elevator pop. ■

DEBBIE MILLMAN : GUEST DESIGNER STUDY

DESIGNER : UNITED STATES

Debbie Millman is a partner and president of the design division at Sterling Brands, a leading brand identity firm. Millman is also president of AIGA, chair of the School of Visual Arts' master's program in Branding, and host of the podcast Design Matters. She authored How to Think Like a Great Graphic Designer, The Essential Principles of Graphic Design, *and* Look Both Ways: Illustrated Essays on the Intersection of Life and Design. *Debbie talks about the fits and starts of getting the job done. With all she's accomplished in such a short time, her story demonstrates that efficiency comes in all forms.*

2.15 *Debbie Millman working furiously after experiencing a gamut of emotions ranging from dread, hope, procrastination, inspiration, despair, stops, and starts, sulking, and diversion to success and tweeting.*

20 EASY STEPS

1. Look at calendar and realize my deadline for my monthly visual essay for Print magazine's online publication, *imprint*, is looming.

2. Think about essay for a few days and hope I can come up with something original.

3. Do ten other things to avoid having to think about project.

4. See a movie; tell myself my goal is "inspiration." Find none.

5. Sketch out ideas. Throw everything away.

6. Surf the Internet, ostensibly for more "inspiration." Find some.

7. Sketch out ideas inspired by Internet inspiration. Realize everything I sketch is derivative. Throw everything away.

8. Come up with an idea I find mildly interesting. Work on it for two days, and make two trips for supplies: one to the Container Store, one to Michael's Art Supply Store. Realize effort is derivative of a previous essay recently completed and published. Discard, but don't throw away.

9. See #4.

10. Go to Barnes & Noble to research threading techniques for a new idea. Buy some books.

11. Realize books cannot help me.

12. Start work on a new piece using thread and paint. Spend two days working and reworking.

13. Sulk. Discard piece.

14. Come up with an idea. Feel energized and hopeful. Start furiously working (**Figure 2.15**).

15. Assemble for photograph.

16. Work with photographer to shoot hi-res images.

17. Send to client. Hope and pray.

18. Client approves and publishes (**Figure 2.16**).

19. Smile, link, and tweet.

20. See #1. ∎

Seeing Duff

this duplicity we have in common.
you know I prefer to think we are liars
Pretending what we want to believe is real

as our hearts are breaking.

Yet you Gasped when you saw her
your chestnut eyes wide
and I knew then that
you were a kind man

I knew that you were (like me)
desperate to be filled up
and drained —

fooled into thinking that
more may be enough —
as if back-up could insure that
we would never be left again.

there is comfort in this lie
as we languish in our sweat
and wait for trouble.

2.16 *Her completed project: seeing Duff (Duff is one of Debbie's dogs)*

VON GLITSCHKA : GUEST DESIGNER STUDY

DESIGNER : UNITED STATES

Accolades came early for Von. At the age of 5, he won a contest and was awarded a Speed Racer coloring book. That's when he realized a career could be made from drawing. Von subsequently started Glitschka Studios in 2002, a multidisciplinary creative agency. His clients include Coors, Proctor & Gamble, Rock & Roll Hall of Fame, Major League Baseball, Nike, Target, Wendy's, and Landor Associates.

GATHERING CLOUDS

For me, design exploration is like solving a mystery. Once I understand new industry lingo, methodology, vernacular, and process, I force myself to dive deeper. Literal ideas can serve an end purpose at times, but I tend to view them as the surface of the creative water of the concept pool. You could

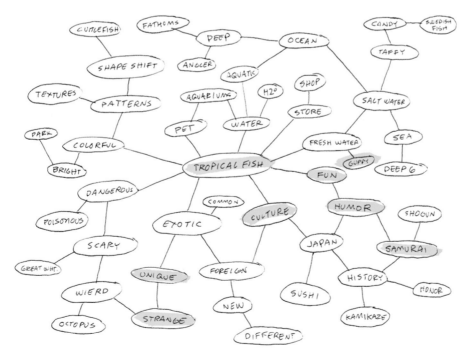

2.17 *Von's initial brainstorm cloud showing his selections of the strongest potential words for graphics.*

SAMURAI GUPPY

YOUR TROPICAL FISH EXPERTS

2.18 *The final logo for Samurai Guppy combining the best word contenders translated as a composited visual design (above).*

call this "design psychology" of sorts I suppose. Usually, I don't bother to explain the in-depth process to a noncreative client. It's different working with a creative director who understands that process, and it also helps the collaborative process.

When I go deeper, I'm attempting to make visual analogies with shape and form, color representation, composition, and movement of the viewer's eye by controlling the aesthetic flow. Much of this is subtle graphic hinting that reinforces the larger concept through micro associations. Some people may never notice these types of design details, but they all add up to complete the final design.

This is why a designer should be a good thinker. If your concept pool is shallow, you won't be able to dive deep. You should continually grow your knowledge on a variety of topics to support thinking diversely. Design is a continually evolving discipline more than a learned skill.

The cloud (**Figure 2.17**) shows one way to problem solve using associative words. I then find the most relevant ones that have the best potential for a visual interpretation. This is a good way to blend concept with visual (**Figure 2.18**). ∎

SOCIAL/UK : GUEST DESIGNER STUDY

DESIGN FIRM : UNITED KINGDOM

Social helps its clients to better identify with or broaden their audience, to tell a more succinct story, and to make the client look good in the process. Its approach leans closer to common sense than complicated philosophy, and its design solutions are based on client need. Social adapts to the plethora of challenges that walk through the door. This is a story of how the firm uses group participation to solve a design problem.

CLIENT/DESIGNER COLLABORATION BRINGS ECLECTIC POWER TO CONCEPTS

The project brief and the level of client interaction shape the creative process at Social. As designers, we have no set method, but more often than not, there is collaboration between designers and clients to create a final solution. The method we use depends on the clients' level of input: Some have very strong ideas and want a high level of involvement; others are very open to our interpretation of the brief.

In terms of the design process, we take a varied approach. Some designers are linear, some sporadic. The approach is often determined by the nature of the brief. A project that requires a high level of detail and focus can often benefit from a linear approach, a methodical process to reach the solution. A more creative brief can benefit from throwing down as many ideas as possible up front and being less structured and confined in the process—working in a more naturally progressive manner. Either way, we review development on a project regularly to ensure that we are creating something that is right for the client.

By building trust with the client, we are often given a greater level of creative freedom. With fewer constraints and boundaries, we can arrive at a unique and original solution. This approach requires a solid understanding of the client and target audience of the project in question to ensure that the solution is creative and original but still entirely relevant.

2.19 *Design collaboration on various conceptual ideas for Good Godfrey's, a pub in London's Waldorf Hotel.*

2.20 *Menu and signage designs for Good Godfrey's. Waldorf Hotel, London.*

We are very aware of individual strengths within the studio, and although we are generally a team of all-rounders, designers are often briefed on projects based on what their strengths can bring to the solution. Briefing more than one designer on appropriate projects allows us to present the client with a variety of concepts that cover a wide range of possibilities (**Figure 2.19**). Working in groups as well as individually is important: Too much of either leads to no real direction or diversity. We try to create an initial presentation with design routes of varying experimental degrees: Some more obviously relate to the clients' expectations, and others push the boundaries of the brief. We find that our clients see merit in both approaches, and often a final solution is reached by taking elements from each.

For idea generation, designers are encouraged to be aware of current trends in design, art, fashion, technology, and anything that surrounds us. It is important that we are not led—but inspired—by current trends to create solutions that are original, current, and above

all else, relevant. To build on this, we have a think-tank session every six weeks where we involve directors, the account management team, artworkers, and designers alike. We discuss current and exciting ideas, and then send information on the most inspiring to our clients in our e-newsletter called Social Spark. This is a great catalyst for new ideas.

We often get together to generate ideas as a team, bouncing ideas off one another to arrive at a set of concepts before creating specific design routes. Although some briefs require an in-depth thought process to arrive at a successful solution, we try to recognize that sometimes an initial idea can in fact be great. It is possible to overthink a brief to the point of obscurity.

Figure 2.20 shows the final solutions of our process on a recent brief for an upcoming bar. Social's role was to name and subsequently brand the identity for the newly refurbished bar at The Waldorf Hotel in London. We were asked to help bring back the buzz and glamour of days gone by, and Good Godfrey's was born. ■

DESIGNERS ACCORD : GUEST DESIGNER STUDY

GROUP PROBLEM SOLVING : UNITED STATES

Designers Accord is a global coalition of designers, educators, and business leaders working together to create positive environmental and social impact. In this next story, the Japan Society, Common Ground, and the Designers Accord held a charrette in Brownsville, NY, to examine design solutions for social problems and ways for designers to contribute pro bono work for the proposed solutions.

THE DESIGN DIFFERENCE: USING DESIGN TO CONDUCT A PROBLEM-SOLVING WORKSHOP

Derived from an article by Alissa Walker for Good Magazine *(www.good.is).*

As a process, design has always required a fair degree of problem-solving skill. Even so, it is only recently that design principles have been used to effectively solve social problems. Through collaborative meetings known as charrettes, groups of designers are coming together, utilizing the problem-solving principles inherent in design, and constructing potential solutions for real-world issues. The Design Difference, sponsored by the Japan Society, the Designers Accord, and Common Ground, is one example of an effective approach to design-inspired problem solving. This charrette demonstrated how design lends itself to the creation of ideas just as well as it does to the creation of objects and images (**Figure 2.21**).

Valerie Casey, the founder of Designers Accord, organized The Design Difference in hopes of improving conditions for residents in Brownsville, one of the most troubled neighborhoods in New York City. With few opportunities and soaring rates of violent crime,

Brownsville has been plagued with serious problems for far too long. If Casey's program could, in fact, manage to make a positive difference in a place like Brownsville, then similar design-focused efforts could surely achieve great things in other areas. It is this possibility that fuels Casey's interest in utilizing design and collaboration to inspire change. "This charrette is part of an ongoing exploration into how we might get better at using our craft in more purposeful and relevant ways," said Casey.

From the beginning, The Design Difference relied on input from Brownsville residents. Without help from members of the Brownsville community, designers involved in the project would have lacked a solid foundation to build from. "When faced with the abstract and seemly intractable issues around sustainability, designers often ask for specific direction about what they can do," said Casey. Established contacts in Brownsville, such as the Brownsville Partnership and Common Ground, provided participants in The Design Difference with the guidance needed to move forward in a constructive manner.

The problem-solving process used by The Design Difference emphasized the importance of improving the quality of life in Brownsville. Rather than tackling specific problems in the community, such as drug abuse and violent crime, groups worked to develop ideas that could indirectly contribute to the reduction of other issues. Work in these areas, which ranged from safety to general-welfare concerns, encouraged the creation of ideas in a structured manner. Groups cycled between

2.21 *Group problem solving starts with any and all input—illustrated, noted, detailed, and brief—with each idea reviewed as a possible solution.*

areas to keep their ideas fresh and prevent designers from burning out (**Figure 2.22**).

In the end, The Design Difference was a successful gathering. The combined efforts of designers and members of Brownsville's community produced a variety of ideas that could improve the lives of local residents—and perhaps even lead to the resolution of a few of Brownsville's most evident problems. Of course, the results of projects like these are slow to come, and it is impossible to predict exactly what kind of effect The Design Difference will have on Brownsville. Without projects like these, however, projects that inspire people to work together toward a better tomorrow will inevitably remain as they are. ■

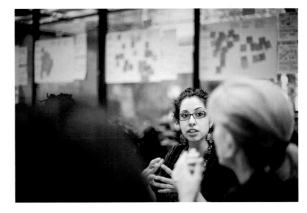

2.22 *Fairness is key in group interactions for successful outcomes: Ideas are discussed, debated, and occasionally, decided.*

Putting It into Practice

You can't help but think because you've been blessed with consciousness, and there are ways to optimize the thinking process to take advantage of the more natural flows and rhythms within and without you. Problem solving doesn't have to be all work and no play. In fact, the best solutions often come as a result of the two.

ENHANCING CREATIVE PROBLEM-SOLVING SKILLS

The following list suggests thinking approaches you can take to create more efficient, more relaxed, and more pleasing design solutions. Borrowed from a variety of wisdom-based sources, the ideas carry into any problem-solving skills relevant to both work and personal life.

1. Open mind. *Absorb.* Take in any and all information when you're thinking about the problem. This is an uncritical and unfiltered state of mind that doesn't censor anything.

2. Multiplied mind. *Allow a full experience.* Record all you can about the problem. Allow emotion, allow senses. If you're designing a brochure for a children's organization, go to a children's museum, observe and interact with children in a park, or do something childlike. Notice sounds, tastes, textures, and smells. Get on your belly and look at things from the ground level. Keep the activity short and make it fun.

3. Connected mind. *Relax the focus.* Begin to make connections with the information you have gathered intellectually and viscerally. See the big picture. More connections provide an opportunity for more solutions.

4. Divided mind. *Design divergent solutions.* Get a timer and set it for 3 minutes. Think of how many ways you could use a third arm coming out of your back or tongues in the middle of your palms. What else could you use a paperclip for? Make up your own ideas. They can be totally silly. No judgments allowed! Use the full 3 minutes. Set the timer again for 3 minutes. Think of a design problem. Perhaps the client whines, or maybe the project is less than inspiring, or maybe it's important to create a connection, but you can think only in abstracts. Again without judgment, list anything that comes to mind. Find a few gems in the ideas you came up with that might actually present a new perspective on the problem's solution.

5. Linear mind. Use reason to support you.

- *Define* the problem. What is it and what caused it?

- *Set* a realistic goal to solve it. If you're on a tight deadline, try to accommodate it by arranging your schedule around it.

- *Brainstorm* solutions (use step 3).

- *Evaluate.* What are the pros and cons of each idea?

- *Choose* the most effective solution using the one with the least cons rather than the most pros. Efficiency optimizes the process, so start with the short list.

- *Plan* your approach. What are the steps to implementing it?

- *Assess.* Did your solution work? If not, try another approach.

- *Persistence.* Don't give up. Even if problem solving isn't working using a linear method, remember that there's a lot going on behind the scenes (see "Intuition and Creativity" and "Synchronicity" in Chapter 1, "Aesthetics: Enjoy the Ride").

6. Uninterrupted mind. *Stop unproductive thoughts.* Allow yourself time without distractions. This is hard to do in today's world; you are surrounded with constant diversions and distractions. Start with 5 minutes and see how it goes. Put your own structure in place to bring you back to the problem. Print out a copy of a stop sign shape (not the words) to remind yourself to return to the problem. Turn off sounds and unneeded sights (TV, Internet). Take a walk. Surprisingly, when you change your environment, it can help you focus doubly well. People tend to surround themselves with a protective insulation when in unknown circumstances, which heightens sensitivity to external factors while honing in on internal receptivity. When you're out in nature, look at the sky and return to emptiness when unnecessary thoughts intrude.

7. Mind's eye: *Think visually.* To enhance visual thinking, use visual puzzles such as optical illusions, or create your own. Try the following exercise to enhance visual thinking.

CREATE A NAME TOTEM

John Langdon, ambigram designer of The da Vinci Code *and* Angels and Demons *fame, shared one of his visual word forms as an exercise.*

Using the letters of your name (or any word or phrase) written vertically, find similarities that might be optimized when combined, reflected, or otherwise organized to share similarities and maximize the efficiency of the visual.

Eighteen of the 26 letters of the alphabet have either natural lateral symmetry (like H, M, O, T, etc.) or can easily be designed to have that symmetry (e.g., C open at both left and right sides, E without its vertical stroke, lowercase n rather than capital N, etc.).

Let's take the word THANK YOU as an example and walk through the steps of creating a totem. In this case the T, the H, and the A are all symmetrical.

1. Add each laterally symmetrical letter in a vertical stack until you encounter one that is not symmetrical. The K is not symmetrical.

2. Look ahead to see if one of the next couple of letters could be a symmetrical counterpart to the asymmetrical letter.

The K can be used as a flipped A, and a symmetrical lowercase N can go in between the A and the K.

3. Stack the Y, O, and U because they are all symmetrical. But the K looks a bit too much like an A.

4. Go back and try a different approach. Try flipping the capital N to create the K.

The third rough is the most pleasing solution (**Figure 2.23**).

Now that you have an idea of how to create a name totem, you can try it on your own. When you encounter an asymmetrical letter, you may have to look both ahead and behind to find possible candidates for a symmetrical match. Of course, many words will not cooperate with this approach to creating ambigrams. But the chances of creating a symmetrical ambigram are greater in the totem form, because you can rearrange the letters that need to be symmetrical, which is not possible with rotational ambigrams (**Figure 2.24**).

2.23 *Rough sketch to begin to find opportunities in the letterforms.*

THANK YOU

2.24 *A finished "word totem" by John Langdon showing the use of multiplicity to optimize similarities in creative word forms.*

UPSIDE DOWN AND BACKWARD

When you design following the flow of the message, you are working with that message's inherent power. As nature-artist Andy Goldsworthy describes it, "Everything has the energy of its making inside it." Likewise, all problems inherently contain a solution. Finding it often requires thinking differently.

1. Think about a current issue or problem you are having.

2. On a sheet of paper, list the downsides or stops, one item per line. Allow a little space between each line.

3. On a sheet of tracing paper, list all of the positive aspects of solving the problem: What would be better if it were worked out? What other issues might it impact in a positive way if it was resolved? Again, one item per line, with a little space between each one.

4. Turn the tracing paper 90 degrees on top of the list of downsides.

5. Look at how the negative interrupts the positive. Find similarities. Start with common words. Begin to find similar aspects that can be reconciled. Find differences that can be transformed into complements. See if you can weave difficulties into positives and use them as a common leverage to solve the problem.

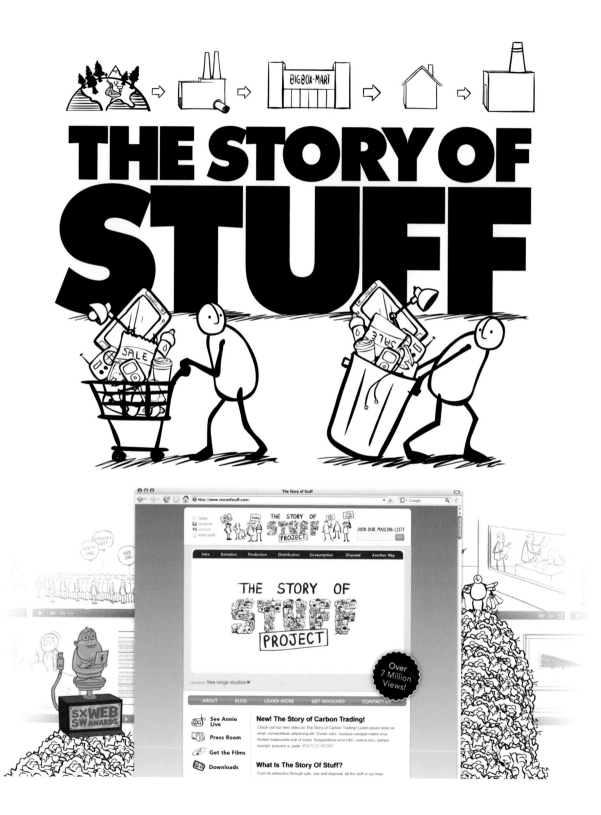

3

NATURE'S ETHICS

EVERYONE'S BUSINESS

"Design creates culture. Culture shapes values. Values determine the future." —Robert L. Peters

In human terms, ethics is a philosophy of doing the "right thing" based in personal and cultural values. Ethics is a conscious participation in the flow of life that uses common values to serve everyone. When you act ethically, the instinct to focus solely on yourself becomes secondary so you might consider how your actions will affect others, putting the greater good first. Ethics carry into all human activities, because they impact cultural and business exchanges, as well as the biological systems that support the world and everyone in it.

KEY CONCEPTS

- Nature's ethics differ from human ethics.

- Design guidelines can be based on permaculture principles that nurture and sustain food growth and production.

- Abundance and limits translate to information design.

- Intention is a key force of invention.

- Mutation is essential in nature and design to create new responses to changing circumstances.

- Changes in design education are embracing a natural approach to teaching and learning.

- You can use a personal approach to integrating nature's design ethic outside the workspace.

LEARNING OBJECTIVES

- Understand how nature embodies natural ethics.

- Use the *Twelve Design Principles from Nature* based in sustainable permaculture approaches and apply them to design.

- Appreciate the use of abundance and limits in information design.

- Learn about the importance of Intention to Invention.

- Learn more about fringe thinking—from street art to design education—and how it is expanding ethics as the core working principle in designed communications.

n nature, ethics do not translate as "good" or "bad." Nature doesn't get caught up in judgments—its ethic is to simply do the "viable thing"—whatever is the most workable and sustainable. Nature is *response-able*: appropriately responsive as necessary. Left to its own devices, nature "rights" itself quickly and efficiently when things go out of whack because of its inclusive and immediate connectivity. Nature's built-in monitoring system of checks and balances are a result of the interconnected relationships between all living systems. These relationships provide spontaneous feedback to keep the overall system in balance as it continually adjusts to circumstances.

The principles that drive equilibrium in nature's design also power human design. To be unethical is to be unprincipled—the very same principles that drive balance in nature. By integrating naturally derived principles into your designed communications, you bring subtleties into play that support the message with inclusiveness and balance. Communications that are designed with forethought of multiple perspectives have wide appeal, because they reach people of different cultures through common understanding.

This chapter provides resources, guidelines, and examples of how you can create your design projects to include ethical approaches to balanced and principled design. You can do this by choosing work that is meaningful to you, by contributing your energy to organizations that you care about, and by being thoughtful about the design principles and perspectives you put into the world.

Natural Guidelines for Ethical Design

3.1 *A landscaping design makes the most of an area by following the natural contours of the earth. This site plan was designed for Children of Uganda's Sabina Primary School in Rakai District, Uganda. Permaculture allows the school land to be more productive and the children's diet to be more varied, with higher yields from extreme conditions (opposite). Illustration: Amanda Cuyler.*

Permaculture is a system that mimics nature's patterns and relationships to provide high-yield natural resources (food, fiber, and energy) with low impact on the environment. Originated in the arid climate of Australia in the mid-70s by Bill Mollison and David Holmgren, permaculture bases its sustainable principles on working within nature's limits while providing abundance for the local area by optimizing local features (**Figure 3.1**). Following nature's dictates of being ordered with a variety of designs from which to work ensures optimal productivity and growth. The term permaculture has evolved to represent an intentionally designed permanent or sustainable culture founded on natural principles. These, in turn, are applied to the organization of people, their buildings, and their culture as they live on and use the land. It is, essentially, whole-systems thinking.

Design principles are universal when based on nature, and the same principles apply to designed communications. The basic ethics that drive permaculture are derived of three broad maxims:

1. **Take care of the earth** (conserve soil, water, and forests).

2. **Take care of people** (yourself, kin, and community).

3. **Fair share** (set limits on consumption and reproduction, and redistribute surplus).

Over the last few decades, permaculture has shown that when the first maxim is followed, the second two follow. These basic ethics could be reworded to apply to communications:

1. **Be conscious of your impact** (don't be wasteful of materials, time, or others' goodwill).

2. **Support those close to you** (work with clients who provide services or products that improve the community and have fair business practices—locally, when possible).

3. **Use cooperation over competition** (share resources, including those that generate business revenue, donate pro bono work to an organization you believe in, start a community garden, pick a cause you have a passion for and become active in it).

12 Design Principles from Nature

David Holmgren developed the twelve universal permaculture principles that support the three core ethics of a natural system (**Figure 3.2**). These principles can also be used as design tools to support value-driven communications. Not all of the principles may come into play in each project, but for optimal design, be conscious of and integrate as many of them as possible (**Figure 3.3**).

1. **Observe and interact with nature.** By participating with nature, both passively and actively, you learn firsthand about its processes. This helps you identify natural processes that manifest as patterns and shapes. Your project can be designed most effectively by matching shape and pattern appropriately to the intent of the client or the project.

2. **Catch and store energy.** Beyond the obvious of saving for a rainy day, recognize that capital can be maximized in other ways besides money. If you understand capital as being just another form of energy, it could also be

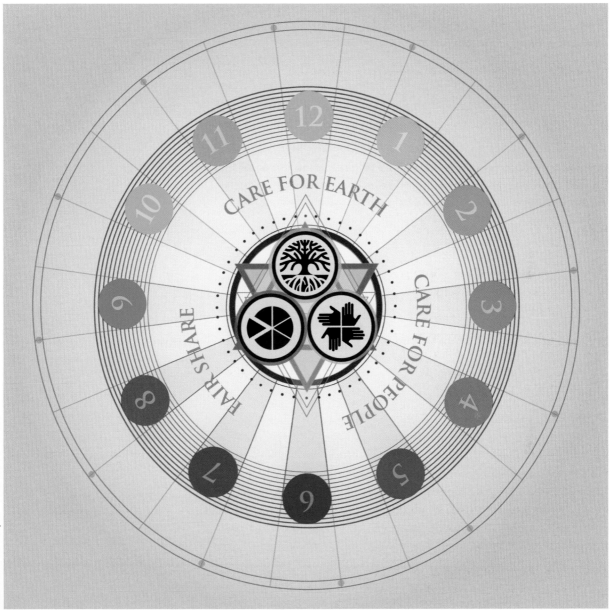

3.2 *Permaculture's 12 principles of design as universal design-thinking principles. Illustration: Fernando Gaverd and Maggie Macnab.*

interpreted as identifying an opportunity for the future, pacing yourself over the course of a project so as to distribute your energy for better efficiency, or thinking in terms of taking steps toward a larger goal.

3. **Obtain a yield.** Your time and its end result are valuable. Don't give yourself away for the sake of working. Generate a realistic (not excessive) profit to support yourself so you can support your family and community, and the future of your work.

4. **Self-regulate and accept feedback.** Put structures in place to avoid excesses: in work, company growth, or in keeping yourself on task. Accept feedback from those you work with and those you serve. Even if you don't act on every suggestion, being receptive to what others contribute increases flow between you and them (that is, trust), and facilitates the working environment.

5. **Use and value renewable resources.** Work with renewable resources in mind. Reuse and recycle what you can in your own workspace, and use green products and services whenever possible.

6. **No-waste communications.** Besides the practical aspect of physically renewable or recycled resources, remember that people's time and mindshare are valuable. Design your communications to provide useful information that doesn't contribute to the massive amounts of visual noise or junk information in the world.

7. **Design from patterns to details.** When beginning a design, look at the overall picture: What do you want to accomplish with it? What types of visuals could support that message? How might it be interpreted from another perspective? What sort of environment will it be received in? Begin as a generalist and finish as a specialist.

8. **Integrate rather than segregate.** Maximizing relationships for the best result can be translated to effectively designed communications by relating the parts to the whole. Provide visual cues, transitions that link ideas through graphics and word interplay, and families (color, fonts, graphical styles) to distinguish key relationships between the parts. The parts will retain their integrity to provide distinct pieces of the communication while the viewer is taken into consideration by presenting the components as part of the overall visually fluent communication.

9. **Smaller and slower solutions.** "More is better" is an idea that needs to be rethought. There are many advantages to smaller, slower thinking that recognizes niche possibilities. Macro-level perspectives can't see in these

3.3 *Well-designed communications use many of the same principles as permaculture design. The Bob Dylan poster created by Milton Glaser in 1967 integrates all parts of the communication, is designed from pattern to detail, and maximizes edges. Many of the design principles are behind the scenes (for instance, the feedback received during the creation of a project; principle #4) and aren't apparent in the execution.*

terms of detail. In larger organizations that have many designers involved in a project, this translates as allowing many ideas to be considered; for individual designers, allow yourself to see the problem from as many angles as possible. Take the time to think it through and appreciate the quirky idea.

10. **Allow for diversity.** Nature never relies on just one solution. Complexity and diversity are essential to flexibility. Diversity is built into nature to provide options, and complexity provides many ways to get there.

11. **Understand the value of edges.** In nature, edges distinguish changes between different processes, for example, grasslands abutting a forested area. In visual terms, edges can emphasize transitions between thoughts or ideas. Remember that you read the white space as much as you do the filled, and allowing a rest between them facilitates processing and understanding. In another sense, edge-thinking is innovative, dangerous, and exciting. New ideas don't come from the center but from the edges that surround it.

12. **Follow nature's lead of resilience.** Nature is always in flux, rebalancing and restoring itself continually as new environmental circumstances come up. Likewise, when core values are recognized and represented in an integrated piece of designed communication, they accommodate external or superficial changes and the fundamental principles remain intact. Resilience is supported by a sound center from which it can expand.

In the context of nature, ethics describe an inherent integrity of all parts spontaneously functioning in support of the whole, just as they do in spherical living forms, from cell to planet.

Abundance and Limits

When you think of nature, you don't typically consider limits. Nature is abundance manifested. Because nature continually adjusts itself to change, "not enough" isn't part of nature's vocabulary. But when you use a resource continually and go beyond its limits, you must be conscious of tapping it out from overuse. Energy needs to be regenerated with periods of latency. It's true for all things: Your energy gets tapped, and so do overused design trends.

While studying philosophy in my early 20s, I came across a small but influential revelation from the mathematician Alfred North Whitehead. He said the earth is finite but unbounded. What he meant by this is that you can traverse the world without ever stopping because of its spherical shape, but you are equally confined to traveling only its finite surface. Because they appear to be conflicting

concepts that are deeply entwined, the idea of abundance intersecting limits has always been of interest to me. This idea can also apply to conceptual design work. Aesthetic, efficient, and ethical design continually balances abundance with limits. Information must be distilled to its most relevant aspects and designed within the limits of time, budget, and materials.

Limits are important to more than just the tangible aspects of a design project. If you find yourself staring at a blank piece of paper or monitor screen in dread, you're not alone. Even the most experienced, famous, and best designers do this. In the process of design, you might find that it helps to set parameters for your thinking to begin the project. Defining the box provides the edge to move beyond. For example, you might start with a list of words that have great visual potential and find relationships between them. You might query the client in detail for gems, or counterbalance intensive research time with a day hiking in the woods. Different approaches are important resources; you never know which one might reap the best result, and various approaches bring depth to the pool of options.

How you communicate information is bound to the ethics of its presentation: What you delete, edit, and emphasize are key to the perception of that information.

Information Design: Discerning and Distilling Beautifully

Good information designers are masterful at putting an abundance of information into context with its most essential parts. It must be limited in quantity and context to be meaningful. They then visualize it in a way that is useful and beautiful. The Italian design research lab, DensityDesign, is one such firm that visualizes complex social, organizational, and urban phenomena. Its designers create intuitive and digestible visual contexts of complex data. DensityDesign's research aim is to "describe and unveil the hidden connections within complex systems," and visualize them through accessible information graphics.

The creative collage of information design shown in the conceptual development of **Figure 3.4** and the final information graphic of **Figure 3.5** were commissioned by *Wired Italia* and based on the results of the online role-playing game Superstruct by Jane McGonigal. Jane is an online-game designer who studies how gameplay impacts the real world. Superstruct asked players how they envisioned what would be important in the future. Their ideas were the basis

3.4 We will be here—Map of the Future
rough concept. DensityDesign team:
Creative Direction, Donato Ricci; Concept
development, Gaia Scagnetti; Visualizer,
Mario Porpora; Artist, Michele Graffieti;
Designer, Luca Masud.

for this retro-futuristic infographic that displays the challenges of the future and how people might overcome them. Note that one of the key subtleties that gives structure to this design is the visual association of past to future with its retro design style. The way the information is presented suggests that all future issues are rooted in a past cause. This limitation has been juxtaposed with wildly imaginative ideas about the future, such as urban farming networks or interspecies collaboration. Limitation is balanced with abundance as an approximately parallel experience of how the future unfolds. In hindsight, it contains obvious restraints from the past combined with the unexpected twists of the future.

Intention and Invention

"As designers, we realize that design is a signal of intention but it also has to occur within a world, and we have to understand that world in order to imbue our designs with inherent intelligence." —William McDonough

Consciousness, by definition, creates intention. Thinking allows you to plan and anticipate future outcomes. Through this process, you invent how you are to live. Design coincides with the ability to think. All humans in all times have done it. When you design a piece of visual communication, what you are really designing is an intentional relationship. People design everything they make or

3.5 We will be here—Map of the Future *final design. Using retro-futuristic graphics to fluently describe how the past is linked to the future, DensityDesign created a complex and beautiful infographic based on Jane McGonigal's online game Superstruct.*

imagine—from how to structure a presentation, to the shoes on your feet, to the structures we live and work within, to the beliefs that inhabit different cultures. Although different disciplines define design in different ways, it is ubiquitous to human nature regardless of its time or place in human history. Design is *the* universal discipline. It is such a ubiquitous activity that the word *design* is one of the few in the English language that can represent an object, convey an action, or be a descriptor: for example, a finished Web-site *design* (noun); I am *designing* a poster (verb); or *designer* accessories (adjective).

The following text labels appear within the figure:

orbital debris
ubiquitous cubesats
ce as market
digital labeling and packaging
urgency filters on drugs
arch engines: multimedia, ocial, "human flesh"
social networking tools for gift economie
open food
open media
open pharma
open-source science
OPEN-SOURCE DEVELOPMENT
Brain imaging= reading thoughts. End of the 5th emendation
cross-species politics
non-human knowledge
cognitive self-discipline
"collective intelligence" as organism
shared emotional matrix
human-animal communication
digital body swapping
FILTERS AS BRANDS
Google
amazon
academic recognition/ reward crisis
filantropy credits
decentralization & democratization of philanthropy
INTERSPECIES COLLABORATIONS
non human partners in eco monitoring
personal data auras
NEUROSOCIAL SYSTEMS
non zero sum currencies
fertilization
carbon accounting
local clean industry ventures
SOLIDARITY NETWORKS
mobile phone minutes as currency
edea Hypothesis
social stock exchange
NGO to NGO networks
distance solutions = new value
over-the-counter medical testing
designer aging
medical ATMs
new ocean research partners: pelagic animals and big fish
"Fun" healthcare
ALTERNATIVE CURRENCIES
DIY MEDICINE
micro-philantropy networks
MULTI SECTOR SOLUTIONS
seed networking

Just because people have been designing and inventing since they could think doesn't mean everyone always does it well or with the best intentions. Designs can be poorly conceived to begin with, and when technology or trends change, they become obsolete. But for better or worse, the need to design is a human ritual of understanding: People create things to know the world around them and live better within it (**Figure 3.6**). The need to balance conscious thinking with intuitive feeling and physical interaction is fundamental to human behavior. In fact, it is so pervasive that some people don't even notice they do it. It is as natural as breathing.

From mundane to elaborate objects and systems, individuals create designs to be usable, understandable, elegant, and organized. At its best, design brings order and meaning to people's lives by facilitating information, the use of a tool, or by enhancing an experience.

©DBACHMANN

3.6 *The 3,600-year-old Sky Disc of Nebra is made of bronze with the sun, moon, and stars applied in gold leaf, and is the oldest known visual representation of the cosmos. Discovered in Germany in 2002, this example of decorative art intersects function with beauty and is an example of human design ingenuity. Scholars believe the disc was used as a complex astronomical clock to harmonize solar and lunar calendars for agricultural purposes.*

NASA EARTH OBSERVATORY

©GAFFERA/ISTOCKPHOTO

©SAVORIA/ISTOCKPHOTO

3.7 *Manmade patterns of consumerism, top to bottom: A satellite image of agricultural patterns in the state of Minas Gerais, Brazil, NASA Earth Observatory; stacked shopping carts are a pattern of stored energy (although when empty, they simply take up space); a freeway system is a linear pattern of movement.*

During the last century or so, an explosive growth in population combined with communication speed and information volume dramatically changed human interaction with nature. The industrial revolution was an age that introduced assembly-line production, the birth of consumerism, and the beginning of mass dependency on human-made systems over natural ones (**Figure 3.7**). This thinking evolved quite rapidly into the information age, and now the digital age, with each progression removing us one step further away from nature. Although many inventions and ideas have enhanced our lives on many levels, much of the accompanying worldview of convenience and speed ignores nature's rhythm and flow. When there is a continuous upset of balance—for example, extraction of resources without periods of rest to let nature replenish itself—there is ultimately and always a price to pay. Although many people live under the illusion of being separate from nature, people *are* nature and cannot live outside of it. Many people insulate themselves inside human-made systems—structures, beliefs, and technologies—with an illusion of protecting themselves from nature's unpredictability. You may not think you can make a difference in the world, but your own awareness of nature can educate others and influence their thinking.

The first step you, as designers, can take to make nature an intrinsic part of your perceptions is to relearn design according to natural directives. Nature inherently instills beauty, function, and balance; it familiarizes you with the most fundamental processes of how things work. It teaches you to read patterns of nature and understand their processes, benefiting your own life and that of others with relevance and practicality. In addition, it brings intention to your designs that become more thoughtful, appreciative, and accepting of that which is not yours to tame.

DID YOU KNOW? **The American Institute of Graphic Arts (AIGA) has a manual that focuses on the business aspects of ethical graphic design. You can download a free copy of it at www.aiga.org/content.cfm/ design-business-and-ethics.**

DID YOU KNOW? **You can download a Sustainable Graphic Design widget from Apple.com at www.apple.com/downloads/dashboard/ reference/sustainablegraphicdesignwidget.html. The widget contains three sections—"paper," "print," and "more info"—and provides basic information about the environmental impacts of design methods and techniques.**

DESIGN FOR SUSTAINABLE CHANGE

Change is a natural part of life. Too many systems of human design breech this delicate truth by being either unable or unwilling to flex. Because all systems are interconnected, no one system can change on its own. You and your skills are the necessary component.

Design is a culmination of creative effort with an intentional result, and as such, can be a catalyst of change where change is needed. Many organizations are developing a response to imbalance. The following list contains a sampling of resources for design activism and sustainability around the world:

- **The Designers Accord** (www.designersaccord.org, USA) is a global coalition of designers, educators, and business leaders working together to create positive environmental and social impact.

- **The Living Principles** (www.livingprinciples.org, USA) for Design framework is a catalyst for driving positive cultural change. It distills the four streams of sustainability—environment, people, economy, and culture—into a road map that is understandable, integrated, and most important, actionable. Designers, business leaders, and educators can use The Living Principles to guide decisions.

- **Icograda** (International Council of Graphic Design Associations, www.icograda.org/resources/library.htm, Canada) has an online document library in which you can find papers on sustainability, practices, education, and policy.

- **Design 21 Social Design Network** (www.design21sdn.com, Worldwide), in partnership with UNESCO, inspires social activism through design by connecting people who want to explore ways design can positively impact and create change in worldwide cultures.

- **Design Can Change** (www.designcanchange.org, Canada) focuses on how graphic designers can help increase awareness about climate change.

- **Society of Graphic Designers of Canada** (www.gdc.net/designers/sustainable_design/articles816.php, Canada) has several excellent resources and sustainability links on its Web site that include blogs, articles, printing processes, and certifications.

- **Next Nature** (www.nextnature.org, Netherlands) explores the changing relationship between humans and nature.

- **O2 Global Network** (www.o2.org, Worldwide) is an international network established to inform, inspire, and connect people interested in sustainable design. Network members are involved in industrial design, architecture, styling, graphic design, fashion, innovation, and the arts. Also included are people from academies, universities, public authorities, private companies, nongovernment organizations (NGOs), and knowledge centers.

- **EcoArt Project** (www.ecoartproject.org, Italy) is an international cultural platform focused on drawing attention to the environment through the creative energy of artists. EcoArt Project develops both online and offline projects, initiates and promotes contests, organizes exhibitions and events, and creates publications and green marketing campaigns. Its activities involve a dynamic network of professionals in the world of communication and contemporary art, as well as individuals and groups involved in the growing green economy.

- **The SEGD Green Resource Guide** (greenresourceguide.segd.org, USA) is a forum for sustainable innovation in environmental graphic design and an initiative of the SEGD (Society for Environmental Graphic Design) Sustainability Forum.

- **Re-nourish** (www.re-nourish.com, USA) is a not-for-profit project dedicated to helping the graphic design industry grow into a truly sustainable field. By providing accessible, credible design tools and information, Re-nourish empowers designers to implement smarter decision making in their day-to-day work.

This is by no means a complete or even extensive list, as new organizations are popping up all the time. I encourage you to do your own search online and within your local community to find ways to extend design ethics of balance further into the world.

Mutation

The essential quality of life is movement: Movement creates interaction, and interaction creates change. Adjustments must be continually made within relationships, because more than one is involved. In nature, changes sometimes occur as a mutation, a spontaneous change in a previously consistent genome sequence. These alterations can support the organism by adapting to changing environmental circumstances, lead to extinction, or recur without much impact on the overall species, such as albinism (**Figure 3.8**). In nature, mutation corresponds to an alteration in genetic DNA caused by radiation, chemicals, viruses, errors, and transposons (or *jumping genes*—the spontaneous transposition of genetic information that either copies, or cuts and pastes itself within the cell's genome).

3.8 *Albinism is one of the most common mutations and occurs in all vertebrate animals. It is caused by a lack of melanin (pigment DNA for skin, hair, and eyes) from a recessive gene. Clearly, this is a detrimental mutation for an animal that relies on camouflage for survival in the wild. For humans, it happens in about 1 in 17,000 births.*

DAVID LANCE GOINES : GUEST DESIGNER STUDY

A CAREER MUTATION OF UNEXPECTED DIRECTIONS

*David Lance Goines has produced hundreds of designs for posters, books, and exhibitions featuring his distinctive Arts & Crafts style (**Figure 3.9**). In 1968, he founded the St. Hieronymus Press in Berkeley, California. One of the few graphic artists who designs and prints his own work, Goines uses both letterpress and photo-offset lithography. The Library of Congress, Museum of Modern Art, and Louvre have collected his work. He authored* The Free Speech Movement: Coming of Age in the 1960s *(Ten Speed Press, 1993) and* Punchlines: How to Start a Fight in Any Bar in the World *(self-published).*

3.9 *Lino-block portrait of David Lance Goines by Molly Sampson.*

I didn't mean to become a printer and graphic artist. I didn't mean to become anything. When I was 7, I wanted to be a Lutheran Minister, but that didn't work out. I entered the University of California at Berkeley with a vague interest in the Classics, but in the summer of 1964 fell in with evil companions and became involved in campus politics and the Civil Rights Movement.

On September 30, 1964, I set up a table under Sather Gate to sell the banned *SLATE Supplement to the General Catalogue*, for which, at my summer roommate's behest, I had contributed the cover illustration. My friend was to take a turn selling them, too, but he had to go to class; so I, not he, was there when the deans came up and took names. That night at 11 P.M. I was expelled from Cal because of it (**Figure 3.10**). During the subsequent Free Speech Movement (FSM), I printed the daily leaflet on a mimeograph machine, a skill I had acquired in high school. The mimeograph was supplanted by a Multilith 2066 lithographic press, and in early 1965, the FSM print shop merged with the Berkeley Free Press,

3.10 *Newspaper story about the civil rights student expulsion in the* San Francisco News-Call Bulletin, *1964.*

where I apprenticed. A succession of owners, each of whom went bust trying to make a go of it with modestly skilled pressmen and machines that were fugitives from the scrap yard, showed me that there was no fortune to be made in commercial printing, at least the way we did it.

In 1966, I taught a calligraphy class, and because I could not find an instruction manual that suited me,

wrote and printed *An Introduction to the Elements of Calligraphy*. I wanted the book to look like actual hand lettering, so I printed the 12-inch by 18-inch book with drop-out halftones. To those unfamiliar with printing, each book looked as though it had been lettered by hand.

In 1968, Alice Waters and I were commissioned to do a weekly cooking column for the alternative newspaper, *The San Francisco Express Times*. Although we started out with no particular idea in mind, after a short while the column evolved into a blend of Alice's early efforts at expressing a cooking philosophy and mine at design. Soon we had enough recipes to consider publishing a cookbook. Although I carted it around to various prospects, nobody was interested. In 1970, I persuaded my boss to let me print it on off-cuts of stock we had kicking around the shop. Just before Christmas, I produced 500 copies of *Thirty Recipes Suitable for Framing*. Placed exclusively in The Kitchen, a cooking supply store on Shattuck Avenue, for which I had done my first poster in 1968, the edition sold out in three days.

I took the money, reinvested it in paper and ink, and printed 5,000 copies, which sold almost as quickly as the first. The proceeds allowed me to buy the shop, lock, stock, and barrel. I renamed it St. Hieronymus Press, which was the imprint under which I had published the calligraphy book.

So there I was the owner of a business. I knew that commercial printing was a no-starter, so what was I to do? Stick with what you know. I got going on another calligraphy book, *A Basic Formal Hand*, and got my second paying commission for a poster from the business across the street, Velo-Sport Bicycles.

After a bit of batting around, peering into this artistic style and that, trying them on for size, I settled on the Vienna Secession and the Jugendstil—the German Art Nouveau—as models. They, in turn, draw from the deep well of Japanese ukio-e woodblock prints of the Edo

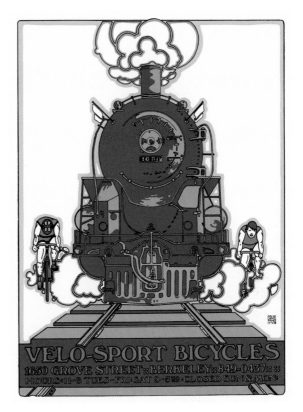

3.11 *An early Goines' poster for Velo-Sport Bicycles, Berkeley, California.*

period to which the West was exposed from the third quarter of the 19th century. The Velo-Sport design is bilaterally symmetrical, employs avian symbolism, contrasts light and heavy elements—the tiny bicyclists racing the great death-symbol steam locomotive—cheerfully throws together two completely different kinds of perspective, and gives a nod to the surrealist notion of the visual pun (**Figure 3.11**). To soften the transition from one area of color into the next, I adopted the soft gray or pale color outline motif from Ludwig Hohlwein.

So, here I am, 47 years after getting kicked out of Cal. I didn't set out to be here, but this is where I ended up. ∎

Mutations can also be caused by the actual organism. Sometimes a small population within a species will have a loss of fitness or well-being, which is called a *deleterious mutation*. Normally, this will correct itself by being "selected away." But if it continues for a long enough period of time, the species becomes trapped in an "extinction vortex" and goes into a "mutational meltdown." Mutations are usually thought of as physical alterations, but ideologies coupled with resulting technologies can alter physical circumstances in very short periods of time. As Dr. Rex Jung would say, "High-speed intelligence is outstripping slow and thoughtful creativity."

For designers, this translates to a plethora of graphics programs that come with all sorts of canned graphics or templated options, as well as a handful of giant-sized stock companies that offer the same images or illustrations to anyone who peruses their site. Although templates and wide availability to stock resources can be a great place to start from, they are sometimes used as a frequent default. Stock is convenient; much of it is quite well done and provides good support to the designer, but what if the same image shows up in an ad from your client's competition? Immediate connection via the Internet also allows designs to be easily searched and copied. Done in excess, templated design, stock reuse, and using existing work on which to base design concepts instead of inspiration can lead to redundancy, or information junk. The temptation to "step and repeat" can compromise your work from being as creative as it could be. There is nothing wrong or bad about technology—nor is it unethical—but it is important to think about what may be sacrificed by trimming time and money by reusing a redundant idea without exploring a way to make it new again. It's all in how the tool is used. The biggest problem I've encountered with design students is that they don't think critically because they haven't been taught how. To compromise, they rely on defaults. As with nature, when you recombine what already exists into something new and unique in the world, you learn from new ways of seeing the connections you already know. This is very compelling for human beings: We love puns, jokes, *and* the visual metaphor in design because we learn from unexpected connections.

Technology is a human-made tool with both good and bad aspects. For instance, it is revolutionary in human history to be able to interact with millions of others around the world instantly via the webbed connectivity of the Internet. This ability has changed people's viewpoints to include many others. People can rally as a virtual group through social networking sites, monitor natural crises and corporate or governmental mismanagement, and offer support to those in need, monetarily or emotionally. Now, "locally" refers to the entire planet.

Astronauts returned the first satellite photos of planet earth suspended in a void
of black space in the late 1960s (**Figure 3.12**). In the moment that single image was
seen just over 40 years ago, we realized how interdependent we all are. The eco-
system we are a part of is the only one we have. As creative and inclusive thinkers,
designers are naturally drawn toward finding balance where it is lacking. With
everyone in flux and everything at stake, thoughtful designers can apply their
skills to bring awareness to issues that go beyond advertising and into education.
Design is mutating into areas of social activism as a countermeasure to the imbal-
ance of modern civilization.

3.12 Earthrise *taken by astronaut William Anders, Apollo 8 mission. Image: NASA, 1968.*

An International Design Response to a Manmade Disaster

Nature runs its business without waste or excess. It's a straight-up exchange policy. When something is used up in nature, it doesn't go to a landfill; it is broken down into parts that are renewed and reused. Humans are the only animals that generate trash, and there are heaps of it. We are taught that nature is there for the taking, and waste is a fact of life. This is a good place to reiterate the meaning of the word "value." If nature had a mission statement, it would be *a fair exchange.*

This kind of thinking—or rather, thoughtlessness—impacts us now and in the immediate and long-term future. There are any number of examples; all you have to do is look at the news. A recent event that captured the world's attention was the BP oil spill in the spring of 2010. British Petroleum is an international energy company focused primarily on petroleum products, as its name clearly states. Their brand, however, was designed to "symbolize a number of things—from the living, organic form of a sunflower to the greatest source of energy…the sun itself" (from the BP Web site). The branding message did not match up with the actions that led to the largest marine oil spill in history when one of BP's oil rigs exploded in the Gulf of Mexico. This went somewhat opposite of its brand's intended message. A company has integrity, or *wholeness* (more about wholeness in Chapter 5, "Shapes: Nature's Vocabulary"), when images and words match action in all aspects of the branding effort—from communications to policy—and consistently support the whole.

The Internet has brought more transparency to the workings of our systems. People around the world networked, shared information, and twittered their anger and helplessness to actively respond to the disaster. One response self-generated by designers around the world was to reinvent the BP brand. Thousands of reinterpreted BP logos were designed in the context of bringing awareness to the disaster; over 2,000 of these were submitted to a Greenpeace UK competition from which **Figures 3.13** to **3.17** were taken. **Figure 3.18** is a poster I designed using Joel Nakamura's illustration based on the BP event to announce his talk to students.

3.18 *Joel Nakamura based his illustration addressing the BP oil spill on the Japanese creature features of the 1960s. I used this image to announce his talk to students at the Santa Fe University of Art and Design. The Japanese roughly translates as "Take that! You British Petroleum bastards!" I used the Illustrator effects of 3D extrude and distortion to create the headline (opposite).*

3.13 *Ken Cool, USA.*

3.14 *Lyn Irvine, Australia.*

3.15 *Habib Khoury, Israel.*

3.16 *Samuel Toh, USA.*

3.17 *Brian W. Jones, USA.*

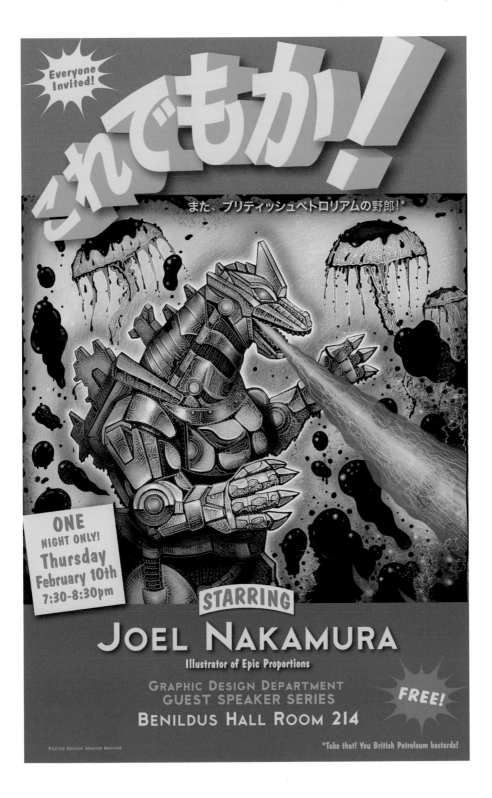

Street Galleries

Street artists—in a cross-mutation of art and social activism—express their angst at modern culture in the public forum of the streets. Without input into the quality or quantity of the daily noise of advertising, news sound bites, or other commercial messages that are everywhere at any hour of the day or night, street artists counterpunch corporate messages by posting, painting, gluing, and spraying their anti-war, -capitalist, or -establishment messages in public places. Beyond graffiti or tagging, street art has mutated into a metaphorical art form that combines the personal statement with a social message.

Their canvases range from corporate billboards to walls that segregate politics or religions, to the sides of buildings, or on sidewalks—and even appear inside the systems themselves. Often pointed and sometimes poignant, street art can present an alternative message with wit, intelligence, and talent.

"The greatest crimes in the world are not committed by people breaking the rules but by people following the rules."

—Banksy

BANKSY: THE ANTI-FAMOUS STREET ARTIST

Banksy is one such artist who has become an anonymous sensation. A British street artist who began his career in the late 1980s, he is a fine artist as well as a master at stenciled creations. His work has sold at auction for hundreds of thousands of dollars, and his 2010 film *Exit Through the Gift Shop* (billed as "the world's first street art disaster movie"), was nominated for best documentary at the 2011 Academy Awards. In March 2005, Banksy disguised himself and slipped into four major museums in New York City (**Figures 3.19** and **3.20**) to insert his work alongside fine art and natural history artifacts complete with ornate frames, name plaques, and explanations of work. Banksy says, "They're good enough to be in there, so I don't see why I should wait." Some were removed shortly after being installed, and some weren't discovered for several days.

LUDO: GRAPHIC DESIGN MEETS SOCIOLOGY

A French street artist simply known as "Ludo" has been working on a series called "Nature's Revenge" (**Figures 3.21** and **3.22**) in Milan, London, New York, and Paris for the past few years. Ludo studied sociology in Paris and graphic design in Milan, and it shows in the silkscreened images he creates of organic/techno hybrids.

3.19 Withus Oragainstus, *Banksy's anti-war beetle specimen was slipped into the collection of the New York Museum of Natural History, New York City, March 2005.*

3.20 You Have Beautiful Eyes, *The Metropolitan Museum of Art, New York City, March 2005.*

The images ask us to consider technology's impact on our individual and collective humanity (**Figure 3.23**). Since this project, Ludo has begun a new series called "Co-Branding" in which he combines famous luxury brand names with some eyebrow-raising graphics and posts them on Parisian bus-shelter advertising panels.

Ludo's work is about testing "community standards," or what is considered ethical behavior for advertising by questioning the ethics of consumers and corporations as extractors of nature's resources.

3.21 *Anonymous French street artist Ludo distinguishes his work as a black-and-white palette accented with an acid green. His art responds to the ethics of consumerism imposed upon the ecosystem, demonstrated in his piece* Greed Is the New Color.

3.22 *Ludo installing a circuitry butterfly on a building wall in Brooklyn. Photo by Jaime Rojo.*

3.23 *Ludo's butterfly engaging children as they pass by.*

Ethics in Education: Rethinking How and What We Teach

In *Blessed Unrest*, environmentalist and author Paul Hawken describes the remarkable force of social innovation in the world as "the largest movement on earth, a movement that has no name, leader, or location, and that has gone largely ignored by politicians and the media. Like nature itself, it is organizing from the bottom up, in every city, town, and culture, and is emerging to be an extraordinary and creative expression of people's needs worldwide." People from every culture and discipline are working toward creating positive change in a world that has strayed from what is practical, ethical, and beautiful.

As a designer and educator, it has always been my contention that design—as the conduit through which a creative idea is fused into a workable real-world solution—is a viable approach to *any* type of problem solving for an elegant answer. Any manner of issues can be addressed because of the skill sets you must have to be effective at your job. Designers marry word to image, work with large pattern associations, visualize outcomes, and distill relevant information from vast quantities of noise. You are creative thinkers, but you are primarily *design thinkers*: You are not just satisfying a personally creative urge, you are creatively addressing a problem to make a positive impact in the world.

There is an ever-growing acknowledgment within the academic design community that nature-based principles should be taught as essential components in useful designed communications, and that design thinking can be applied to a larger playing field of world issues. The purpose of design is to make things better on every level, not to make a bad or useless idea temporarily desirable. Consumer-based advertising has directed much of how and what has been designed in the last several decades, but many schools have been broadening their focus to using design as a way to think about larger problems not necessarily related to commercial endeavors. More and more nontraditional programs are being offered in design education; the following sections describe some of those currently available.

DID YOU KNOW? **You can download the Designers Accord Toolkit for Integrating Sustainability into Design Education at http://edutoolkit. designersaccord.org.**

School of Visual Arts/New York City

The Design for Social Innovation (DSI) program at the School of Visual Arts (SVA) teaches students to transform their good intentions into good outcomes. DSI teaches social innovation—one of the most dynamic disciplines in the world today—to create new ideas, strategies, and organizations to address current challenges and strengthen society. Innovation addresses renewal or improvement, with the fresh idea being a consequence of that improvement. To innovate, you must change the way you make decisions, or make a choice outside the way you usually think about an issue or problem. The power of ethical thinking parallels nature's ability to revise and renew for a more appropriate response to the current circumstance.

Design for Good is an undergraduate class at the SVA in New York and has served as a prototype for the types of initiatives created by the MFA Design for Social Innovation. In this class project example, students collaborated with the Elephant Listening Project (ELP) at Cornell University, begun by Katy Payne. Katy—a biologist from Cornell, along with a group of dedicated colleagues— demonstrated that elephants often communicate using sounds below the threshold of human hearing. These sounds carry over vast distances and bind the elephants' complex family social system together as vocal communication. Through ELP, a team of scientists are "eavesdropping" on elephants, decoding their language, and working to preserve this extraordinary species.

The work of the class included a strategic plan for a communications system, a new identity (**Figure 3.24**), Web site (**Figure 3.25**), video, and a children's book.

THE ELEPHANT
LISTENING PROJECT

3.24 *Logo design for the Elephant Listening Program at Cornell University by SVA student Ben Anvy.*

Carnegie Mellon University/ Pittsburgh

The Communication Design Program at Carnegie Mellon University's School of Design studies design principles, theories, and skills that synthesize traditional approaches with technological innovations to meet societal and environmental needs. The program teaches that design is central to a better future for people and the planet. As part of a major research university, the Communication Design Program draws upon the strengths of the liberal arts and the scientific and creative disciplines to shape cross-disciplinary problem solving and prepare students for a future in which they will use their communication skills as a catalyst for positive change.

3.25 *Page from the Web-site design for the Elephant Listening Program by SVA students Ben Anvy, Kenia del Rosario, and Yeojin Tak.*

In one project, graduate and undergraduate students in the School of Design's Color and Communication course collected recyclable material, such as plastic milk cartons, pop bottles, and straws, and used these materials to first create masks and then posters of the masks (**Figure 3.26**) to bring focus and attention to the issue of recycling and reusing waste material. Masks and posters were on display at the Whole Foods Market in Pittsburgh's East Liberty neighborhood in celebration of Earth Day 2008, and shoppers were able vote for their favorite posters.

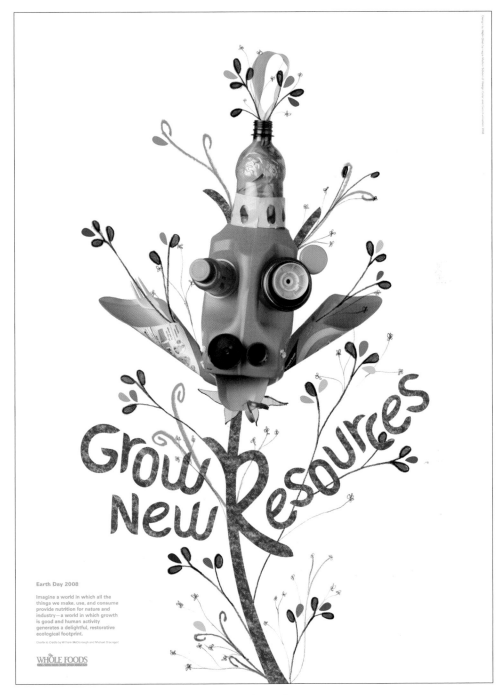

3.26 *A poster example from Carnegie Mellon's School of Design's Color and Communication course by student Hajin Choi.*

DAVID GREY : GUEST DESIGNER STUDY

BUDDHISM IN THE DESIGN CLASSROOM

David Grey is Chair of the Graphic Design Department at Santa Fe University of Art and Design, a part of the Laureate Network of international universities. He is dedicated to teaching graphic design as contemplative art. Combining interests in image making, perception, and meditation, David sees design as the integration of personal expression and professional practice. Buddhism, at its essence, is a practice of being fully awake. When a student's mental activity is calm and present, there is a greater opportunity for equanimity and equilibrium, resulting in design that displays ethical behavior.

Teaching graphic design as contemplative art provides the space for students to recognize that the manifestation of their creative path is closely connected to the projection of their personal perspective. As designers, we attempt to make sense of this unfolding experience by visually connecting everything from distilled ideas to extended narratives. By regularly revisiting the question "What is the criteria for critique?," students are asked to look closely at how their internal storylines interweave with those of everyday society. These storylines grow in richness and clarity when appreciating the prism of our environment, the wisdom of localized culture, and the energy of a connected community. By taking the time to look inward before projecting outward, students are able to develop a sense of awareness that transforms the conceptual design process into an exploration of freedom (**Figure 3.27**).

My intention during class is to cultivate joy and curiosity by helping students learn how "to see" before they "look." Because of this, students have a responsibility to develop a heightened sense of perception. The clarity provided by this view sets the ground for both exploratory and real-world class assignments.

3.27 *A 3D letterform project from David Grey's Typography I class. Malik Daniels, Tyler King, Rafael Picco.*

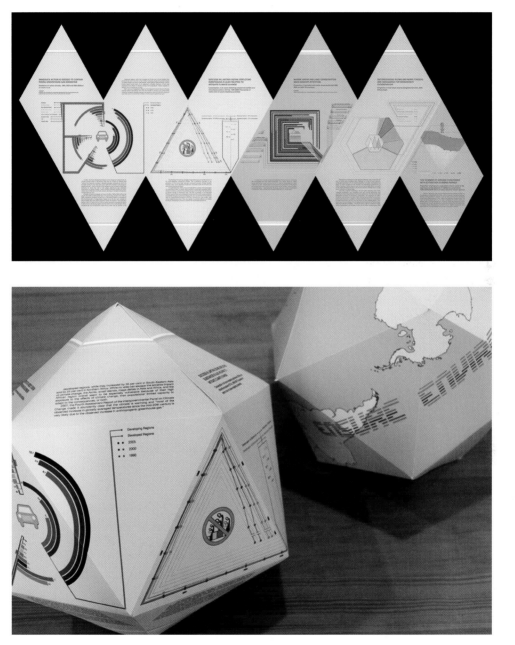

3.28 *Information graphics for the United Nations' 2008 Millennium Development Goals Report by student Rafael Picco, Graphic Design II taught by David Grey.*

continues on next page...

...continued from previous page

Through these assignments, students begin to appreciate how constraints and requirements can inspire. They embrace the combination of serious effort, deliberate application, and sudden surprise. Equilibrium becomes a main ingredient in both concept and form (**Figures 3.28** and **3.29**). But most important, students deepen their connection to the understanding that what we communicate both mirrors and manifests our community at large. ■

3.29 *Close-up of information content of the 2008 Millennium Goals project.*

Upcycled Design: Applying Nature's Principles to Personal Design

Upcycling takes a used product and uses it again in a way that increases its value. Recycling, or *downcycling*, on the other hand, takes a used product and turns it into something with less value by extracting what is still valuable and throwing away the rest. This is a wasteful process—and a polluting one—with many unusable by-products. In the following example of practical ethics applied to personal sustainability from Rob Peters, nature's principles cross over into personal use as a way to surround yourself with principles that are *upcycled*, or principles reused for something as great, or greater, than they previously were.

The Common Denominator Between Aesthetics, Efficiency, and Ethics

You've probably noticed a recurring theme in the first three chapters of this book. Aesthetics, efficiency, and ethics are fundamental expressions of nature's design, and they all have one basic quality in common: balance. Good design—design that is pleasing, useful, and meaningful—is balanced design. Balance occurs in every aspect of a successful design. The designed communication is elegant: The aesthetic matches the intent of the message to be fluid and accessible. The meaning of the communication is relevant and useful—not wasteful of materials, the designer's talents, or the viewer's time. The next two sections of the book teach you how to bring balance into your own design by using nature's forms and processes.

Before delving into Section Two, read the following story about coming full circle and applying nature's design principles in the personal realm for an aesthetic, efficient, and meaningful experience of living.

ROBERT L. PETERS : GUEST DESIGNER STUDY

DESIGNER : CANADA

Rob is a designer and principal of CIRCLE, an award-winning communications consultancy based in Winnipeg, Canada. He is past president of the International Council of Graphic Design Associations (Icograda), a foreign feature correspondent for Communication Arts *magazine, author of the book* Worldwide Identity, *and a Fellow of the Society of Graphic Designers of Canada. Rob is active internationally as a consultant and design strategist, policy adviser, writer, juror, and guest lecturer.*

THE BUILDING OF SOLACE HOUSE

In December 1973, at the age of 19, I stepped off a plane into the bitterly cold, −30 degree darkness in Winnipeg, Canada. While driving across the frozen prairie the next day, I experienced the incredible power of the sun beating down from an impossibly clear blue sky: This seeming contradiction between hot and cold made an unforgettable impression on me.

In the following months, I was amazed to discover that almost no one was building solar-heated structures in this part of the world, seemingly missing the obvious connection between predictable need (for warmth every winter) and ongoing opportunity (a sustainable, clean, endless source of *free* energy). An AOPEC oil embargo and "energy crisis" was in full swing, the price of fossil fuels was soaring, and futurists were predicting dire consequences for the planet if wasteful consumer attitudes and habits were not curbed. It was clear to me that new solutions were called for.

Raised and schooled in Germany and Switzerland, I was accustomed to overcast gray winter skies and smog. After a rain-soaked year of college in the UK where I met my future wife (a small-town girl from the Canadian prairies), I left Europe for Canada.

Always an outdoors and nature lover, I arrived in the Canadian west, a vast frontier of untrammeled natural wilderness. Manitoba offered endless virgin forestland and more than 100,000 unspoiled freshwater lakes. Nature quickly became a dominant force in my life. Taught survival skills by my brother-in-law, an avid outdoorsmen, I bought a canoe, and began "living for the weekends." I photographed the four seasons, painted landscapes, illustrated wildlife, and soaked in whatever literature on natural history and ecology I could (**Figure 3.30**).

3.30 *Solace House, built by Rob Peters in 1980, was a graphic designer's approach to the paradox of cold winters coupled with lots of available sun. With a little elbow grease and common sense, the design process can be applied to any problem. Everything you need to work with is right outside your door—and the ingenuity is inside you (opposite). Illustration and design: Rob Peters.*

Passionate about conservation and environmental ethics, I was committed to living as simply and sustainably as possible. Having observed how poorly conventional Canadian housing performed given the dramatic seasonal temperature changes, I was convinced that low-energy solutions were critical. And of course, the ongoing opportunity of a *free* solar heat source was just too compelling to pass up.

Due to limited financial means and discouraging conversations with local architects and builders, it became clear that designing and building a sustainable home would become a "do-it-yourself" project. I undertook an extensive literature search of solar and "vernacular" architecture (20 years prior to Google searches), and attended meetings of the Solar Energy Society. I hungrily absorbed research results from whatever experimental housing was taking place. Volunteering my time, I helped build a few barns and learned basic construction techniques.

In 1979, I bought 40 acres of virgin woodland just off the edge of the prairie. During the first fall and winter, I carefully cut trees for a road and small clearing. At sunny noon on 21 December, I sat in the snow in the exact spot where Solace House would later be built and observed that the sun angles were exactly as predicted.

Building materials were delivered to the wooded site in late April 1980, and the enclosed structure was completed by July. Finishing the interior would stretch out for more than another year.

I've now spent nearly 30 years living here in the woods in the low-energy, passive solar house I designed and built. The energy-saving efforts invested paid off quickly. The well-sealed and heavily insulated home is comfortable year-round and requires only about 15 percent of the annual energy needs of a conventional Canadian home. No natural gas, oil-powered, or electrical furnace is required for space heating!

Living here has gone a long way to fulfilling my goals of being close to nature, living simply, acting wisely, and sharing with others. I'm pleased to say that many other conservation homes and passive-solar-heated homes have been inspired by my little housing experiment. ■

Solace House

MATTER

UNDERSTAND AND CREATE

The plexi components at the end of the windblades spread out the light, so the entire form will be visible

The sections at the joinpoints are filled with a bamboo fiber composit resin instead of concrete.

Rain protection made of composite resin

Dinamo and Super Capacitor

Bearing

The crossing bamboo bars hold the lamp in the ground such as the roots of the trees. In this way we can avoid using concrete basement.

4

PATTERNS
NATURE'S DYNAMICS

Even though you may not know it, you are intimately familiar with patterns. Patterns are not only all around you in nature, they are also *within* you. Patterns form the branching arteries that guide blood and electrical impulses throughout your body, create the spiraling whorls on your scalp and fingertips, are woven into the double helix of your DNA, and store vast amounts of information in the meandering convolutions of your brain and energy in the compact cells of your body. Patterns connect you from the inside out by giving form to energy, allowing you to sense and interpret how they are meaningful.

KEY CONCEPTS

- Understand the nature of patterns and why they are useful in design.
- Strategize your approach of using nature-based patterns in design.
- Recognize and implement the branching and meandering patterns of movement.
- Recognize and implement spiral and helix patterns of regeneration and creativity.
- Recognize and implement patterns that pack and store energy.

LEARNING OBJECTIVES

- Identify, analyze, and reuse patterns of nature.
- Understand how basic patterns can be used to support the visual message.
- Create patterns from direct experience in nature.
- Identify and implement patterns to support visual communications.

JOSE R. ALMODOVAR RIVERA, UNIVERSITY OF PUERTO RICO

Patterns organize and define relationships in nature and can be integrated into design to substantiate and support visual communication. Because design's purpose is to create a relationship with the viewer, the language of pattern helps to frame what that relationship is before the message is read or even consciously processed. The best designs use visual relationships to communicate intuitively, fluently, and immediately. By incorporating simple natural patterns appropriately into your design—such as branching to imply movement or a spiral to imply a regenerative progression—you can add a significant dimension to support the message's communication.

In the globally connected world, it is most practical to communicate with messages that have universal relevance. In this chapter, you'll uncover the patterns that are always there (although sometimes the only evidence of them is their effects on other systems) and leverage them for more effective visual communication.

"Nature uses only the longest threads to weave her patterns, so that each small piece of her fabric reveals the organization of the entire tapestry."

—Richard P. Feynman

Energy Visualized

Everything is composed of energy, whether it is interactive and dynamic or in a state of stored stability. It exists not only in obvious forms such as lightning, but also in inert objects that seem anything but "energetic," such as the rocky ledge of a cliff. When you understand how nature works through the handiwork of its patterns, you understand fundamental truths of the energetic process.

In the same way nature neither gains nor loses energy in the process of change, energy cannot be created or destroyed but transforms itself constantly when interacting with the fundamental forces of nature. Heat, wetness, and sunlight support the spiraling growth of a compact seed bundle (**Figure 4.1**) just as curling, filigreed tendrils support the idea of creativity, growth, and freshness in this poster design created by Marian Bantjes for a summer class with Milton Glaser (**Figure 4.2**). Marian says of her design, "This is a map of all of my significant artistic influences since childhood, including methods and materials used, interests, and obsessions." By representing influential events in her past with spiraling creativity and weaving in meanders of circumstance, Marian encapsulated her prior influences as beautiful and functional patterns in her design.

4.1 *The spiral of new life that occurs in almost all life-forms is a result of natural forces interacting with energy in a pattern of growth (opposite).*

MARIAN BANTJES' INFLUENCES & ARTISTIC VOCABULARY AUGUST 2006

What Is Pattern?

What exactly is a pattern? Biologist and mathematician D'Arcy Thompson, who wrote *On Growth and Form* in 1914, said: "The form of an object is a diagram of forces." Another way to put it is *form describes an energetic force and tells a story of function*. Whatever the language, culture, or era, human beings have recognized pattern as a visual harmony of various qualities working together in beneficial relationships. They work together so well, in fact, they do it over and over again to create repeating organized systems that extend from the smallest microbes to the most expansive galaxy. When you perceive pattern, you already have an idea of what's coming next because an expectation has been set up through repetition. Human design communication is bracketed somewhere between the two extremes of micro to macro and shares the same patterns of energy that exist in the universe at all scales.

In the example of a "phylogenetic tree" in **Figure 4.3**, a map of evolutionary relationships for biological life on the planet expresses layered relationships in an intuitive visual form. These relationships are visualized as patterns of concentric circles (growth over time), branching (linear relationships in space), and a spiral (regenerative creativity). The map depicts 3,000 species, which represent less than 1 percent of all known biological species.

If you look at the etymology of words when you work with design, which I often do, you'll realize that all systems of human design and communication—including written language—come from our original understandings of how the world works. All symbols, letterforms, language, and ideas are rooted in the experience of life. The word "pattern" comes from the Old English "patron," or "father." The complement to pattern is "matrix," which means "womb" or "mother," and is also where the word "matter" is derived. The crossing of form with force creates everything you experience around you.

Nature is economical and practical: It uses what works and discards what doesn't—and it's had billions of years to perfect its designs. There is no such thing as waste in nature's workbook: Everything is perfectly matched to its task. Effective visual communications also work on these principles. For example, a business identity must be as simple as possible but also must contain enough information to set itself apart. When you model your design on nature's process and pattern, you provide a wealth of information in an economical way that everyone understands because we are all a part of the same source.

Remarkably, there is only a handful or so of patterns that create the abundant diversity in nature. From the balance of opposites contained within the spiral,

4.2 Influences and Artistic Vocabulary, *a poster designed by Marian Bantjes on her personal history of creative influences, 2006 (opposite).*

to the lackadaisical meander, to the penetrating helix, to perfectly sequenced stacking shapes that contain latent energy in snuggly compressed packets, to the active movement of the extending branch—these patterns all have specific functions in storing, connecting, and transporting energy in the universe. It may sound a little esoteric, but bear with me and you'll see that these processes are common in everyday interactions and that you use them constantly.

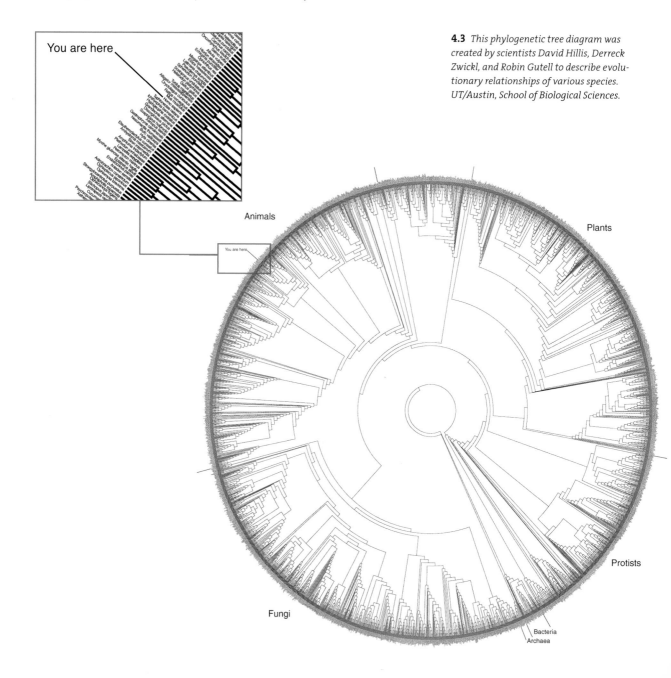

4.3 *This phylogenetic tree diagram was created by scientists David Hillis, Derreck Zwickl, and Robin Gutell to describe evolutionary relationships of various species. UT/Austin, School of Biological Sciences.*

How Natural Patterns Are Relevant to Design

Understanding pattern language is a capacity human beings have always had, and because energetic patterns do not change over time, they provide a consistent benchmark with which to interpret and process events in the external world. The language of nature's patterns is an instinctual knowing accumulated by our ancestors over millennia through their experiences of living. It is stored in the personal and collective unconscious of all human beings. Patterns help you to identify constants in an evolving world by allowing you to recognize and respond to external information in different contexts. Civilization provides immense convenience and benefits to everyone but is a relatively new circumstance for human beings at only about 10,000 years of age compared to the millions of years of our species' existence on this planet. Besides creating more intuitive communications, you should be conscious of patterns in the natural world and how they relate to you directly. For instance, did you know that fruiting plants with five-petaled flowers are typically edible for humans, or that six-petaled flowers can often indicate a poisonous plant? Check this out for yourself: Pears, squashes, and cherries all have five-petaled flowers—even spiraling roses that produce rose hips used in teas are based on the number five. Six-petaled flowers that grow on plants like lilies, mayapples, and star of bethlehem are examples of the six=poison principle with varying levels of toxicity (tomatoes are an exception to this rule but are in the nightshade family, which is usually poisonous). It is to your benefit on every level to understand the process of patterns. Enhancing your pattern acuity is a reminder of instincts long sublimated but not forgotten, regardless of how advanced technology becomes. Awareness simply takes your observation.

Pattern understanding converts to all matters you visually sense because patterned forms repeat predictably. The dynamic forms of relationships are shaped by specific events: Rushing water creates sharp cuts that will eventually carve a canyon out of rock, whereas a stream rolling across a plain in smooth, meandering curves is superficial and slow enough to evenly nourish the surrounding vegetation without pulverizing it. This may sound obvious, but you don't consciously think about most of what you sensually process. It's no accident that investment-related identity brands typically have corners in their identity symbols (**Figure 4.4**), but community-oriented nonprofits have curves (**Figure 4.5**). Financial companies must appear precise and accurate, whereas nonprofit organizations convey the flexibility to encompass and support, or contain, a wide range of people or services.

4.4 *The underlying angular pattern of the Goldman Sachs logo shows the tendency of financially oriented corporations to associate themselves with accuracy and precision.*

4.5 *The UNICEF (United Nations International Children's Emergency Fund) logo is naturally spherical to describe the delivery of worldwide services to children and addresses the concept of wholeness, or well-being, symbolically integrated as a circular and curved entity.*

Most people don't think about such basic matters. They are so intuitively apparent, they often naturally present themselves as a structural framework or element for the design solution. With that said, when a serious design mistake is made in aligning the correct pattern with the message, it is intuitively interpreted as wrong and is consequently mistrusted as "false" or ignored as information without value. An appropriate match between visual presentation and message provides a comfort zone to the viewer and invites a conscious "listening" to seeing.

Keep in mind that repeating any message often enough sets it up as a pattern because it mimics how patterns work in nature. Repetition triggers your viewers' responses to accept and respond to a communication as an established pattern regardless of the value of its content. High-saturation advertising uses this tactic to push advertising messages above the clamor—although it often contributes to it with intensive repetition of its message across the multiple media of television, radio, print, billboards, Internet advertising, and social-marketing sites. Branding is simply pattern recognition through repetition, and it is established across multiple tiers of application with the frequency and saturation provided by the energy of money.

Capturing the Energy of Your Design

A basic design skill is detective work. To be a good detective, you must be alert, receptive, curious, creative, and intellectually and intuitively smart (trusting your gut is as much a skill as any other). Learning to interpret patterning clues helps to establish the most effective way to visually frame a designed communication by "capturing" the energy of its essence. It requires thinking about all aspects of the design: determining the depth of information, identifying the edges that separate, realizing the relationships that connect the words and graphics, balancing the strategies involved, and figuring out how to best present multiple complexities into a seamlessly integrated message. Should it be highly structured with specific angles and solid forms? Or a loose and fluid meander? Or a balance of opposites? By first identifying the contextual filter of the message, you take a significant step toward aligning the visual underpinnings of the design with what you want the design to communicate. By integrating intuitive information that is pervasive but subtle, you establish the "feel" of the design with its "look." This prepares the viewer to receive and evaluate the communication within the visual context that you establish. All advertisers hope for an emotional connection, and this is only possible when a relationship has first been made.

Learning the language of nature gives you tools to effectively communicate. A good design detective will "capture" the energy of the communication to do

4.6 *La Grande Bibliothèque, used as an illustration for* Teachers and Writers Magazine, *2007, by Béatrice Coron.*

4.7 A Web of Time, *cut Tyvek art piece, Béatrice Coron, 2010. Photo: Etienne Frossard.*

much of the intuitive legwork in its understanding, and you can most effectively accomplish this when you consciously understand and implement what all human beings intuitively sense. Most people want the security of a connection. They want to understand what they experience. Your job as a designer is to be attentive to this need. When you convey a message with fluency and creativity through the use of pattern, you create a gestalt (described in Chapter 7)—or overall understanding—through the interaction between the elements of your design.

In the two examples shown in **Figures 4.6** and **4.7**, paper-cutting artist Béatrice Coron uses a similar exterior shape with interior patterns that convey different messages. The concentric rings convey a centralized layering of relationships between educators and writers, and the webbed image creates a direct connectivity between separate eras of human history. Béatrice says of her work: "These invented worlds have their own logic and patterns. Images are conveyed through words, whether automatic writing or premeditated scenes. My creative inspiration comes from a text, a poem, the news, or from a philosophical concept that can be reduced to a mere title. I research collective memories and myths, questioning the notions of identity and belonging. For each theme, I explore various narratives: One story leads to the next, and the creation process weaves different layers of our relations to the world. My work tells these stories."

Transforming Energy as a Design

Once you've done the preliminary investigation for your design, you become designer, artist, and storyteller. Your design can be anything you decide it will be: You are the creator, but always a creator in service of the message. This is not your personal art piece but a piece of communication: Ultimately, it belongs to the viewer's interpretation. As long as you are embedding the crucial pieces that connect the dots for the audience, you can be as mild or wild as the situation allows. The most important thing for you to do is visualize the energy of what you are communicating to generate a reciprocal understanding, leading to a relationship with the viewer.

Energy is the eternal pulse of the universe that everyone feels, and you can captivate your audience by capturing this force and integrating the patterns of nature to transform them as expressions of a relationship. The first step to transforming information into communication is to understand the language of pattern. Life *does* come with instructions, and they are revealed when you are able to still your mind, be present, and connect with a deeply integrated "knowing." Nature reveals itself to you continually; you have only to listen to its language to understand its message.

The Patterns

Patterns reflect relationships and their interactions. These aspects can't be measured, quantified, or weighed. They are not structures per se, but they do provide a background of form upon which to present more detailed design information—either nature's or yours.

Only a few energetic patterns fit perfectly into the world as physical manifestations by packing and using information in the most effective way: Some of these are spirals, shapes that divide by multiples of three, meanders, branchings, and helices. These patterns are fractals, or the visual trails left behind as evidence of an energetic event. Repetitions occur in this way (stratified layers of sediment; hexagons in a beehive) because they fit perfectly into space (the Greek translation of this concept is the word *harmonia*, whose etymology means literally "to fit together"). Patterns are completely scalable and appear from oscillating atoms to galactic motions—and everything in between. Each pattern is unique and has a different purpose manifested in slightly different ways, but all patterns share related principles because they all exist within the same structural design of existence.

4.8 *Tree branchings reach out from the center of the plant for sunlight and moisture.*

4.9 *Leaf vein structure is also a pattern of branching. Leaves serve as the tree's "hands" by capturing and converting the sun's energy into food, just as our hands do work for us.*

Patterns of Movement

Patterns of movement are easily recognizable because they are everywhere. They are responsible for everything that moves within and without the human body: for example, highway systems, brain convolutions, ant trails, blood veins, circuitry connections, power lines, plane contrails, a bird's wing feather, intestines, and more. All of these are patterns of moving energy from one place to another— either through direct branching or the not-so-urgent meander.

BRANCHING PATTERNS

Specific patterns relate to specific energetic principles; for instance, the branching pattern in all circumstances—drainage, tributary, human or plant vein structure—are connected to the immediate transference of energy. Branching patterns are typically angular or a series of bifurcations (**Figure 4.8**) that range from miniscule filaments to great rivers. Your blood carries food energy to all organs from the inside out and carries waste away; neural impulses direct electricity through your body to add force to movement; the veins in a leaf transport converted sunlight energy into food throughout the plant (**Figure 4.9**); and waterways branch into the contours of the earth and provide the lifeblood of plants and animals (**Figure 4.10**). Just as in the earlier example of torrential waters cutting canyons through solid rock, branching angles have a continual and constant force and speed.

Branching is different than its sister pattern of movement, meandering. It is not "easy," relaxed, or languid as is the meander.

MEANDERING PATTERNS

The sinuous meander gives the visual impression of a lazy movement without much concern for efficiency, but its looks are deceiving. Meandering is actually a very efficient distribution of energy because it doesn't exhaust its energy with intensity. This pattern can be part of a lackadaisical stream, brain convolutions that store memory density while keeping it readily accessible, a snake's languid and undulating movements, or the unicursal labyrinth associated with the journey of life's experience (**Figure 4.11**). The meander levels peaks of work with comprehensive consistency by moving and distributing energy methodically and evenly.

A labyrinth is a human interpretation of a winding path that leads to a center point. A maze differs by branching into many optional routes, most or all of which are dead ends with only one leading to the ultimate destination. **Figure 4.12** gives the impression of a maze in its design because of its angularity, but if you follow its path, it is actually a singular trek to a destination. A labyrinth is a metaphorical

4.10 *A false color satellite image of the branching tributaries of the Susitna Glacier in Alaska. Glaciers flow downhill just as water does with the tributaries joining to form larger rivers. Credit: NASA/GSFC/METI/ERSDAC/JAROS, and U.S./Japan ASTER Science Team.*

PATTERNS OF MOVEMENT DEFINED: BRANCHING AND MEANDERS

Definition: Branching and meandering patterns are two different ways to visualize the pattern of energy moving from one place to another.

Branching Purpose: Branching is an angular pattern with purposeful linear movements that show direct intention, efficiency, and interaction. Branching's energy is immediate and usually efficient in time (directness implies urgency).

Branching Examples, Human: Road systems, family trees, circuitry, hierarchical structuring in governments, businesses, or religions.

Branching Examples, Natural: Branching corals, river tributaries, brain dendrites, leaf veins, trees, fingers, circulatory and nervous systems.

Meandering Purpose: Meanders also show patterns of movement, but this pattern has a wandering and loosely diversionary method of delivery. Meandering is circuitous and efficient over a body of space with more comprehensive distribution.

Meandering Examples, Human: Human paths and trails, labyrinths, decorative borders popular in art and architecture from the Mediterranean to Native American pottery designs—called *Greek Key* or *Greek Fret* patterns.

Meandering Examples, Natural: Animal paths and trails, brain coral, brain convolutions, winding valley streams, intestines.

journey toward a person's center that doesn't require much external attention to allow for an internalized meditative and passive experience, whereas a maze forces you to actively choose a path by making strategic decisions to arrive at an intended goal.

This distinction between a labyrinth and a maze is important for intuitive messaging in visual communications. Meanders "relax" into their destination, whereas branching is purposeful, directed, and attentive. Many natural forms include relaxed meandering patterns, such as clouds or waves, and are also displayed in more intense interactions of the fluid dynamics of jet engine force.

4.11 *A meandering labyrinth in an ornamental garden courtyard in Kuala Lumpur, Malaysia. Labyrinths provide a guiding path, allowing a person to journey into a meditative center without needing to make directional decisions (left).*

4.12 *This print ad for the National Museum of Nuclear Science & History shows another form of a labyrinth that appears to be a maze because of its complex and angular construction. If you look closely, you'll see a unicursal pattern, or one path leading to the ultimate destination. The purpose of the campaign was to "stir thoughtful debate about nuclear science and its role in history, war, deterrence, and medicine." Design: 3 Advertising (right).*

THE BRANCHING PATTERN IN IDENTITY DESIGN

Several years ago I was retained to design an identity for ISTEC (Ibero-American Science and Technology Education Consortium), a nonprofit organization based at the University of New Mexico/Albuquerque. ISTEC connects American technology corporations that provide software, hardware, and training to university programs across Central and South America. In return for their investment of knowledge and tools, the technology companies are able to select the very best students that come out of these programs to add to their teams. Clearly an exchange was going on both in tech-transfer and human-resource terms. This reciprocity was the first clue that led me to choose the underlying template pattern that would communicate movement and exchange in an economical way. I addressed it by integrating the branching pattern as a design template for the organization's identity.

At their peak, I knew that many indigenous cultures had sophisticated technologies in their own right. And because the Americas were the primary focus for this design, I researched the cultures of the Aztec (interestingly, a name very close to ISTEC), the Inca, and the Maya. The Maya had the most fascinating and extensive visual content in its architecture and glyphs, so I narrowed my focus to this culture. Although the Maya had no written language, the civilization did have a very complex system of symbols and built an amazing and technologically advanced culture. For example, the Mayan calendar is based on the cyclical patterns of nature and is accurate within seconds every

year. In contrast, the modern Western Gregorian calendar must be recalibrated every four years, adding an entire day during a "leap year," because a calendar based on a linear movement is out of sync with a cyclical universe (**a**).

I began my design process with a list of words to try to discover the most viable visual combinations (**b**). My first rough came out of my Maya glyph research, which displayed almost all human faces in profile (**c**). To this, I added an aspect of technology to further expand the information of the graphic. Early on I knew that I wanted to reference both current-day and ancient technologies, and the relationship between both cultures: North American business and Central and South American education. I did this by integrating circuitry into a ceremonial headdress design, unusual for those of us in the United States, but a common element of the glyph artwork in Mexico and other countries south of the border. In theory it was a good idea, but because the visual was becoming much too complex (**d**), I had to go back to the drawing board. It then occurred to me that by turning the face forward, I could minimize the complexity of the information by duplicating it. The eye knows when information is repetitious and doesn't need to spend extra time processing it. I then began to experiment manually with tissue overlays so I could try different things quickly (**e**). The result was closer to what I was going for, but trying to literally describe the rounder physical features of this indigenous culture just wasn't working with the angular circuitry pattern (**f**). I was

(**a**)

features: what makes a Mayan?
forehead slope + height
almond eyes
flat nose
full lips

Culture: elaborate & detailed
costuming
technology (adv.)
warring
sacrifice
mythology / spirituality

(**b**)

(**c**)

toggling between hand-drawn concepts and then trying them out as vectors, ever evolving the concept forward.

Conceptualizing abstract sketches in a software program like Illustrator takes a lot of focus, attention, and time, because you can't help but want to perfect the design when the tools are at hand to do so. But this design wasn't at a final stage yet, so putting lots of effort into making it look good would have been a waste of time. The conceptual stage needs to stay loose because it is where you find variety and options. I then went into my "Egyptian period" (**g**). It was during this process that I stylized the facial features to appropriately match and integrate into the pattern: They had to be angular to fit into the overall look. I continued to experiment with making the face more angular and connecting it into the line work. Ultimately, after drawing several of these sketches by hand, I drew the design in Illustrator to match the angular pattern of the headdress.

The completed logo (**h**) delivers in its communication by referencing culture and technology to provide instantaneous information about the client. In addition, the past and present are given equal stature, demonstrating mutual respect in a subliminal way. This is important in cross-cultural interaction, which is happening more frequently in the global economy and social networking on the Internet. If you have the opportunity to work for clients who are not from your culture, it would behoove you to delve into their cultural background to understand how to create a design with which anyone could associate positive principles, and demonstrate respect by integrating the intelligence or skills of that culture within the design.

The branching pattern's underlying template immediately conveys exchange and movement, which is an appropriate metaphor for a tech-transfer business. As a metaphorical touch point, it references technology, networking between business, education, and cultures. The branching pattern could also be considered for a communications, delivery, networking, financial, or transportation business—or any client involved in moving and connecting people, products, or services.

(**d**)

(**e**)

(**f**)

(**g**)

(**h**)

DUFFY & PARTNERS : GUEST DESIGNER STUDY

MEANDERS IN MOTION

(a)

Duffy & Partners created this identity to brand the Islands of the Bahamas (**a**) with distinctly atypical and vibrant characteristics of form and color. A meander isn't a usual pattern to use in logo design because it is so loosely organized, but in this case—as a descriptor of travel, fun, and spontaneous island hopping—it works perfectly. The tendency to think of meanders as a linear and connecting form is prevalent, because they usually are. In this case they are, too, although much of the connection of the island chain is submerged below the ocean, as you can see in the patterning the designer picked up from maps and expanded upon in the initial conceptual roughs (**b**).

The Duffy group describes its experience of creating this design system: "The Islands of the Bahamas needed a differentiated and flexible identity system with the ability to communicate multiple stories in an immediately recognizable way. The branding elements unify the many communication needs of the public and private sectors as well as individual island destinations.

The design solution was not determined by a single logo, but by a complete system that highlights each of the nation's major tourist destinations and the variety of unique activities available throughout the islands. Distinct island silhouettes and a custom-designed iconography system present a one-of-a-kind Bahamian personality across many different messages.

The result is a graphic celebration of this Caribbean nation. An abstract depiction of the geographic positioning of many islands inspired by the vibrant colors

(c)

(b)

(d)

DESIGN: DUFFY & PARTNERS

and fluid shapes of its cultural flora and fauna. The clean, contemporary lines of san serif type present custom letterforms reminiscent of the circular forms found at the center of the identity's many island-like shapes.

These simple and elegant elements of the identity system combine to deliver a robust set of tools for a practical and enduring approach to branding a country and its many diverse attractions."

As the group suggests in its side notes: "Oftentimes the best design solutions are found in simple insights and obvious observations. The fact that The Bahamas is an island nation is one of the most differentiating and compelling stories to attract travelers of all kinds time and again."

The logo works in multiple applications, and is shown here as a pattern dropout overlaid on a sky and surf photo to more deeply integrate the identity into the brand book **(c)** and as a product application on a luggage tag **(d)**. ■

Patterns of Regeneration and Connectivity

Spirals and helices are some of the most appealing patterns to human sensibilities. When you construct the shape of a golden spiral, you will understand it to be a combination of expanding curves that are constrained and linked within angles. Part of this pattern's appeal is in its inherent balance of oscillating opposites that are bound at a central but invisible axis. This pattern describes your connection to the infinite process of life's regeneration in both tangible and unknowable ways.

4.13 *Related to one another through form, galactic to microscopic spirals connect as a universal pattern of regeneration and creativity regardless of scale (opposite). Credit: NASA, ESA, and the Hubble Heritage Team (STScI/AURA).*

SPIRALING AND WHORLING PATTERNS

A galaxy reveals its underlying power by unfolding in a spiral of stars (**Figure 4.13**); the earth spins on its axis in a spiral motion; and cycles, when their movements are traced and connected over time, record their movements of spin as a spiraling pattern. The spiral, without doubt, is one of the most aesthetically engaging and versatile patterns. It is the essence of creativity. All complex organisms share a common morphology in their beginning stages. Once an embryo begins to form, be it fish, snake, or human, it uncurls in a spiral from the base of its spine out (**Figure 4.14**), as does the reaching curl of a plant's vine. Vortices organize turbulence into spiral patterns as well (**Figure 4.15**).

PATTERNS OF CONNECTIVITY AND CREATIVITY DEFINED: SPIRALING AND HELICES

Definition: Spirals and their sister pattern, helices, are two different ways to visualize the pattern of energy regenerating itself, an act of creativity (although energy itself is not created or destroyed). This pattern extends into the future through the connection of self-similar progressions.

Spiraling Purpose: Spiraling is an ever-expanding pattern of curves that progress geometrically outward (logarithmic spiral) or coil in successive turnings that have a constant distance of separation (archimedean spiral).

Spiraling Examples, Human: Staircases, Celtic knots, the Golden Mean (see Chapter 9).

Spiraling Examples, Natural: Mollusks, plant tendrils, hurricanes, rose petals, fingerprints, vortices.

Helices' Purpose: The helix is a concentrated form of energy funneled precisely and directly with purposeful intent.

Helix Examples, Human: Staircases (they come in both helix and spiral shapes), the medical caduceus, woven fabrics.

Helix Examples, Natural: Spider webs, genetic materials, water spouts, black holes.

4.14 *What could it be? It's difficult to identify animals in the embryonic stage because they all display a spiraling shape as they grow from their center outward. This is a baby mouse. Credit: Seth W. Ruffins, Biological Imaging Center, California Institute of Technology, Pasadena.*

4.15 *Turbulence—in this case the heat of smoke rising in cooler air—creates spiraling and entwined helice-patterned vortices.*

4.16 *The identity system for Dignity, a Tokyo-based undertaker, uses rotations and spirals based on the first letter of the client's name to address the cyclical nature of life and death. Note how the use of black adds elegance to the design along with an element of truth. Designer: Bankbrook Studio 12/London.*

4.17 *Dignity's building exterior integrates a different look and feel to a subject not usually addressed in such a subtle way. Designer: Bankbrook Studio 12/London.*

The spiral is also a shape (see Chapter 5, "Shapes: Nature's Vocabulary"), so this form works as a repetition of connected and expanding curves (or contracting curves, depending on your point of view) as it scales into infinity. It also works very well as a singular shape that stands alone. The spiral is both contained and continuous. Spirals grow without ever changing shape, a metaphor for any species' regeneration into the future. People also spiral out of existence, as described in this identity system for Dignity, a Tokyo-based undertaker (**Figures 4.16** and **4.17**). Spirals extend themselves into life and add an element of creativity and connectivity to design patterning.

WEAVING AND HELIX PATTERNS

The sister pattern to the spiral, the helix, contains a curve that is far less interesting and yet far more fundamental to life. It is exactly due to the fact that the helix is always at the same diameter, like a corkscrew or speeding bullet (**Figure 4.18**), that makes it so important. It doesn't continually expand geometrically like the spiral. The helix is not nearly as pervasive as the spiral in scales you can perceive, such as whirling tornadoes or the spiraling pattern of this lily's singular petal (**Figure 4.19**), but it is dominant in life at its smallest levels.

STEFAN MICHAEL MATWIJEC/SHUTTERSTOCK.COM

4.18 *A bullet graphic displays the penetrating pattern of the helix as it spins through space with intense velocity.*

JOSÉ R. ALMODOVAR RIVERA, UNIVERSITY OF PUERTO RICO

4.19 *The formation of what appears to be a single petal of the arum lily orbits its spadix (the central spike composed of many tiny male and female flowers arranged in another complex spiral) in a logarithmic, or a geometrically progressed, spiral. This type of spiral is common in nature and extends itself outward, as opposed to the redundant coiling of a helix.*

JOSÉ R. ALMODOVAR RIVERA, UNIVERSITY OF PUERTO RICO

4.20 *The iconic weaving pattern of the ultrastrong, ultralight spider's web.*

4.21 *A logo I designed for the acupuncture clinic Oriental Medicine Consultants in the late 1990s. This design purposefully uses the double helix to combine the opposite modalities of Western and Eastern medicine to express equal but opposite approaches to health care for comprehensive and stable results.*

Helices make up the strings of long molecules that provide the instructions to power life and form the double helix of DNA. Instead of extending from the center outward as the energy of the spiral does, the helix contains and focuses the spreading energy of the spiral as a vertical form. This compact, stable, and penetrating form is perfect as a pattern for a set of entwining genetic instructions, for holding together the warp and woof of woven cloth, for weaving a web with which to capture food (**Figure 4.20**), for securing structures with screws, or for use as the "spiral" binder in a notebook that secures and organizes multiple layers of paper. The helix pattern is extremely strong because it binds together opposites in cooperation and support of one another.

In design, helices are the basis of the snakes entwined in the caduceus of Western medicine that reference the relationship between medicine and poison, which actually contain the same principle distinguished simply by dosage. In the logo I created for Oriental Medicine Consultants (**Figure 4.21**), I also integrated the idea of Eastern and Western modalities in the form of the Western caduceus energetically transforming into the "qi" of Eastern medicine.

Patterns That Stack and Pack

The physical world is composed of an abundance of spherical and cylindrical objects. Cells, molecules, seeds, eggs, and viruses are a few of these infinitesimally small structures, out of which just about everything around you is made. The more tightly these spherical or rod-shaped objects are packed together by the crushing pressure of gravity and heat (**Figure 4.22**), the more closely they assume the tessellated shapes of hexagons or four-sided shapes. The hexagon is a rigorous shape: Its near perfection of fit speaks to the quality of roundness condensing itself into the maximized fit of angles. There is no waste or excess in this fitted form, expressed in nature as no gaps, and no overlapped—or redundant—pieces. Stacking and packing shapes afford the most efficient way to store latent energy until it is needed while keeping it quite accessible. Bees know this inherently, as

4.22 *Stained cross-sections of plants reveal plant cells tightly packed as a storage pattern of energy. This is a cross section of a dahlia flower stem at x10. Credit: Eckhard Völcker/Germany.*

JOSÉ R. ALMODOVAR RIVERA, UNIVERSITY OF PUERTO RICO

4.23 *In both two dimensions and three, the lateral diffusion of hexagonal connectivity (or viruses, gossip, and social-networking media) can be spread from one person (or any point of connection) to another and rapidly expand across mass populations in minimal time. Six is the magic number that expands outward in the most efficient way, The number six is also the basis of medicine or poison (and why each works so quickly): Six-petaled flowers are typically toxic, or medicinal. In a wasp nest (pictured), beehive, or geodesic dome, it is also the repeating shape pattern that holds the most content and is constructed out of the least material.*

4.24 *Mimicking nature in human terms: Apartment buildings in Hong Kong stack and pack living spaces to store food and material objects, and provide the boundaries within which people raise their families. Population density in Hong Kong is high, and the apartments extend vertically to fit as many into a limited space as possible.*

LEUNGCHOPAN/SHUTTERSTOCK

DID YOU KNOW? **There are three tessellating shapes, or a tiled shape that fits together perfectly with no gaps or overlaps, to create structurally sound storage compartments for three-dimensional space. The shapes are squares, triangles, and hexagons. See more about tessellations in Chapter 8, "Symmetry: A Balancing Act in Two or More Parts."**

PATTERNS OF STORAGE AND EFFICIENCY: TESSELLATING SHAPES

Definition: Stacking and packing patterns are derived of the multiple spherical and cylindrical shapes in nature that compress into angled shapes when pressurized.

Stacking and Packing Purpose: Stacking and packing patterns store energy in a stable and accessible way until it is needed.

Stacking and Packing Examples, Human: Money, built environments, catacombs, modular furniture, fencing, grates, air filters that capture contaminants, and Chinese Ru ware crazing.

Stacking and Packing Examples, Natural: Beehives, wasp nests, cracked mud, settled layers of stratified rock, the scutes of a tortoise's exoskeleton, snowflakes.

do wasps and other six-legged insects that build efficient hives and nests to store their food and raise their young within hexagonal chambers (note the correlation of six legs and the six-sided storing and incubating shapes of compartmentalized hives; **Figure 4.23**). The hexagon is an immensely effective lateral shape that spreads in all directions with great speed and ultraconnectivity in two dimensions, as well. There is a reason for the theory (which has been verified) of six degrees of separation: Six-sided figures connect quickly and comprehensively by expanding in every direction at once on a two-dimensional highway of pattern.

Humans use stacking and packing patterns in all manner of storage, including housing. Just look around you. Sidewalk squares, rectangular bricks and the walls they construct, and rectangular windows within the houses bordering linear streets (**Figure 4.24**) compose and compartmentalize people's lives within four-sided, city-planning grids.

The pattern of stacking angular shapes is a design of efficiency, transparency, and stability. You might notice that many financially oriented companies—banks, insurance, real estate, and investment companies—choose a symbolic or abstracted identity design that leans toward angles of precision and efficiency. Money itself is a form of energy. You can walk into a store with a scrap of paper or a plastic card and redeem it for goods because there is an agreement that these representations—having no real intrinsic value in and of themselves—are symbols of energy storage that can be exchanged for a tangible item of value. The Chase MasterCard is a good example of an abstracted logo that contains the principles of stacking and packing, as is HSBC, along with multiple corporations that just opt for the indistinct square or rectangle, such as American Express, H&R Block, or the New York Stock Exchange.

Tessellated shapes are also effective as interiors, as shown in **Figures 4.25** and **4.26** by the Dutch product design company Freedom Of Creation. This space divider is the company's solution for personalizing and dividing residential and commercial environments. The modules have an irregular, dynamic mesh pattern that can assume various configurations: floor-standing within a predefined frame; as open compositions that can be hung from the ceiling, fixed to the wall, or mounted between two layers of glass; or as multiple-layer installations for a freestanding application.

A Sounding Board for Visuals

Patterns add depth to a simple visual and enhance it by adding compelling, intuitive information, just as your senses complement one another by giving more dimension to the physical sensations of sight, touch, smell, taste, and sound. Patterns add the additional information as a background to set the mood and expectation. As an identity designer, I must pay close attention to the most economical and communicative graphics. Communicating through metaphor is the key to effective identity design, and nature's patterns are a perfect way to substantiate the design economically.

But patterns are not just used in logos. They can also be woven into more complex design projects, such as illustrations, banner or billboard ads, and poster designs that have limited space for the message—any use, really, that relies on an immediate and clean connection to deliver the communication. With today's information bombardment, this applies to just about any piece of communication. Whatever essential information you can add that enhances the message is particularly useful for designs that must also rely on efficiency—such as banner or billboard ads constrained by time, or Web-site or print applications constrained by space. The immediacy and diversity of a global world require fluency in visual communications. Start with what everyone intuitively knows. It is crucial to be thoughtful of each component of your communication to be heard. No one wants to decipher a clumsy message, and no one has the time to struggle through redundant messages that have no distinguishing qualities or discernible content value. Remember the time-to-effort ratio of viewers and make it worth their while.

When considering a pattern for a design, keep in mind there will often be more than one potential contender; your job as designer is to discern which one communicates the most crucial information to communicate the client's message and its overall purpose. It's also possible to combine different patterns successfully. Even limited options can produce infinite possibilities when you invent combinations, just as nature does. All you need is a few basic templates from nature and the understanding of how to use them.

The next chapter discusses how shapes relate to you as an individual, which is an excellent training ground to understand how to integrate them into design. Some of the following exercises also help to explain more about your personal inclinations and unconscious tendencies—a very good place to start to understand those of your clients to assist you in creating designs for them that fit.

4.25 *A view of Freedom Of Creations' Macedonia Space Divider used in the interior of the new RI3K offices (paperless insurance trading company) in the center of London. Design: Janne Kyttanen, Freedom Of Creation/Amsterdam.*

4.26 *Another use, showing dramatic contrast of color and line. The clean lines of the architecture, furniture, and sparse decoration accentuate the organic-looking structural interior of the space divider's cells.*

"FLOW" : COMBINING NATURE'S PATTERNS WITH DESIGN

IGENDESIGN : BUDAPEST, HUNGARY

Created by Alberto Vasquez of IgenDesign in Budapest, Hungary, "Flow" is an example of combining nature's design solutions into a practical, functional, and beautiful piece of industrial design.

"Flow" is a self-maintained public lighting system that operates on the principle of a vertical wind turbine (see the full-page image that opens this chapter and note the "roots" of its installation system). It uses readily available bamboo, a locally available material. The whole lamp disintegrates in nature except for the electronics, which can be recycled without downcycling. Due to the simple junctions and mechanics, the system can be produced by the local workforce without any need of special skills.

The light sources are situated at the ends of the wind-blades and can form continuous lighting surfaces or slow, waving movements and play of light, depending on the speed of the rotation. Due to its spiral form, the lamp can hold the wind from every direction (**Figure 4.27**).

The object was mainly designed for the Colombian coasts. Because I am Colombian, I was inspired by a problem that I experienced in Cartagena, a coastal city in Colombia (**Figure 4.28**). The coast side of the city is busy and safe by day, but at night is abandoned and dangerous due to the lack of public lighting, because the power grid cannot be transmitted to the shores.

The wind dominates the shores over the entire year and is an ideal resource for the lighting. Bamboo is one of the easiest-to-find and cheapest-to-produce raw materials in Colombia. Its utilization is not 'eco-harmful.'

It was a socially important aspect that the lamp be produced by the locals; thus, it can be integrated into the area's cultural and economic rhythm. Hence, I designed the buildup in the easiest way: This product can be assembled by the locals with just an instruction guide. My aim for the lamp was to utilize locally available materials and to visually sync the object into the local culture's natural forms, as demonstrated in **Figure 4.29**.

4.27 *The spiral shapes of the wind turbine affords capturing the energy of any wind direction.*

4.28 *The designer's visualization of how the lighting fixtures would line walking areas along the beach.*

4.29 *Solving local problems with local resources.*

continues on next page...

...continued from previous page

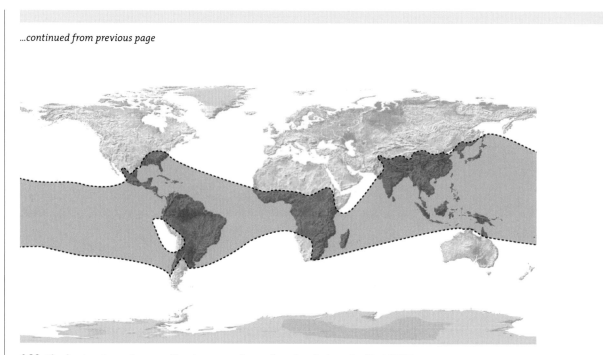

4.30 *The dominant growth areas of bamboo across the southern hemisphere. Credits: MOME project | Designer: Alberto Vasquez | Design consultant: Balazs Püspök | Engineering consultant: Daniel Lőrincz.*

In Third World countries, the lack of public lighting is a common problem. Construction of an electric network is too expensive or not even possible in many remote areas. There also aren't enough resources at hand—raw materials, money, or a skilled workforce for production. The fundamental needs of lighting are that it is cheap, can be installed in places that cannot reach the network, and can be easily produced with local resources. Many of these areas are in eco-zones that produce bamboo (**Figure 4.30**), either as a naturally occurring or cultivated raw material that is cheap to produce and high in quantity. I coupled this readily available resource with the readily available energy source of wind." ■

Putting It into Practice

Pay attention to patterns around you in nature—and in designed communications. What do you notice about their qualities? Can you identify how a pattern supports the client's message, or perhaps, where it doesn't succeed in this area? The following exercises will help you consciously experience what you intuitively know.

A SIMPLY SILLY EXERCISE

Nature follows the principle of expansiveness. You don't see perfection and completion in nature; you see approximation and movement that allows for growth, change, and evolution. Try this simple experiment to demonstrate how conceptual thinking is different from the reality of nature.

1. Close your eyes and visualize a circle. You can see it, right? In all of its round perfection.

2. Now, try to draw a perfect circle on a piece of paper. Not quite as easy, is it?

In design, as in nature, you must feel your way to the solution through trial and error because you are manifesting an idea. Transforming a nonphysical entity into the existing rules of physical order takes experimentation. Your mind perceives concepts ideally, but the fine to gross movements of a physical body are not perfect, nor are they meant to be. What would the purpose of perfection be when life itself is in the constant motion of evolution?

FINDING THE ESSENCE OF PATTERNS IN NATURE

Any significant human discovery was made either by accident or by intensive observation, or a combination of the two. The best-case scenario uses both because the human mind and heart are designed to work together. The mind rationalizes with its intellect, whereas the heart feels its way to the right solution. Although you can't force yourself be more creative or inspired, you can create more opportunities for creativity and inspiration to occur with intentional structures that support engaging the mind and heart.

PART I: OBSERVING PATTERNS

Take your sketchbook into nature and choose an object to draw every day for a week. You don't have to be an artist to do this. This exercise isn't about realistic drawing skills or making a perfect piece of art. It's about seeing what you look at. Also, make notes about your observations, and if possible, collect actual samples of your subject and keep them in your book if they're flat or in a separate container if not. For example, if your subject is a tree, putting a branch into your sketchbook won't work, but perhaps a leaf from a branch would.

Remember to observe the parts as well as the whole. Take photos if you want to, but keep in mind that a photograph is a representative artifact of life and doesn't show movement or interaction. Spend at least 15 minutes each day doing this exercise, and more if you can.

1. Choose a subject in nature. This will be your drawing matter for the week. It can be an animal, vegetable, or mineral; it is your choice. It's optimal to do this outside, but if you're experiencing inclement weather or it's too difficult to get out and into nature on a daily basis, choose a houseplant or a pet, or look out the window.

2. Get a feel for the overall structure. Create "gesture" drawings. These are quick, broad drawings without detail. Find the feel for the object you are drawing. What clues do you see in its expression? Is it sharp and angular or flowing and smooth? Perhaps it has both features, like a cat for instance. Do several drawings in a few minutes; set a timer if you like and do one drawing every 30 seconds.

3. Don't change the subject. Literally. Focus on one object or entity every day for a week. How many angles can you observe it from? How many different gestures can you find in it? Create a relationship with it through the give and take of consistent observation.

4. Identify the pattern(s). Which patterns are dominant? Are there secondary or tertiary patterns? Do they relate? Make notes about your findings as visuals or words.

PART II: DETAILING PATTERNS

You should be fairly intimate with the object you have spent a week observing and sketching.

1. Choose a detail from your nature subject. What attracted or intrigued you most when you created the gesture drawings? This is what you will focus on.

2. Explore this one detail. What pattern is it related to? Is it obvious what purpose this pattern is serving in this particular context? (For example, if it is linear, what is being transferred? If it is a spiral, what is generative about it? If it is an enclosed shape, what is being stored?) Note your observations to prepare for the next part of the exercise.

3. Explore your subject to its fullest and transform its literal context into an abstract one. You should now be familiar enough with your subject to take liberties with stylizing it. Go through your notes and sketches, and find the most prevalent shapes and patterns to prepare for the next part of the exercise.

DID YOU KNOW? **There is a terrific 1-hour documentary by filmmaker Vanessa Gould called Between the Folds, which shows folds used in art, science, medicine, theoretical physics, and design. It's widely available, so be sure to watch it for a deeper understanding of dimension's role in design and patterning.**

PART III: EXPRESSING PATTERN AS DESIGN

Now you'll choose three or four different ways to represent your subject as a visual that communicates its dominant pattern. In my students' examples in **Figures 4.31**, **4.32**, and **4.33**, various subjects are presented in different ways to communicate their patterns. This exercise brings your overall skills of observation and drawing studies into a finalized representation of the object's pattern(s) and what it communicates. It will help you to identify and replicate patterns by visualizing and creating them in different media.

1. Create a realistic drawing. Draw your subject as accurately as you can with your choice of media (pencil, colored pencils, pen, etc.). If the subject is too detailed and you find it overwhelming to draw the entire object, pick a part of it to focus on.

2. Explore your subject in three dimensions. Take an aspect of your subject (or the whole subject, if you care to), and create a three-dimensional representation of it. You can do this with paper folding, craft materials, or natural materials. Observe the primary movements or shapes of patterns to help define a three-dimensional representation that accurately conveys the pattern. Origami is not difficult to do, and you can find all sorts of instructional videos on the Internet of how to create different folded and bent forms.

4.31 *In this example by Santa Fe University of Art and Design student Erick Ferrer, clouds provided the subject matter to explore the undulations of spirals, curls, meanders, and waveforms. Erick simply cut out strips of paper and curled them into his desired shapes for the 3D representation. An ethereal form like a cloud communicates fluidity, impermanence, accommodation, and yielding to external forces.*

4.32 *Santa Fe University of Art and Design student Luis Zarate used the image of an armadillo lizard to explore the repeating pattern of sharp scales combined within the opposite shape of a protectively curled body. This animal also creates the symbolic shape of the uroborus, or the universal symbol of a snake that devours itself in the cyclical dance of life consuming itself (life) to survive.*

4.33 *Susana Lázaro Mateos, another of my students from Santa Fe University of Art and Design, explores the layers of encircled leaves of the rose cactus. Susana created a combination of pencil sketches and Illustrator vectors for her project, and cut out varying scales of her design to bind together and mount as a 3D representation of the cactus's pattern of waveform, scale, and circle.*

3. Create a detail. Find an aspect of your natural object to detail. This can be an edge, a shape, or the overall pattern refined into a simplified detail of it.

4. Stylize the form. In black and white (either pen and ink or as a vectorized illustration created in Illustrator), find a pattern to stylize as a repeating form.

WALK THE NATURE TALK

Get your sketchbook and pencil and take them with you on a walk.

1. Focusing on only natural forms (not buildings, sidewalks, or anything else manmade), try to identify each of the five patterns discussed in this chapter: spiral, meander, stacking and packing shapes, branching, waveforms, and weaving patterns.

2. What does their form tell you about what they do? Can you identify what the pattern is doing in context of how it is used?

3. Is there more than one pattern working together? How do they interact or support one another?

EQUATOR AS IT
TURNS WOULD
READ ●●●● O O O O ●●● O O O O
FOR EACH CYCLE

H

AS H ROTATES
IT ALTERNATES
POLE

5

SHAPES
NATURE'S VOCABULARY

Patterns create a connected flow describing the process of nature's energy, and shapes comprise this continuous stream of visual information. Most of what you communicate isn't in its literal syntax: Your words are given depth and dimension with gestures and emotions—even your chemical pheromones tag your behaviors and elicit a social response from those around you. All animals sense fear, anger, elation, and ease in multiple sensory ways. In a similar style, whereas patterns help you visualize the overall integration of a design, shapes allow you to fit significant and relevant pieces within the context of your designed communication. They are useful as structures that convey the general purpose and intent of the design "without a thought." Shapes help you to organize—and your audience to intuitively recognize—the specifics of the message communicated in your design.

KEY CONCEPTS

- Understand the relevance of fundamental shapes to math, dimension, and nature, as well as to emotional and intellectual states.
- Recognize and implement the shapes of circle, line, triangle, square, and spiral as intuitive parts of your design's communication.

LEARNING OBJECTIVES

- Identify shapes in nature, analyze their purpose, and reuse shapes appropriately in design.
- Complete a shapes exercise to become acquainted with how shapes are relevant to you personally and how they lend meaning to design.
- Create a personal symbol that is evolved through your understanding of shape.
- Create a mandala using personal preferences of shape and color to enhance your design understanding and Illustrator skills.

Shapes are consistent in their function: A circle rolls and encompasses, a box sits squarely with stability, a triangle points to something beyond itself, a spiral twists with elegance, and lines travel and intersect. Each of the fundamental shapes has eternal relevance to you individually, as well as to humanity, because each coincides principle with purpose. Consequently, across any culture and in any era or language, there are fundamental meanings embedded in the geometric alphabet of nature's vocabulary. Being thoughtful about how shapes help to compose visual communication increases the power of your design by providing additional information with minimal effort for the viewer.

This chapter explores the range of fundamental shapes and their meanings and functions—from the mechanics of how they are constructed to the emotional impact they have on the human collective, making them quite useful to design.

Shape-speak

"The soul never thinks without an image."

—Aristotle

You can't understand shapes without knowing a little math. Just a little—this I can promise, because I am no mathematician. Mathematics encompasses theory and philosophy, as well as hard numbers, and it would require volumes to cover its significance. It is, nonetheless, important to understand some of the basics of how math works, because everything you know about the universe is based in it. The binary code that underlies the digital world you interact with every day is an example. Binary numbering is nothing new. It's the basis of many visual and audible patterns in human language: the Chinese I Ching, Braille, and even the poetic rhythm of *prosody*, which measures intonation and emphasis in written language. If you didn't have rudimentary math skills, you wouldn't be able to create *anything* humans are known for—from inventing a system for bartering goods to designing sophisticated satellites that explore the universe. Math, along with written language, are two of the most powerful tools humans have ever developed. Alone, however, numbers are conceptual abstractions that can quickly lose their meaning. Shapes define numbers with intuitive references to the real world in tangible ways that can be physically interacted with (**Figure 5.1**). As you will see, shapes describe processes that range from emotions to dimensions. The more you understand the basics of math, the more organized your thinking process and elegant your images. As with anything in this book, if an idea sparks your interest, it's the universe's hint that you need to know more! Pursue it and educate yourself further.

5.1 *Scanning electron microscope image of the eye on a fruit fly (opposite). Image: Louisa Howard, Dartmouth College Electron Microscope Facility.*

Defining Extraordinariness with Numbers

Humans first learned to understand mathematics in the simplest and most accessible way: counting. People figured out that the five fingers conveniently located at the end of their palm could represent another type of digit besides a body part (**Figure 5.2**).

DID YOU KNOW? **Humans aren't the only ones who can count. Many animals—including insects and birds (not just those considered "higher thinking" mammals)—can retain up to four items in memory reliably. For this reason, your social security number, phone number, checking account, and credit card numbers are broken into four-digit sequences or shorter.**

It would make sense that once humans discovered how to count linear quantities, they would want to measure the qualities of length, angle, volume, and area. Humans discovered the system of measuring all earthly things with geometry (*geo*=earth and *metry*=measure), using the classical measuring instruments of the compass and straightedge to figure curves and angles. Don't let the simplicity of these tools fool you. Their ordinariness is what makes them flexible enough to help you understand and emulate nature's incredible depth. Geometric shapes provide a concrete shorthand for numbers. No one knows who stumbled onto geometry originally. Evidence shows that the Indians, Babylonians, and Egyptians were early comers. But because all physical things disintegrate after enough time passes, this evidence cannot be validated.

Euclid (323–283 BCE) is regarded as the father of many of the basic understandings of spatial relationships and for developing a rigorous math with which to verify findings. The Greek philosopher Plato is credited with the idea of objects that are seen are not real but are actually "mimics" of the real "forms." In Plato's theory, the shapes hold the power to create everything people physically interact with. Centuries later, the German mathematician and astronomer Johannes Kepler (1571–1630 BCE) applied the notion of geometry to the basis of the universe. He visualized it as the five Platonic solids (which Plato did not discover; there are Neolithic examples of them that go back at least 1,000 years before his time; see **Figure 5.3**) nested within spheres and relating to the paths of each of the solar system's planets around the sun (**Figure 5.4**). The five Platonic solids consist of the tetrahedron: 4 faces; cube: 6 faces; octahedron: 8 faces; dodecahedron: 12 faces; and icosahedron: 20 faces. Kepler realized that the planetary orbits around the sun were not circular but spherical and that by nesting the planetary orbits within

5.2 *Finger digits to numeral digits to digital technology: Your fingers put you in touch with quantifying the universe and organizing the world to your liking. Image courtesy of Visual Language, www.visuallanguage.com.*

5.3 *An ornamental petrosphere from the Neolithic period. Almost all of these carved stone balls are found in Scotland. Their purpose has been postulated as weaponry, tools to work hide, "speaking" stones (the person talking holds the stone while others listen in silence), game pieces, or oracles. This example is so intricate and lovely, I consider it having other significance beyond mundane or daily use: perhaps as a circular book of information, a portable song or praise, or even an expression of our physical binding into the whole universe. The Ancient Stone Implements, Weapons & Ornaments of Great Britain. Longmans, Green & Co. 1897.*

5.4 *Kepler's Platonic solid model of the solar system from* Mysterium Cosmographicum *(The Cosmographic Mystery, c. 1596). Image courtesy of Visual Language, www.visuallanguage.com.*

the shapes of Platonic solids, he could determine their orbits, speed, and intersections. This was one way to visually comprehend complex movements, bodies, and relationships of the universe beyond the perceptual abilities of people but within their intellectual reach.

Abstract thought allows you to study and conceptualize things that are beyond your everyday experience, and you do it all the time: planning your schedule for the week, creating different concepts for a design development, or imagining potential scenarios in an interaction you had or will have—all are examples.

Measuring led people into more visually complex descriptions that required shapes instead of markings. Like everything else in the connected universe, shapes simply needed to be realized, understood, and worked with to create a human benefit. When you grasp the fundamental workings of shapes and the relationships they contain, you link visual with communication, which allows you to ultimately connect with your audience. Simplicity and truth are roughly equivalent and universally appreciated.

Shapes as Truths

"We hold these truths to be self-evident," is one of the most powerful statements ever made. It states a simple concept in a direct way. Truths don't have anything to do with "facts," nor do they need any sort of qualification. Truths are eternal principles that human technology and intellect don't influence. Shapes are examples of universal truths that are inherently sound: They do not change. In contrast, facts are momentary human beliefs that are based in what is known at the time. Humans are continually learning and evolving, and the depth of understanding is expressed through contemporary culture and its technology.

With all of the various interpretations expressed through multiple cultures, which are particularly apparent in global interactions, where do people connect? The common and timeless vocabulary for all is in shapes that take communication beyond written language or current trends. Shapes have basic relationships to the realities people experience every day that don't change. By connecting consciously with these simple truths, you can expand your scope of communication with a depth that transcends current beliefs. Meaningful visual communications provide a range of freedom—or flexibility—that is independent of opinion.

A Universe of Freedoms

"Freedom" is usually thought of as a political status or something to do with doctrines or bills, but a freedom is simply a term of an independent capacity that is separate from other systems. Meanings are easily manipulated or misunderstood when translated into words. Everything in the world has inherent freedoms—or capacities—that develop more complexity over time. In physics, this is called *degrees of freedom* and relates to more freedoms or separations that lead to higher levels of complexity and independence. Once born, babies have the freedoms to physically and verbally express what they couldn't in the womb. Over a lifetime, these capacities become far more sophisticated than where they

originally started (well, usually). A point with no capacity of movement evolves into a circle with infinite possibilities for other shapes.

How is this relevant to design? It is the heart and soul of understanding where your inspiration comes from and how to apply it to more elegant, more essentially communicative design. When you understand the progression of simple to complex, you are able to distill information into an elegant design that has the flexibility to expand into a range of collateral materials and yet retain the essence of its meaning. Degrees of freedom express this expansion, allowing you to approach the core of your communication with a range of movement, from simple to complex and back again. This creates the heart of your design and is a perfect approach to designing a symbol or logo for a client.

Let's look at how degrees of freedom relate to dimensions and how dimensions relate to shapes:

(a)

The point (a). The point is a fundamental object of Euclidian geometry. The point solely references a location in space and has no other properties. A point, taken by itself, is a zero-dimensional object. If it were a space, it would be a space in which there is only one possible position. It has a zero degree of freedom.

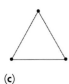

(b)

The line (b). A line segment is created by pushing a point into one-dimensional space. When you "push" a point, you have created a line segment, which is part of a larger, one-dimensional space. This horizontal line extending infinitely in both directions is usually called the x-axis and has one degree of freedom, or a position of only being a line in space.

(c)

The plane (c). The plane enters the realm of shape and is created with a third point that allows all points to connect and enclose a two-dimensional surface. The plane has two degrees of freedom, or is a shape that can be measured with two numbers (the x-axis plus y-axis) to fix its position in space.

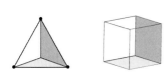

(d)

The tetrahedron or cube (d). With a fourth point, depth (the z-axis) is brought into the equation. This is the most accurate way to show three-dimensional space (via the use of only four points), although it is more typically thought of as the six-sided cube you see in any 3D program or effect. They both have three axes in common: width (x-axis), height (y-axis), and depth (z-axis), or three degrees of freedom.

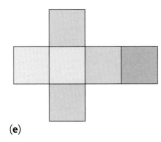

(e)

Applying the spatial dimension in real life (e). The representation of a third dimension on a two-dimensional surface is created by an illusion. Another way to visualize this is to actually construct the cube in three-dimensional space. It's easy to do and will give you some hands-on experience with package design (albeit at its most simplistic level!). I recommend you try other shapes in three dimensions to better understand how they work.

By thinking in detail about how you can use degrees of freedom to extend ideas from a lower-dimensional space to a higher-dimensional space (physics), you are able to see the basic constructions that form all material objects in nature (geometry), as well as how these objects develop from nothingness (philosophy). This is how the rules of simplicity progress into complex conceptual theories that take you far beyond everyday experience.

Understanding the origin of shapes and their basic degrees of freedom gives you a simple technology to explore not only the world around you, but also worlds that are accessible only through organized thinking. The awareness of lower-dimensional connections to higher-dimensional shapes reveals their structure and provides opportunities to extend a visual format into related levels of design complexity. You can also use this awareness to refine a design back to its origins and retain an elegant relationship. In a later section in this chapter, "'In Form' Yourself by Understanding Shapes," you will learn how the fundamental shapes relate to your viewers' emotional responses of aspiration, stability, independence, creativity, and connection with others. You will personally interact with these shapes in "Putting It into Practice" at the end of the chapter to directly use the intuitive language of geometric shapes to create a personal symbol.

It can't be said enough: Design is relationship regardless of its genre—whether realized as designed communications, architecture, art, or utilitarian items, design's purpose is to facilitate relationship, be it between user and tool, individual and institution, or buyer and seller in a transaction, or in the wooing stage of transaction. Humans have always used nature's most basic principles to achieve success in these areas. Designers must be conscious of how nature uses basic principles to connect people with one another and to the world around them for usable designs. These principles are made tangible in shape.

Human Translations of Shape

The five basic shapes—circle, intersecting lines (equidistant cross or plus symbol), triangle, square, and spiral—are universally used in all human art forms from prehistory forward. Each shape can be drawn, painted, or chipped out of stone and serves as a representation for events or structures in three-dimensional space. By being visualized as two-dimensional objects first, shapes provide schematics for future buildings, structures, or objects. Shape as symbol directly relates to the primitive and unconscious sense perceptions everyone shares as a common reality. Shapes are the timeless working templates for all human-based design.

Cultural anthropologist Angeles Arrien has dedicated a large part of her career researching and cataloging these common shapes and was the first to identify the universal meanings attributed to them found in all art worldwide. In her book, *Signs of Life: The Five Universal Shapes and How to Use Them* (Tarcher, 1998 ©Angeles Arrien, all rights reserved), Dr. Arrien examines what she has found to be the most prevalent shapes in art that have consistent cross-cultural meanings regardless of family or cultural imprints. This unified agreement of the meaning of shapes highlights human cooperation through commonality and is an important approach to creating accessible designed communications for the global community. Dr. Arrien calls the five basic shapes the "perennial truths," and they are essential as neutral pieces of common understanding with which to bridge different people and cultural experiences. For example, in her studies of cultural perceptions of shape, the square in 100 percent of responses represented stability, solidness, or a similar concept related to "squareness." How could it be otherwise?

Each shape contains multiple relationships to math, dimension, emotion, and complexity. Used correctly, the right shape can lend more power with austere economy to your design, allowing you to embellish it further with visual details to inform and connect the viewer.

"In Form" Yourself by Understanding Shapes

"Everything has the energy of its making inside it."

—Andy Goldsworthy

Each of the basic shapes evolves from an original point. The point is theorized in the concept of the Big Bang as the infinitesimally collapsed origin of everything. Human beings, regardless of when they live, create stories, myths, art, and symbols that tell the story of all coming from one. As described earlier in the section "A Universe of Freedoms," mathematics also explains the phenomena of a point progressing into a line, a plane, and then into three-dimensional space. These shapes have been recognized by all human cultures as the basic visual descriptors that relate to dimension, number, and the human experience of life. Discussing math, symbols, and shapes may seem a stretch from design, but actually they are all deeply and inextricably related. They provide analogies that you can comprehend to describe the way nature creates a complex organism from a single

THREE ESSENTIALS FOR SUCCESSFUL LOGO DESIGN

Because I've been designing logos for over three decades, I've learned some essentials about how to create an effective symbol that people recognize and remember. Knowing that shape is an important component of a logo, I decided to include this information in this chapter. I've developed three general categories as guidelines for a logo design that retains its value over time and trend. Check your logo against each of these criteria to gauge its communicative and functional power:

- **Black and white.** Start with basic structural supports. If your design works in black and white, it will work in any color, in any medium, and with almost any technique. Secondary or tertiary visual information, such as applying color or technology-generated effects (gradations, for example) can be useful to enhance the concept, but it's most important that your logo communicate at its essence. Look at the logos below. They all work well in black and white, and will therefore work well in any application, be it an embossed piece of chocolate, a phone app, or a printed business card. Think about what you want the design to convey in the conceptual stage, and evolve it toward a tangible representation by using relevant shape and metaphor. This may seem counterintuitive, but defining the logo's edges gives it flexibility.

- **Balance of negative and positive space.** Integrate approximately equal amounts of positive and negative space. A balanced ratio between negative and positive space ensures that the logo will scale in size (more on scaling in Chapter 9, "Messaging: A Meaningful Medium"), which is essential for broadly reproduced designs. Attention to how your logo scales allows it to follow the principles of scaling in nature and makes it usable over varied circumstances and applications. None of these logos are an exact 1:1 ratio of negative and positive space, but they

all contain enough of each to scale and retain legibility. You will never be fighting with lines that disappear when the logo is reduced to minimal sizes or displayed on the Web, nor will it look cumbersome and unwieldy when reproduced in large sizes, such as on a sign or billboard. Don't forget that the empty space speaks to the viewer as much as the filled. Spaces give pause to the eye and mind, allowing for a more even absorption of the visual information and a space to grasp its meaning to the viewer.

- **Story.** The most memorable logos engage the viewer in a story. Storytelling is a key ingredient of design because it connects people into the eternal human ritual of dramatizing memory and imagination through narrative and myth. Can you begin to infer a story with any of the following logos? Can you guess what sorts of clients might use them? The flickering campfire may have been replaced with the monitor's glow that has taken away much of the direct involvement with community and family, but people's need for this relationship is still strong. Connecting with the story is an important touchstone in relating to your viewer. Explore the symbolism of simple shapes to help frame your message, because this sets the stage for the rest of the story. As Einstein said, "Be as simple as possible, but not too simple."

Finessing the design is also crucial but isn't something you can be taught intellectually; it's more of an exposure. Aesthetics come from your own sensibilities, experience, and understanding. If you pay more attention to nature using some of the exercises included in this book, as well as exploring your own ways of interacting with it, your aesthetics will be enhanced as will your understanding of how the world around you works. This understanding will appear both intentionally and intuitively in your work.

ALL DESIGNS BY MAGGIE MACNAB.

egg or seed, or "all from one." Life grows through division and then collapses the process all over again in the creation and sowing of seeds (or oats!), whether plant or animal.

Vectorized computer programs draw from point origins as well: Vectors (which mean angles) must begin with a point and require additional points to bend into angles or curves that lead to shapes. Rasterized images are composed of pixels, or little squares. Note that rasterized images don't scale in both directions like a vector does: They usually scale to smaller sizes successfully, but the image breaks down when scaled into a larger size.

DID YOU KNOW? **Archetype, a term made popular by the psychoanalyst Carl Jung (1875–1961) who specialized in symbols and their interpretation, means "original model" or "pattern." Archetypes often contain opposites because they reference the origins of the universe. Energy and matter are one before separating into dimensional space. Not surprisingly, most of the basic shapes have inclusive opposites because they represent the "original patterns" from which everything comes.**

A point is the origin of a curve, just as a compass demonstrates. Curves move in any direction, and consequently, dimension. A pixel is a square. Squares don't cycle like a circle. They have no movement whatsoever because they are manifest and grounded. Their energy is about staying, not going. Thinking about a point can lead into deep contemplation (if you let it), because it is from the simplest and smallest original—the archetype—that the most complex and massive are sourced. Meditation, in fact, is the practice of focusing on the point—the center—while the world swirls around it. As in nature, as in math, and as in digital imagery, the principles of curve and angle apply to everything.

Each of the shapes tells a story of progression and has particular, inherent qualities that do not change and are clearly associated to its shape, as you will recognize.

In the following section, you can construct the geometrical shapes along with their descriptions to get a feel for the forms. It may seem too simple to even be worth your time, but it helps your muscle memory reconnect with what you learned a long time ago and to perhaps relearn it in a way that truly serves you.

BEFORE YOU READ ON

Look at the five archetypal shapes. Draw these shapes in the order in which they appeal to you from the most (position one) to the least (position five). Then put your drawing aside for the later "Shapes Exercise" section toward the end of the chapter.

The Circle

The circle is the beginning of all other shapes. The circle is constructed with the aid of a compass and begins as a point. I know this is like going back to grade school, but don't underestimate the power of simplicity. Just get a piece of paper, a compass, and a straightedge, and follow along. Start by drawing a circle with your compass (**a**).

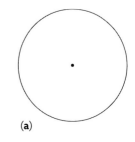

(**a**)

The point is a fixed position in space and from it a continuous arc can be drawn that connects an infinite number of points into the shape of a circle. This is the archetypal component of the circle: It includes all within its circumference and excludes everything else outside it. It also addresses the singular (the point) and the totality (the circle). The circle is known as the "mother" shape and contains the possibility of all the other shapes within it, just as it contains an infinity of points that surround it. The shape of the circle is the initial shape of source, completion, or wholeness.

All is one and interconnected is not a new idea. This concept is at the heart of almost all religions, spiritualities, and philosophies, although its symbolic details vary from culture to culture. For thousands of years, philosophers have gazed at the stars and known that one thing must exist in common with, and connect to, the many things within the universe. In general, the shape of the circle represents wholeness and the underlying concept of "source" for all cultures. The "all" is contained within one—everything else comes from this original form. It is realized in the halo in Christianity, the circular ceremonial kiva of Native American spirituality in the southwest (**Figure 5.5**), the whirling dervish dance of the Sufi, and the concentric circles chipped out of stone in the dreamtime petroglyphs of the Australian Aborigine, along with many other examples (**Figure 5.6**) that date back from prehistory to the current day (**Figure 5.7**). It is the shape of the sun that illuminates all and appears to encircle you every day in its continuous cycle of rotations. It is life itself.

Embedding the circle within your design brings it wholeness, integrity, and a sense of interconnectedness. At the same time, the circle's form is quite independent from all other shapes, with nowhere to make a stable connection on its periphery. It is an excellent shape to use in worldwide operations, for community-oriented or collaborative organizations that contribute to a greater "whole," or for a company that wants to impart comprehensive services (**Figure 5.8**). It connects to all, and none in particular, all at the same time.

5.5 *Casa Rinconada, located in Chaco Canyon, New Mexico, is one of the largest ceremonial kivas in the southwest. This time-lapse photograph shows star constellations that were used by the Chacoans as templates for pueblo plans within the canyon. Courtesy of the U.S. National Park Service; Photo: Dr. Tyler Nordgren, University of Redlands.*

5.6 *A Tibetan mandala (a Sanskrit word that means "circle" or "of essence") is a symbolic offering to and of the entire universe, represented primarily by the circle and its center point of the axis mundi (center, or navel, of the world that connects heaven to earth). Mandalas often also incorporate the other four universal shapes.*

THE CIRCLE DEFINED

Definition: The circle is all encompassing. Just as the fertilized egg contains the blueprints within its circular shape to create any body part needed, the circle contains all other shapes within it that can be realized through geometry. The circle symbolizes wholeness, connectivity, independence, and/or movement.

Dimension: The circle begins with only a location in space represented by a single point, or zero dimension. It is expanded into its full shape with an infinity of points that are connected as a line.

Archetype: The circle contains all within itself and excludes all that is without. It is both whole and hole, and all and nothing (as in zero).

Emotion: *Negative:* Aloofness, isolation; *Positive:* Self-starter, independence, sacrifice of self for the overall "whole."

Purpose: The circle is wholeness personified. As such, it expresses working independently and autonomously or toward a greater good in teams.

Natural Expressions: Germs, cells, viruses, planets, stars, bubbles, eggs, seeds and their extensions of trunks and stems, revolutions of the seasons, and planets.

Human-made Expressions: Sports balls and stadiums, religious artifacts (halos, stained glass, Dharma wheel, yin yang), and ceremonial or institutional structures (Stonehenge, kivas, cathedral or governmental domes).

5.7 *A contemporary mandala created by Icelandic graphic designer Thorleifur Gunnar Gíslason. Create your own mandala in Illustrator in the "Putting It Into Practice" exercise section later in this chapter.*

5.8 *Although no one knows the actual shape of the universe, NASA has effectively used the circle as its underlying shape to communicate "everything," as well as adding an elliptical path to represent the orbits of planets, stars, and satellites.*

Intersecting Lines

The line is the next geometric step in the construction of shape, although it is rarely used to express a design because it has no shape in and of itself. One dimension is by its nature limited and does not have much relevance to communication alone. However, it can be combined successfully with other shapes to imply literalness and contains the inherent precision of limitation. The IBM logotype is a good example of this (**Figure 5.9**).

5.9 *IBM's updated logo, originally designed by Paul Rand in 1956, captured the idea of precision literally embedded within the company's name, or "who they are." This logo is still in use 55 years later.*

Working with your original circle from the prior section, keep the compass spread at the same diameter (remeasure it from the original center point to the circumference on your first circle, if necessary), and draw a second circle with its center point anywhere on your original circle's circumference (**a**). When the arc swings through the body of the original circle, it will pass through the original center point. Connect the two center points of the original and cloned circles with a straightedge. You have now arrived at one-dimensional space by extending the point into a line (**b**).

Now connect the two overlapping points on the circles (**c**). This is the archetypal component of the line: Two opposites (the horizontal and vertical lines) are intersected, bringing them into a relationship. Notice how this shape also represents the "plus" symbol in math: Two unrelated things are blended into the agreement of summation, or "adding" to one another. This is the crux (Latin meaning "cross"; the connections are contained within language as well) of relationship.

The line is the first example of how you don't have to figure out anything in geometry, you just need to *discover* the points of relationship. Geometry gives you its next step, which is why I continually say it was discovered and never suggest that it was invented. Geometry invents itself. People were simply clever enough to figure out a few of the first steps. You now have a pair of intersecting lines that create a new center of relationship that has its origin in duality. And, you have angles in the negative space (don't forget to be aware of emptiness!). Let's make those angles real.

(**a**)

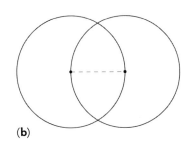

(**b**)

(**c**)

THE LINE DEFINED

Definition: The line is the point's first foray into space. By extending itself beyond a singular position, it creates a line in one-dimensional space. The line is defined in a literal and linear way. It is useful for specific, precision-oriented messages and to define edges. Intersecting lines (equidistant cross or plus symbol) are the shape of relationship: Two opposites combined in compatibility.

Dimension: The line is one dimension.

Archetype: The line is constructed by cloning the circle and connecting the center points. Its partner, an opposite line, is constructed by joining the points of overlap between the two circles. The lines both divide and connect the opposites together through the intersection of the vertical and horizontal lines created with geometry.

Emotion: *Negative:* Linear, logical, unable to integrate other perspectives; *Positive:* Complete precision and relationship oriented.

Purpose: The line connects in the most rudimentary way. Not typically used alone in design, it is nonetheless essential to all other constructions that follow and is sometimes used to lead the viewer's eye, just as a pathway provides an access. Two intersecting lines create the ultimate symbol of opposites in a relationship.

Natural Expressions: The horizon, rivers and streams, edges between ecosystems, and as a tracing of the paths of other objects.

Human-made Expressions: Roads, suspension supports, power lines, the Christian cross, plumb bob, ruler, trails, and paths.

The Triangle

To continue to the next geometric step, draw a new set of circles or use the drawing you constructed in the preceding sections. By simply connecting a line from each of the two center points, you can create a spatial plane that borders and defines an area (**a**). It is no coincidence that the triangle is the key component of a directional arrow. Yes, I know it is obviously pointing the way by narrowing from a wide base to a converged point created by angles, but the first angles are the point (!) of this shape.

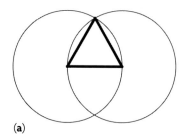

(a)

The triangle implies transformation in its very construction. The opposite concepts of line and dot are connected with angles as in a composite symbol that encloses the next dimension of space, the plane. Just as grains of sand spill from the present into the past through the narrowed neck of an hourglass (**Figure 5.10**),

5.10 *Shapes that funnel, such as the hourglass, address moving from broad to narrow or collecting and consolidating energy to prepare it for transformation. Note that the corresponding pattern of the double helix does just this by compressing genetic information into a blueprint for new life.*

the triangle is a shape that accommodates transformation. The triangle takes everything into account at its base, gathers and compresses it, and funnels it into and through a point in preparation for the next dimension.

Where do you notice triangles in the real world? You often see them in structural supports, such as bridge trusses, because triangles are such functional shapes. The triangle is the fundamental shape of the geodesic dome, as well, as shown in the sketch that opens this chapter by architect and futurist R. Buckminster Fuller. Although not the most popular style of building (perhaps because spheres don't compact as tightly as four-sided buildings for better cost:profit ratios), a dome-shaped construction is the most energy efficient to run, the most structurally sound, the lightest, and the cheapest human-scale structure built. In arches and triangular structures, a third point provides a greater strength between two others.

The pelvis is the truss of the human body, and within it, an embryo (originally an egg, or a point) transforms into a human infant, passing through the woman's triangular truss of reproductive organs and structural framework of the pelvis into the next dimension of life at birth. All words that begin with *tri* (three) or *trans* (across) are based on the number three and upon the shape of the archetypal plane, the triangle. These words address the inherent strength of angles created by three connected points to propel or "transport" energy into another state of being. The Department of Transportation's logo (**Figure 5.11**) triples its communicative power by adding the number three as the main graphical elements in its logo, embedded within the ancient symbol of the triskelion in **Figure 5.12**— a symbol of motion and *trans-form-ation*, referencing the ability of the plane to "change-shape." Of course, the word "transportation" itself reinforces the entire logo design. This word is originally derived from *trans-* and *port*, literally a maritime term for ships moving between ports (also the origin of the word "passport," allowing citizens to pass between international ports). The word now references all travel anywhere. Many automotive makers use three elements, a triangle, or a combination of them in their logos to illustrate their ability to move you. Some of these logos include Mitsubishi, Toyota, Mercedes Benz, Pontiac, and Buick. This is not an accident; these shapes speak directly to your subliminal knowing and

5.11 *The logo for the U.S. Department of Transportation uses a few aspects (three, actually) of the concept "three" in number, symbol, and word.*

5.12 *The Manx triskelion (a three-legged symmetrical design thought to have been originated by the Celts) on a Victorian water wheel on the Isle of Man, Scotland. The motto of the Manx coat of arms is* Quocunque Jeceris Stabit *("wherever you throw it, it will stand").*

create more retention by being accurately assigned. The interesting aspect is that most designers don't consciously design in this way. They just know it "feels right." Now you know why.

Designers are following nature's process of dividing to multiply with this simple construction. By creating the first angles from a circle in your drawing, you have constructed a plane—the basis of *all* manifest structural concerns. Angles are very important as shortcuts and to leverage other elements. With the act of creating the triangle as a simple drawing, you commit it to muscle memory. This is why I recommend you do these constructions by hand rather than by computer.

It is no coincidence that Masonic symbolism (masons that build things to make them real in the world, as their name implies; **Figure 5.13**) and the symbolism from sophisticated cultures—such as ancient Egypt and the United States—have all used a triangular shape in the most everyday interactions to symbolically represent transformative and visionary cultures and ideology (**Figure 5.14**).

5.13 *The Freemason insignia contains the tools of a compass and straightedge. This design is carved into stone on the foundation of a Masonic hall in Lancaster, UK. The shape of an active compass is the triangle, addressing its intimate relationship with the circle to pull energy into matter for constructing the world.*

THE TRIANGLE DEFINED

Definition: The triangle is the shape of aspiration and higher goals. It embodies this in its shape of a broad base that funnels into a point. This shape combines the first two dimensions of point and line into a transformation or movement that progresses it into the next dimension.

Dimension: The triangle connects the line with a third point to enclose a plane in a two-dimensional space.

Archetype: The triangle is a line and a point combined, and serves to direct broader concepts into a refined and focused point.

Emotion: *Negative:* Continual aspiration without real-world results, a dreamer; *Positive:* Stability, inspiration, and ability to transcend obstacles.

Purpose: The triangle is the shape of energy gathered and compressed to funnel and transform it into matter, or the inverse of matter to energy.

Natural Expressions: Mountains, high-elevation trees (such as pines), some leaves and fern fronds, 120° angles created by drying mud or pressure-cracked rocks, faces of crystals.

Human-made Expressions: Religious and transformative symbolism, pyramids, monuments, triangle (the tool), all angles including the expanded compass.

©INSTAMATIC/ISTOCKPHOTO.COM

5.14 *The image of the "eye of providence" is enclosed in a radiating triangle atop an unfinished Egyptian pyramid on the United States one dollar bill, giving it the underlying associations of prosperity, protection, and rising above the mundanity of the past. The motto "Annuit Coeptis" above the eye is from the Latin and means "to favor beginnings."*

The Square

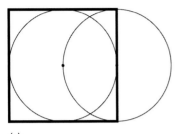

(a)

A fourth point brings the dimension of depth into play as discussed in "A Universe of Freedoms." Technically, a fourth point would create a tetrahedron, or pyramid, but the two-dimensional shorthand for depth is a square or four-sided shape that references the fourth point in a simple and quick-to-draw form (**a**). This is the world manifest, solid and real.

Squares will not roll out from under you. The square references stability and security in form and fact. At the emotional level, it can also reference boredom or stagnation, as well as rigidity—from an inability to change to compulsiveness or addiction (which is the same thing from different angles). It doesn't move around very much, nor will it disappoint or surprise you by doing anything unexpected. It is forthright, fortified, and forward, all words that relate the number four to stability, security, and tangible results. In fact, it is so generic that most likely you can't think of more than two or three logos that use this shape. It's not the most exciting shape in the toolbox, but it's effective for what it is.

Much of the built world uses four-sided objects in construction. Just look around you—almost everything, from windows to walls, tables to chairs, tiles to appliances, and digital circuitry to city plans and power grids.

In design it's a reliable format and consequently is the basis of computer monitors and their subsequent artifacts of browsers, pop-ups, copy or text "blocks," or image shapes; and of paper and all of the printing processes that use four sidedness with which to construct its products.

THE SQUARE (OR FOUR-SIDED SHAPE) DEFINED

Definition: The square is the shape of solid durability, security, and manifestation. It embodies the principle of rigidity and solidness.

Dimension: The square adds a fourth point of connection, bringing depth to the equation for manifest space.

Archetype: The square is the shape of immediate tangibility and what you experience living every moment of every day. It is, however, completely gone before the moment of birth and immediately gone after the moment of death.

Emotion: *Negative:* Sternness, rigidity, addiction; *Positive:* Stability and support.

Purpose: The square contains and stabilizes energy.

Natural Expressions: There are some squarish-shaped broken rocks and cracks in nature, but no true squares. Some crystals, such as salt, sugar, and crystallized soy sauce, have fairly squarish shapes at molecular scales.

Human-made Expressions: Just about everything you see around you. The built world is based on the four-sided shape. Financial, insurance, and megacorporations often use this shape to imply stability. And obviously, so do building contractors.

The Spiral

The spiral is the constant of the universe. Spiral shapes are always in motion and always return to reference a previously existing reality at a different level of experience or at a later time (**a**). Examples are the nautilus's chamber that grows ever outward but follows the original curves of its growth pattern (**Figure 5.15**), hurricanes, scalp and fingerprint whorls, or even from an emotional viewpoint of revisiting a childhood fear from different levels of maturity later in life. The fear may still be there at some level, but it has been tempered by experience: You have *grown away* from it, but not necessarily outgrown it. This is an example of an expanding emotional spiral; it still contains aspects of the original emotion, but the edges have been rounded and widened by experience. The converse of this could be a down spiral: addiction, for instance, or an inability to effectively change destructive behaviors.

Progressed, or logarithmic, spirals are the basis of what most humans consider beautiful proportion (learn more about the golden spiral and how to construct it in Chapter 9) and are the most prevalent in nature. Another spiral, although not nearly as common in nature as the logarithmic is the Archimedean spiral, a coil shape with successive turnings at fixed distances. Plant tendrils demonstrate the Archimedean spiral, as do coiled snakes, winding watch springs, and coiled hoses or ropes. Spiral minarets and "spiral" staircases do as well, just like a stretched-out coil or a helix extended vertically in space (**Figure 5.16**).

The spiral expresses regeneration and creativity, as used in the logo I designed for Valle Encantado (**Figure 5.17**), a family-centric nonprofit committed to locally grown food and traditional generational crafts. The other primary graphics

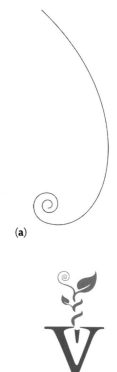

(a)

5.17 *A logo I designed for Valle Encantado ("Enchanted Valley"), a nonprofit in the south valley of Albuquerque, New Mexico, that "cultivates community" with locally based agriculture and crafts.*

THE SPIRAL DEFINED

Definition: The spiral is the shape of regeneration and creative connectivity (as opposed to linear connectivity). The spiral is a dynamic shape that equalizes opposing sides and brings them into balance.

Dimension: The spiral would be the fourth dimension of time (at least this is what I've been told). Time is always new, yet the seasons cycle, the same holidays come again and again, and you celebrate your birth with each new sun cycle—known but renewed (or re-known).

Archetype: The spiral winds around itself. It continually revisits and continually renews.

Emotion: *Negative:* Inability to stay with new projects through completion (the thrill of the conquest without commitment); *Positive:* Generative, innovative, great facility to experiment with new ideas and things.

Purpose: The spiral renews.

Natural Expressions: Tornadoes, water spouts, snail and mollusk shells, unfurling life, the shape of the human ear.

Human-made Expressions: Staircases (actually a helix), half of the traditional heart symbol that expresses "love," jewelry, art, labyrinths.

5.15 *The geometrically progressed turnings of a logarithmic spiral show a history of growth in shells, fingerprints, and many other organic forms.*

5.16 *A spiral minaret at Samarra, Iraq, demonstrates a cross between an Archimedean spiral and the helix, creating a three-dimensional* conic helix.

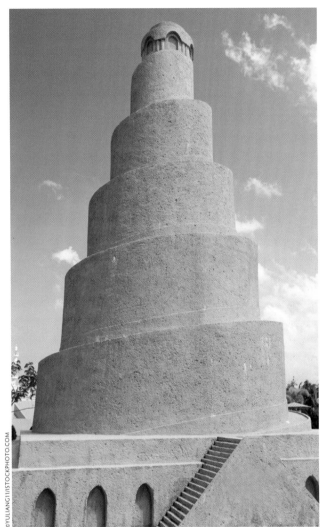

of a spade, metaphorically represented by the letter "V," further reinforce the purpose and the literal name into a composited graphic that is descriptive but simple—and universal but unique.

Now that you know a bit more about the depth and range of these five simple shapes, you'll explore your chosen shapes and their meanings, determine how they relate to you personally, and develop a personal symbol that expresses your core self in an authentic way.

Putting It into Practice

Most likely this chapter has given you more appreciation for the basic shapes and how their simple outward appearance misleads you from their astonishing depth. Shapes are only the first step into far more sophisticated designs that expand upon their practical aesthetic. These shapes are "true," or the eternal archetypes that can be used in design with exceptional results because they are linked to universal principles that everyone knows and responds to.

Design is alchemy. As designers, you blend the universe's language into human communication.

SHAPES EXERCISE

The Shapes exercise and its positional meanings are from Angeles Arrien's "Preferential Shapes Test" in her book *Signs of Life: The Five Universal Shapes and How to Use Them* (Tarcher, 1998, ©Angeles Arrien, all rights reserved). Be sure to add her work to your reference library.

Earlier in the chapter, you drew the five universal shapes in the order in which they appealed to you from most to least preferred. Look at them now (**Figure 5.18**).

5.18 *This is my current order of shapes while in the middle of writing this book. They are different than the last time I did this exercise about five years ago. The order then was spiral, circle, triangle, intersecting lines, and square. Squares, still holding in last place, seem to be either complete or irrelevant for me.*

In Part I of this exercise, you'll look at the significance of each shape's position; in Part II, you'll combine the most significant positions of 1, 3, and 5 into a composited resolution.

PART I

When looking at each shape in each position, refer back to the shape definitions in the prior section, "'In Form' Yourself About Shapes," for how they relate to the positions they are in.

- **Position #1: Your current focus.** As is obvious, your first shape choice is where your focus is. This is what currently holds your attention. What does this shape express to you? (If it's a spiral, perhaps a change is in order; if it's a square, maybe you need more stability in your life at this time; if it's a circle, you are working independently toward a greater good or perhaps with a team of autonomous people; if it's a triangle, you are evolving toward an inspiration or goal; if it's an equidistant cross, a relationship is your priority.)

- **Position #5: What is complete or repressed.** Let's jump to the last shape for just a moment. Just as Position #1 is obvious in its intent, so is #5. This shape represents either something that is complete in your life and doesn't need attention or something you are trying to suppress because you'd rather not deal with it. Only you know which it is. Look at the shape in this position. Which is it for you?

- **Position #3: The center of your power.** What do you think a shape in the central position represents? If you said "balance," you're absolutely right. This position is equidistant between your current passion in #1 and whatever you've chosen to "ignore" in #5. The center position of balance is the most powerful because it gives you the calmness and "centeredness" of being on an even keel: You can use your energy as you desire because you have choice that comes directly from your center without external influence. This is where you truly are rather than where your focus is. What shape is in this position? Whichever one it is, it expresses the actual place of growth you are in now. You work no differently than nature: When things are in a state of balance, energy is in its most accessible and usable state. For this reason, this position is one of great creativity and potential.

- **Position #2: Strengths and skills.** Position #1 is followed directly by the strength that supports your current focus of attention. This is your current dominant ability. This comes easily to you, and you display it this way outwardly to other people. It is so effortless to you, you may not even be aware of it.

- **Position #4: Past influences.** Where you are today has been influenced by what happened yesterday. Position #4 describes the motivation that is a result of a challenge or circumstance you rose to in the past that created the strength of Position #3.

Consider each shape and its position in your order. Only you know what you are personally dealing with right now and where you are stopped, where things are going smoothly, or where you are determined to move forward regardless. This is a tool to support your process of development through change.

PART II

Now you'll combine the key positions of 1, 3, and 5 into a composited design that harmonizes and balances the three shapes into one. You can hand draw quick-sketch ideas for this exercise and finalize them as a vector in a drawing program like Illustrator.

1. Using your shapes in Positions #1 and #5, combine them into a composite shape (**Figure 5.19**). Be aware of what you experience while you are performing this process. Is it easy, hard, or impossible to create something that looks acceptable to you?

2. Integrate your shape from Position #3. Work with all three shapes to transform them into a composited shape that becomes manageable and perhaps even beautiful. Did you learn something new about yourself?

Here's my personal analysis of my three primary shapes combined into one (**Figure 5.20**).

- **Position #1: The triangle/current focus.** I am involved in the process of writing a book, an incredible opportunity that I created out of my passion for the process of creative problem solving through design. I am currently focused on my goals and aspirations to share this with others and to continually develop in my career as a creative and as a person with something to contribute.

- **Position #5: The square/repressed or completed work.** Stability has never been a part of my life in the traditional sense. During my childhood, my family moved a lot, my parents divorced when I was 11, and I went out on my own at 16. There was a time I thought the entire point of my life was to have a home and a family. What I thought of as the ultimate stability—a marriage, a home, and kids—was not what I had imagined in a perfect childlike way. My desire was based on a perceived lacking because my family experience didn't fit into a box. Every piece of life is relevant and important, and I've learned to respect the process. There is so much more at work than we have access to. For the longest time I didn't think I could have that square and thought it was what I wanted most. Through the years, I've learned that I generate my own stability, and it looks nothing like a box. In addition, I've learned to trust my meandering process. It always leads me somewhere.

- **Position #3: Intersecting lines/what is really going on.** The core of my personal passion is relationship: with people and with nature. It's the heart of my stability and my inspiration. It's an amazing thing to teach because I learn so much from my students. The support of my family and friends means everything to me. My clients continually educate me. I love every animal that has smoothed the bumps with their love and affection. It's an incredible experience to connect with the amazing contributors to this book, and now finally with you, the reader.

5.19 *Well, this shape is boring. I've never been a very angular person, but aspiration, precision, and stability have my attention at the moment as I create and structure this book.*

5.20 *I didn't spend a huge amount of time with this graphic, but I did take advantage of color in Illustrator to make the visual more appealing. In lieu of curves (this was a surprise and I was compelled to compensate by focusing on the center), I copied and reduced the triangle 50 percent to give more symmetry—and power—to the center.*

This exercise brings awareness to where you are in your life right now. To support yourself in life, whether as a designer or as a person, you must have balance and compatibility between your intuition, intellect, and physical self to facilitate change, which complements your personal and natural process of growth. By physically engaging with the archetypal shapes—even in this simple exercise—you are developing motor and memory skills to support your choices in the future and learning to fit multiple contexts of meaning within a few simple expressions of shape.

This exercise symbolically teaches you two directions of memory:

- To recognize scale and refine it to its essence (its source: the past).
- To recognize scale and leverage it into expansion (its potential: the future).

"It's a poor sort of memory that only works backwards."

—The White Queen in *Alice in Wonderland*

CREATE YOUR PERSONAL SYMBOL

Now that you've experienced the blending of shapes into a current composite of you, let's up the ante with a symbolic representation that expresses the core of who you are on a less abstract level.

1. Think about what is truly important to you. Make a list, create a thought cloud, or doodle ideas that represent what is important to you. Whatever fits for you is the right way to do it.

2. Pull from these ideas the juiciest, most wonderful things that you love or spark your interest. What is your passion? No holes barred; this is *your* symbol and it's anything you want it to be.

3. Keep your shapes in mind, but don't limit yourself to them. You can use them as a place to start: *Just start!*

4. Begin combining your ideas as visual realities. Find places they match up—similar shapes or common metaphors that might represent more than one idea. How can you begin to merge concepts in a way that makes visual sense?

5. Remember that you are your toughest critic. Don't get discouraged if you don't hit on something brilliant immediately. Let the process work and revisit it until you've evolved your symbol into something you know fits for you. Come back to it after finishing the book if you like. Remember your dreams and save your doodles to look at later: Your unconscious is always at work and more in touch with your feelings than your intellect is.

A student of mine, Gurujot Kalsa, significantly evolved his personal symbol in a matter of a couple of weeks. He began very simply with a lowercase "g" to represent his name,

which evolved out of the spiral being in the #1 position of his shape choice. He embellished this sketch with a couple of personal attributes: the descender of the lower case "g" became a full beard with mustache and face added, and the typographical character's counter (the interior space of the lower case "g") became the turban that is part of his daily dress.

As a concept, the illustrated "g" was more of a cartoon caricature than a personal symbol, and he continued to work with it to evolve it further. The final result (**Figure 5.21**) was an expression of the central commitment in his life. Gurujot funneled his spiritual practice consisting of courage (the lion), outward expression (turban and full beard), and singing (mediation and chanting) through his personal symbol.

5.21 *A personal symbol by student Gurujot Kalsa expressing his commitment to his spiritual practice. ©2010 Gurujot Singh Khalsa.*

CREATE A PERSONAL MANDALA

In this exercise you'll work with shape and color to create a personal mandala with the mathematical power of Illustrator (**Figure 5.22**). This is a medium-level intensive exercise, but it should also be fun. It gives you an opportunity to play with your favorite shapes and colorize them, and become quite adept with the Rotation tool in Illustrator during the process.

5.22 *An example of a personal mandala. This exercise is contributed by Thorleifur Gunnar Gislason.*

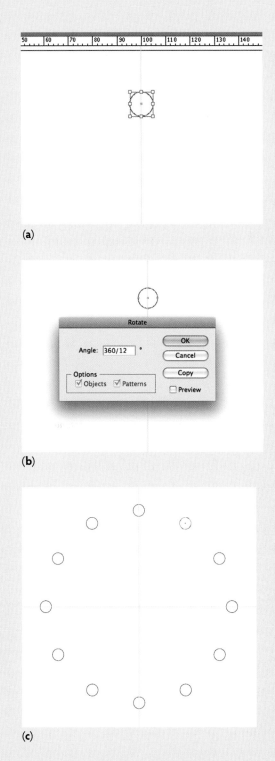

(a)

(b)

(c)

1. Make two guides forming a cross at the center of the artboard in Illustrator.

2. Select the Shapes tool in the Tools panel. While holding down the Shift key to constrain dimensions, create a circle, square, or other shape of your choice. Or, click your desired shape in the Shapes tool, and then click the artboard to enter dimensions manually. Place this shape on the vertical rule line in the upper half of the artboard and provide enough space for several rotations (**a**).

3. Select the circle or other beginning shape, and then select the Rotate tool in the Tools panel. Hold down the Option key, click and drag the cursor toward the center of the two guides, and release the mouse button (**b**).

4. Choose the degrees of rotation in the Rotate dialog box. (Tip: You can insert the rotational degrees and number of rotations and Illustrator will calculate the result for you. For example, insert 360/12 in the Angle field for a circular rotation of 360 degrees with 12 impressions of the shape.) Experiment with size and placement of your archetype (original) shape to find the best spacing. When you determine the number of rotations, click the Copy button. Repeat the process by the number of rotations by pressing Command+D (**c**).

5. Be sure to group the rotated items as you create them, and lock them in your Layers panel before you start the next mandala sequence so that you can organize their coloring by layer in step 7.

6. Repeat the process with different symbols, sizes, and/or rotation values to make the result interesting.

7. When you're happy with the positions and shapes in your mandala, unlock the layers one by one and add color.

6

THE ELEMENTS
NATURE'S SENSUALITY

Part of nature's subtlety is its *sensuality*. There are many delicately complex and understated qualities of color, weather, and element that influence how you feel physically and temper your mood. Subtleties combine to give *sense-ability* to your daily experience of living by providing a background upon which all of life and its movements exist. Your senses are the receptors—physical and otherwise—through which you experience nature's sensuality. Humans, as with all animals, are continually in a sensory intake mode to process the world around them. As a creature of intelligence, you may influence some things you come into contact with, but their causes are usually a far more complex interplay of forces and factors you are not consciously aware of.

KEY CONCEPTS

- Nature displays itself in sensually accessible ways, and it is useful to align its "sense-abilities" as informational and aesthetic supports in design.

- The visible color spectrum is displayed as transmitted or reflected light within which there are subsets, such as structural color and monochromatic color.

- Color is relevant to order as well as emotional and intellectual states, and has natural associations as well as cultural or traditional preferences.

- The five elements are fundamental properties of physical space that are experienced through your senses and are associated with every other physical experience or manifestation.

LEARNING OBJECTIVES

- Experience cross-sensual interplay while being attentive to design and its structure.

- Understand subtlety as a crucial quality that brings depth and meaning to design by relating layers of information.

- Learn to use color and elements and their associated properties to describe and enhance your design.

- Create a "Sense-ability" journal to explore your personal interaction with the physical senses and develop them into a comprehensive design system.

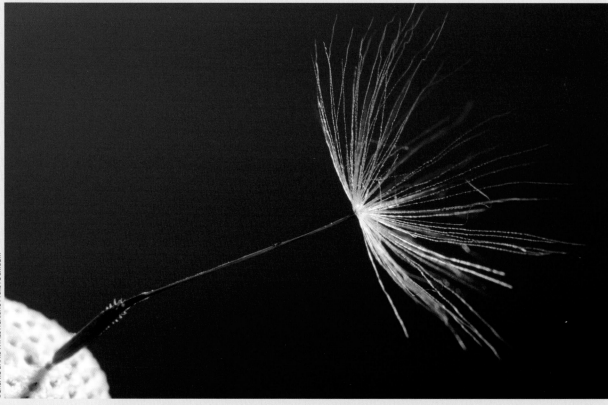

Sensibilities influence your emotional state of well-being, your attention level, and your receptivity. The better you understand how to integrate some of the subtler relationships of sensuality into your design, the more sense-ability it has because you are mimicking nature's play of color, light, and feeling that the human senses respond to. Subtlety plays a significant role in the success of design by engaging the senses deeply and inviting the viewer to receive and respond. This creates design with more longevity and reach. Art and design that survive over time do so by containing perennial aesthetics and accessibility. Anything that survives momentary trends is directly linked into natural and timeless relevance. To create this sort of longevity in your work, you need an appreciation of subtlety. To understand subtlety, you must slow the artificial pace of urgency in daily life (the smaller and faster technology becomes, the more demands it places on your attention, time, and energy) to nature's pace of unfolding what exists around you in its own time (**Figure 6.1**). The beauty of nature is its continuity, which persists with or without your involvement. If you accept nature as your mentor and partner, you will find it a world of truth to learn from. In this chapter, you'll enhance your awareness of how subtlety supports continuity between your design, color, and element—the sensibilities that underscore all relationships.

Color Your World

"Every light is a shade, compared to the higher lights, till you come to the sun; and every shade is a light, compared to the deeper shades, till you come to the night."
—John Ruskin, 1879

Color is a visual effect caused by the composition of the light emitted, transmitted, or reflected by physical objects. Through a complex interplay between the light receptors in your head (your eyes) and the sun's dazzling energy, you perceive the visible spectrum of the rainbow.

Although limited to seven distinct colors, human vision has the acuity to see a range of subtleties in the spectrum visible through the medium of light (**Figure 6.2**).

6.1 *The last dandelion seed clings precariously to the flower head awaiting the right breeze at the right time, to blow it into its next state of being (opposite).*

Light Creates Color

Sunlight is colorless or the white light of which all the colors of the spectrum are composed to make visible those colors the human eye can perceive. When you are looking at a backlit monitor, you are seeing the primary hues of RGB (red, green, blue) being transmitted through light. In daylight you are awash in color displaying variations of hue (the color itself), saturation (intensity), and value (lightness of tint or darkness of shade). Light creates color whether it is bouncing off an object (any physical object from a piece of fruit to a magazine page) or being transmitted through the medium of light (a rainbow or television screen). There are subset variations of seeing light: One of the ways you most commonly see color is through pigment—or a color changed by wavelength-selective absorption, such as freckled skin or the printed image.

In the identity rebrand for Autentika (**Figure 6.3**), a creative-interactive agency in Poland, highly saturated ink pigments combine with shape to create a play between dimension, color, shape, and order that gives the sense of emulating dynamic movement. Spreads from Autentika's identity manual (**Figure 6.4**) show

DID YOU KNOW? **Light illuminates the spectrum of colors that you see with your light-sensing organs, the eyes, which evolved from "eye spots," or light-sensitive cells that could detect movement but little else. "Eye spots" evolved into a camera-like eye structure that constricts to focus. The focus is further defined with depth and detail by a convex lens that is liquid-based and can contract and expand easily. It is the preferred eye structure for almost all higher animals because these factors balance light with movement.**

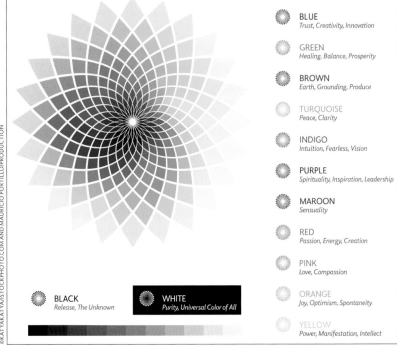

BLUE
Trust, Creativity, Innovation

GREEN
Healing, Balance, Prosperity

BROWN
Earth, Grounding, Produce

TURQUOISE
Peace, Clarity

INDIGO
Intuition, Fearless, Vision

PURPLE
Spirituality, Inspiration, Leadership

MAROON
Sensuality

RED
Passion, Energy, Creation

PINK
Love, Compassion

ORANGE
Joy, Optimism, Spontaneity

YELLOW
Power, Manifestation, Intellect

BLACK
Release, The Unknown

WHITE
Purity, Universal Color of All

©KATYAKATYA/ISTOCKPHOTO.COM AND MAURICIO PORTILLO/PRODUCTION

6.2 *A range of colors visible within the human color spectrum and some of their more universal human associations.*

the serious work that goes into creating an effective illusion of spontaneity. Spontaneity is a result of perfectly balanced structure. Balance provides the freedom to put energy toward something new. Rather than being used to continually align itself, balanced—or neutral—energy can expand into the next appropriately evolved version of itself.

Color can also be visualized in ways besides pigment: structurally (butterfly wings, soap bubbles, iridescent feathers), dyes and stains (bodily fluids such as squid ink or blood), chemically induced bioluminescence (fireflies, marine animals such as jellyfish), as suspended particles (silt in water that creates different hues), and transparency (found in deep water animals). Colors signal many different things in nature, including warning, receptivity for mating, mimicry, camouflage, and transparency (which mimics its source of clear light at ocean depths where color is less relevant).

Color Form

Structural color is a type of reflected color that changes in hue and intensity as light strikes multiple surface layers from different angles. The iridescent luminosity of butterfly wings, hummingbird feathers, abalone shell, and soap bubbles are all examples of this optical phenomenon. Butterfly wings are made up of structural scales that consist of fine ridges that diffract light to create metallic-looking colors, as the series of micrographs show in **Figure 6.5**. The mutation of light displaying as iridescent color is prevalent in tropical areas where vividly colorful wings and shells are in abundance. Because the tropics are inundated with brightly colored flora and fauna, a variation of bright color evolved to help mating partners find one another. Hence, microscopic levers that reflect multiple angles of shimmering light evolved to have an edge over saturated color alone.

DID YOU KNOW? **Black on yellow is the color combination the human eye registers first. It scores highest in memory retention and visibility for printed materials. This combination is associated with poisonous snakes, frogs, insects, as well as road signs that warn of danger to alert and relay a sense of urgency.**

Similar to iridescence in nature, metallic inks have bits of metal flake (or sometimes synthetic pigments that resemble metal) suspended within the liquid that reflect at multiple angles. Metallic inks are more opaque than regular inks and are significantly influenced by the surface they are printed on. Uncoated papers will readily absorb and minimize their shine by sucking up the particles, whereas a coated stock has less absorption so that the metallic particles can rise to the surface, catch the light, and reflect back as glints. Like a tint, they are most effective when used on a large coverage area. They don't hold up well as delicate line art, thin rules, or small type because they can't deliver the same impact of a large surface area.

6.3 *Identity and branding elements for Autentika use highly saturated color combined with shape that express playfulness, inventiveness, and intensity. Design: Jakub "Enzo" Rutkowski/Kommunikat.*

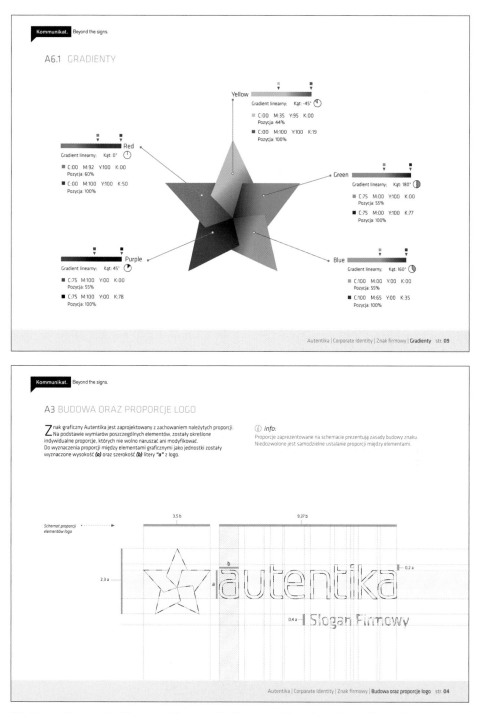

6.4 *Spreads from an identity manual for Autentika demonstrate brand consistency that captures a sense of being lighthearted and professional. Design: Jakub "Enzo" Rutkowski/Kommunikat.*

IMAGE: JAN GRASER, GERMANY

| Approx. x50 | Approx. x200 | Approx. x1000 | Approx. x5000 |

6.5 *SEM image of a Peacock butterfly wing. The increasing magnifications in this series of micrographs reveal the structure of wing scales (which are actually transparent) and the tiny ridges of which they are composed. This feature creates a structural color shift as the insect moves, which in turn changes the angle and reflection of light for an iridescent appearance. Transparency, movement, and light combine to create luminosity.*

The basic quality of color is light, and there are many ways to achieve variations in its appearance depending on how it is bent or what it reflects from. This refers back to angles as the fundamental structures in constructing three-dimensional space from the prior chapter. Structure refers not only to physicality, but also to the more elusive senses that help sort out a world of immense variety, including what you might consider to be the less interesting shades of gray.

The Noncolor Colors

Black, on the other hand, absorbs light and therefore color: When dusk falls, you become color blind and revert to grayscale images because minimal light changes all hues to shades of gray. Human males also have a propensity toward color blindness, with 1 in 12 males (as compared to 1 in 20 females) born with the condition; the most typical color blindness either confuses or is missing shades of red or green. This is the same color vision many animals have, which seems awfully dreary when you think of experiencing the world solely through shades of gray and a few blues and yellows. Your dog or cat sees the world like this, but before you start feeling too sorry for them, remember that they can see far better than you in darkness and also compensate with highly evolved other senses, such as smell or hearing. On the other end of the spectrum, some animals, such as butterflies and bees, see colors you cannot in the ultraviolet range that lead them to pollen—and pollinating. A beautiful system.

Color is varied and without doubt one of the more pleasurable senses. Like anything in nature, it works by certain rules that determine how it is received depending on the circumstance. For instance, whether you are perceiving color under natural or artificial light can make all the difference in its hue, value, or saturation.

DID YOU KNOW? **Considered a "living fossil" having survived several extinction events, the horseshoe crab is bled for its blue blood (because it lacks hemoglobin). It is the only known substance in the world that can be used to test for contaminants in any vaccine or drug. If contaminated, the blood clots instantly. The crabs are collected and bled, and are usually not harmed in the process.**

The Changing Ways of Color

Have you ever bought an article of clothing or selected paint or carpet for a room and found it was a totally different color than what you thought you had chosen? This is called *metamerism* and is most common with neutral or saturated shades. When colors become lighter in value or more intense in color, the spectral range they can be viewed in gets smaller. This means that what looked great under fluorescent lights might look awful in natural light, and vice versa. This is a phenomenon of reflected light and why RGB colors from your monitor can look completely different when printed as a CMYK image in ink on paper. Color is the most malleable of all design elements: It can morph or mutate from one light source to another. This is an instance when embedding a color profile into your graphic is useful, because cross-monitor viewing with different color profiles will influence what you see. Because of the immense color shift variation between RGB and CMYK, a color profile can help to keep some control over how a client views your design. In the world of virtual working relationships it can be a challenge to keep everyone on the same page where color is concerned.

The universal color palette is within the earth-tone hues, whether viewed under artificial or natural light. These are the basic and universal colors found in almost any environment.

COLOR REFERENCES ORDER

In design, color influences mood, emphasizes one thing over another, and creates illusions of space, depth, and movement. Warm colors advance, whereas cool colors recede. Shade defines, whereas tints or lighter colors soften. This is why mountains in the foreground are darker against the lighter receding mountains behind them. Layers of atmosphere tend to make distant objects fuzzy and obstruct aspects of their definition, including color. Color and light, therefore, create order without having any associated form: no symmetry, no size, and no curves or angles (unless you factor in their invisible angles of light hitting a surface).

Colors exist in the larger context of human vision. There are three primary aspects to the perception of color:

- **Sender:** The transmitter of color.

- **Receiver:** The receptor of color.

- **Medium:** Color as it exists (such as a pigment in CMYK inks or skin color, or any object if you are reading this as a printed book) or as light (such as the color of an image on your RGB monitor or if you are reading this as an ebook).

MARK BROOKS : GUEST DESIGNER STUDY

DESIGNER : GRAPHIK DESIGN

*Designer Mark Brooks (New York and Barcelona) uses nature as the basis for many of his projects. In the posters for Biopölitan (**Figure 6.6** is an example of these), subject matter and technique combine for an earthy feel. The King Pigeon Yoga posters (**Figure 6.7**) use color and shape combined in a subtle play of hue, saturation, and value. The dimensional effect applied to the shapes contributes to the mood and ordering of the designs' illusion. These posters were created for readings in "organic poetry," a genre of poetry that describes and praises nature in all of its manifest forms.*

Mark says of the KPY posters: "I was commissioned to design a set of posters to illustrate and promote a series of organic poetry readings at the KPY center in Brooklyn. Organic poetry has nature as its main source of inspiration, and so do many designers. Nature provides the most perfect and fascinating geometrical shapes, exquisite patterns, surrealistic perspectives, rich textures, and delicate colors we can imagine. All we do, all we are, and all we can conceive is based on what nature has created.

The KPY designs were intended as a graphic code derived of this concept. Elemental shapes such as circles and hexagons—even anamorphic forms—are the essence of many living forms and structures. These shapes alone can already have a strong organic presence at a graphic level. The way they interact and morph, along with their chromatic ranges, enhance such values and transport the viewer into a visual realm of calmness, nature, balance, and harmony. These elements are directly related to yoga and meditation, and were requested by the client to be represented in the designs.

Organic poetry is to literature what veganism is to gastronomy. This style of poetry describes earth, fire, water, wind, and the all consequences related to the four elements, and avoids references to manmade or artificial elements, as well as the complexity of human relations." ■

6.6 *Mark Brooks started the Biopölitan project in 2010 as a designer in support of nature. The project invites graphic artists to contribute a design piece for publication. The proceeds from the book will be donated to environmental associations. Biopölitan Limited Edition Poster #III. Art direction and design: Mark Brooks, Barcelona and NYC.*

6.7 *A poster series for "organic poetry" readings at a yoga studio in New York. Plays between color, shape, and the elements combine in an aesthetically stylized collateral system (opposite). Design: Mark Brooks Graphik Design.*

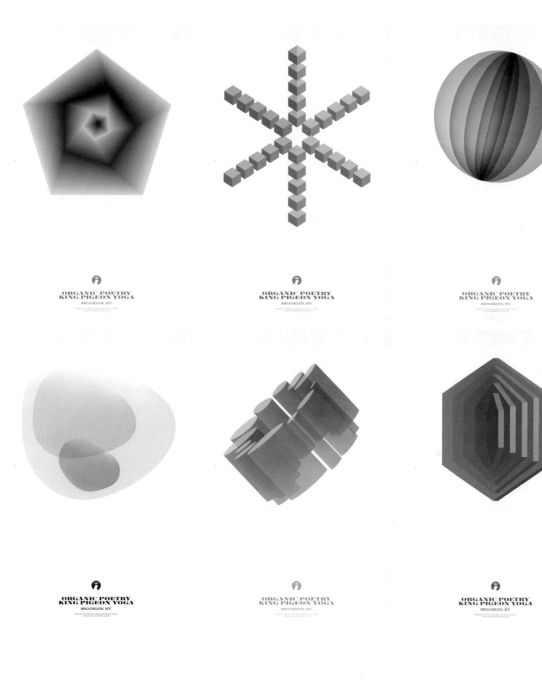

A Natural Palette

When humans began painting, they used "earth" pigments that were either readily available or could be obtained within a reasonable distance on foot. These colors might be considered drab in the flurry of candy-colored intensity today, but you still recognize a warm earthiness and consistency: Blacks were carbon sourced from burned wood, ivory, and bone; red or yellow ochres and umbers were ground from minerals (mining is believed to have originated with the need to procure color from iron ore and other minerals; the human urge for art has always been strong); and white came from ground calcite—all relatively common throughout the world (**Figure 6.8**). Earth pigments don't fade over time and aren't affected by climate changes like dyes from vegetable or animal sources; consequently, these basic colors are common in all prehistoric art. Integrated into your work, they create a timeless palette that relaxes and energizes the viewer, similar to the experience of being in nature. The earth-tone color palette in **Figure 6.9** is a start to creating your own color combinations. Experiment with what makes you feel connected and think about how it might be appropriately integrated to support your design's message.

David McCandless, a data analyst, information designer, and author, investigated color perceptions from different cultures. He asked questions like: What color is happiness in China? Or good luck in Africa? Or anger in Eastern Europe? Are any color meanings universal across cultures and continents? David was curious, so he researched, gathered data, and visualized the result in **Figure 6.10**. Although there are universal meanings for many colors, there are also distinctions between cultures because of custom and tradition. This infographic describes what he discovered while researching the similarities and differences between cultural meanings of color. David's book is *The Visual Miscellaneum: A Colorful Guide to the World's Most Consequential Trivia* (US version published by Harper Design, 2009), or *Information Is Beautiful* (UK version published by Collins, 2010). Of particular interest is that black represents mourning in the West, whereas white represents it in the East, and purple is flamboyant in either place.

In the following section, you'll learn more about the elements, how they impact every aspect of your life, and how to use them as a vehicle to deliver the subtler communications of your design in concert with color.

6.8 *Prehistoric graffiti as a personal statement of "hand to earth" from Patagonia, Argentina.*

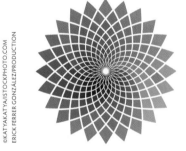

6.9 *An earth-tone color palette makes timeless connections into nature and references common sensibilities worldwide.*

6.10 *"Colours and Culture," an infographic by UK data analyst and information designer David McCandless & AlwaysWithHonor.com (opposite).*

Colours and Culture
The meanings of colours around the world

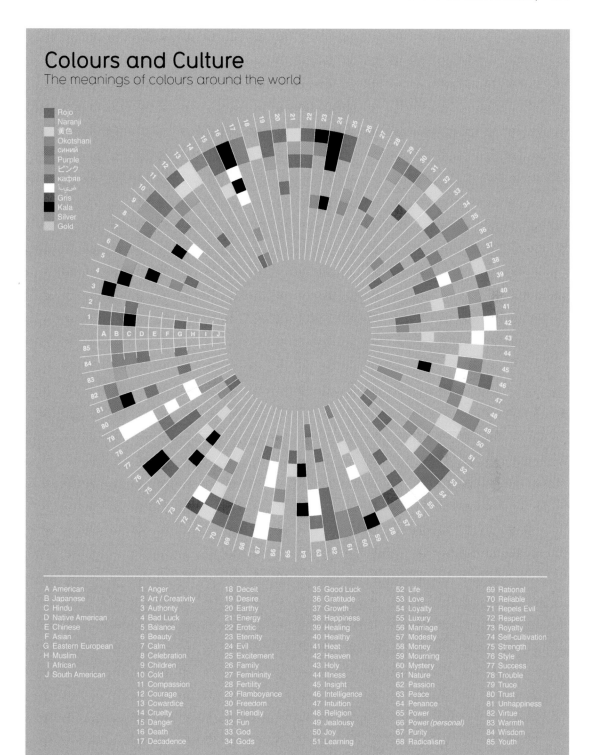

Rojo
Naranji
黄色
Okotshani
синий
Purple
ピンク
кафяв
ضيبأ
Gris
Kala
Silver
Gold

A American
B Japanese
C Hindu
D Native American
E Chinese
F Asian
G Eastern European
H Muslim
I African
J South American

1 Anger	18 Deceit	35 Good Luck	52 Life	69 Rational
2 Art / Creativity	19 Desire	36 Gratitude	53 Love	70 Reliable
3 Authority	20 Earthy	37 Growth	54 Loyalty	71 Repels Evil
4 Bad Luck	21 Energy	38 Happiness	55 Luxury	72 Respect
5 Balance	22 Erotic	39 Healing	56 Marriage	73 Royalty
6 Beauty	23 Eternity	40 Healthy	57 Modesty	74 Self-cultivation
7 Calm	24 Evil	41 Heat	58 Money	75 Strength
8 Celebration	25 Excitement	42 Heaven	59 Mourning	76 Style
9 Children	26 Family	43 Holy	60 Mystery	77 Success
10 Cold	27 Femininity	44 Illness	61 Nature	78 Trouble
11 Compassion	28 Fertility	45 Insight	62 Passion	79 Truce
12 Courage	29 Flamboyance	46 Intelligence	63 Peace	80 Trust
13 Cowardice	30 Freedom	47 Intuition	64 Penance	81 Unhappiness
14 Cruelty	31 Friendly	48 Religion	65 Power	82 Virtue
15 Danger	32 Fun	49 Jealousy	66 Power (personal)	83 Warmth
16 Death	33 God	50 Joy	67 Purity	84 Wisdom
17 Decadence	34 Gods	51 Learning	68 Radicalism	85 Youth

Using Nature's Elements in Design

Cristian Boian's image that opens this chapter is composed of various elements working in harmony to create a whole and integrated pattern. When simple elements interact, they enhance and amplify one another, and become the more complex relationships that you experience as pattern. This process is called *emergence* and is recognized in science as well as philosophy, the arts, and systems theory. The patterns that create and are created through emergent properties combine as a visual *gestalt* of relevance (more on gestalt in Chapter 7, "Structure: Building Beauty") in which the whole is greater than the sum of its parts. Elements understood as a whole are more meaningful than as several individual connections because they contain simultaneous relationships with varied opportunities for interpretation. They culminate as an encompassing relationship instead of several unrelated ones. Design doesn't have to suffer the visual clutter of additional information to have meaningful value. By making more relationships with less information, you leverage the most meaning with the least material. This is how nature conducts business.

In the exercises at the end of this chapter, you'll make connections between your physical senses and how they interpret your experiences, how your senses relate to the elements, and how understanding these relationships can facilitate richness and informational depth in your design. In Chapter 7, you'll look at an *element* as a tangible component of the design process. Your genius is in finding the subtle relationships that complement and expand upon one another to create more meaningfully expressed design.

DID YOU KNOW? True blue and purple pigments are rare in nature and are primarily derived from marine animals. Blues were originally derived from cornflower petals, one of the more available land sources, hence its first name "corn blue." In the latter 1800s, it was commercially manufactured from cyanide, which was discontinued after deaths occurred from the workers handling it. The name "cyan" (from its toxic source) was revived with color photography and is still used in commercial printing today.

Nature Shares Genius

"All children are born geniuses. 9,999 out of every 10,000 are swiftly, inadvertently, de-geniused by grown-ups."

—Buckminster Fuller

There are many levels of genius, but all humans are born with a substantial aptitude for problem solving. Experiencing the subtle nuances of relationship is a quality of genius because connections are where you find solutions—and sometimes in the most surprisingly obvious places. When Sherlock Holmes resolves a particularly perplexing case or Albert Einstein refined the theory of relativity into

the eloquent E=mc^2 formula, each reconciled a thousand loose ends into a single manageable conclusion. All ideas considered in the realm of genius are brilliant for this simple reason: They follow the trajectories of exponentially diverse information and weave it back into its point of origin. The most mundane, seemingly irrelevant, or the too complex is brought into alignment and returned—or at least clearly related to—its original, elemental, and understandable form. The meandering curve of the question mark is brought to finality with the succinct period point of an answer to complete a story of relationship. Even the word "genius" refers back to itself in the word's etymology of *inborn nature*. Nature shares genius by embedding it directly into your genes. Your genius and nature's is one and the same. The only difference is that humans have consciousness to feel and think the experience. Nature simply *is* the experience. When you understand the relationships between the most basic elements, you can evolve more complex relationships out of essential ones, just as nature does.

From Holmes to Einstein—and to you as designer—genius is in the genesis of the thought made relevant. I know what you're thinking: You're just designing an ad layout! But what you may not realize is that the process of design uses the same thinking a "genius" does by sorting, identifying, and relating meaningful patterns. This kind of thinking meanders its way through multiple possibilities to reveal the intersections of relationship. The geniuses of the world sense an overall pattern and find ways of connecting the obscure to the relevant through trial and error, and the medium of intuition. They come to astounding realizations using the very same processes you do. The primary difference between a genius and a "normal" person is persistence. *Where there's a will, there's a way* is an adage because it is the truth.

Your goal as a designer is to create an ambiance and mood immediately upon the viewer seeing your design without any linear thinking or explanation necessary. You do this by connecting into natural relationships everyone instinctively knows. Any visual statement can be finessed and well executed—humans are quite the clever species—but none of it matters in the long run if you don't get the fundamentals right to begin with. Shiny new things attract, but if they prove superficial and fleeting on closer inspection, their value disintegrates along with interest and retention.

Design is discovery for you and your viewer. The more you know about the basics and can encode them into your work, the stronger you'll be as a designer, the more fun you'll have designing, and the more response you'll get from your audience. The tables in the following sections will help you to cross-reference the five elements and their specific properties to integrate sensual qualities into your design. You can understand them best by noticing how you experience them firsthand.

The Classical Elements

The five classical elements—air, fire, water, earth, and ether—reflect the simplest essential properties and principles of all worldly matter and matters. They are the realms of universal energy. The classical elements are common to all life on the planet at all times (**Figure 6.11**). Weather, chemistry, the directions, math, mythology, and many other systems—*all* systems—are connected to the classical elements. Each of the elements is associated with specific traits and relationships that remain stable over time.

In **Figure 6.12**, a classical diagram of the relationships between the classical elements and their properties of wet, cold, hot, and dry is described as one square at a 45-degree angle within another square with its translations.

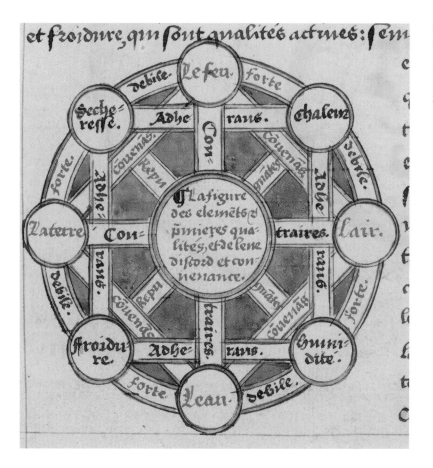

6.11 *An antique visual representation of how the classical elements relate to the worldly properties of hot, cold, dry, and wet.* La Sphere du Monde *by Oronce Fine (c. 1549). Image courtesy of Houghton Library, Harvard University. MS Typ 57.*

Tables **6.1** through **6.5** chart the relationships between the elements and their various properties and manifestations. The illustrations in **Figure 6.13** by Tommy Cash Sørenson illustrate each of the four worldly elements with a combination of typography, illustration, and graphic design. Ether, or quintessence, is an element of another (but pervasive) realm that is often disregarded when you think of the "earthly elements."

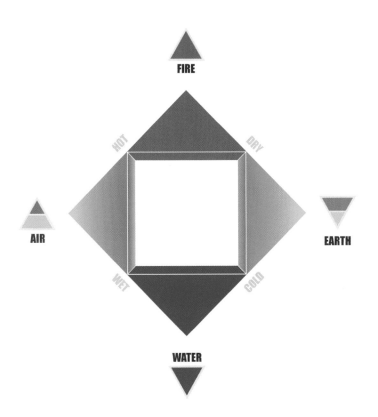

6.12 *The properties of hot, wet, cold, and dry in relation to the elements (with their associated alchemical symbols). Illustration: Mauricio Martínez, Mexico.*

6.13 *The worldy manifestations of the elements combined as illustration, design, and typography. Illustrator: Tommy Cash Sørenson, Norway.*

AIR

Air (Table 6.1) represents the mind and intelligence, communication, telepathy, inspiration, imagination, ideas, travel, knowledge, dreams, and wishes (**Figure 6.14**).

TABLE 6.1 **Air**

Gender	Masculine
Human element	Mental and mind
Physical humor	Blood
Attitude	Courageous, amorous
Temperament	Artisan (healing)
Creative process	Development and imagination
Consciousness	Intelligence
Action	To dare
Judgment	Scientific
Jungian	Thinking and thought
Viewpoint	Outward
Direction	East
Energy	Projective
Matter	Gas
Quality	Warm and moist
Symbols	Sky, wind, breezes, clouds, feathers, breath, vibrations, smoke, plants, herbs, trees, flowers
Elementals	Sylphs, zephyrs, fairies
Time	Dawn
Cycle of life	Infancy
Season	Spring
Colors	Yellow, white, ice blue, sky blue, violet
Sense	Smell
Stones	Topaz, pumice, rainbow stones, crystals, amethyst, alexandrite
Metals	Tin, copper
Vegetation	Clove, myrrh, pansy, primrose, vervain, dill, lavender
Trees	Acacia, almond, aspen, hazel, linden, maple, pine
Animals	Eagle, raven, spider
Chemical	Oxygen

6.14 *Realistically illustrated and rich with saturated color, this ad campaign by Ars Thanea/Poland engages your most fundamental senses in a way that is impossible to ignore. The "Air" ad for the Martini Asti series. Design Director: Peter Jaworowski.*

6.15 *The "Fire" ad for the Martini Asti ad campaign. Design Director: Peter Jaworowski, Ars Thanea/ Creative Agency.*

FIRE

Fire (Table 6.2) represents energy, inspiration, love, sexuality, passion, and leadership. Fire is the element of transformation. It is the most physical and spiritual of the elements (**Figure 6.15**).

TABLE 6.2 **Fire**

Gender	Masculine
Human element	Life force
Physical humor	Yellow bile
Attitude	Bad tempered, anger, intensity
Temperament	Idealist (protection)
Creative Process	Idea and intent
Consciousness	Will
Action	To know
Judgment	Faith
Jungian	Intuition
Viewpoint	Future
Direction	South (north for southern hemisphere)
Energy	Projective
Matter	Energy
Quality	Warm and dry
Symbols	Flame, lightning, volcano, rainbow, sun, stars, lava, heat
Elementals	Salamanders, firedrakes
Time	Noon
Cycle of life	Youth
Season	Summer
Colors	Red, gold, pink, crimson, orange, purple
Sense	Sight
Stones	Ruby, fire opal, volcanic lava, agate
Metals	Gold, brass, iron
Vegetation	Garlic, hibiscus, red bells, cinnamon, coffee, beans, seeds, chile peppers
Trees	Alder, ash, cashew, cedar, chestnut, fig, juniper, mahogany, oak, holly, rowan, walnut
Animals	Dragon, cat, lion, horse, snake, cricket, mantis, ladybug, bee, scorpion, phoenix, coyote, fox
Chemical	Nitrogen

WATER

Water (Table 6.3) represents emotions, fertility, absorption, subconscious, purification, movement, wisdom, fluidity, the soul, and the emotional aspects of love and femininity (**Figure 6.16**).

TABLE 6.3 **Water**

Gender	Feminine
Human element	Emotional body
Physical humor	Phlegm
Attitude	Calm, deep
Temperament	Rational (vision)
Creative process	Reception
Consciousness	Wisdom
Action	To know
Judgment	Opinion, subjective
Jungian	Feeling and emotion
Viewpoint	Inward
Direction	West
Energy	Receptive
Matter	Liquid
Quality	Cold and moist
Symbols	Ocean, river, shell, spring, lake, well, rain, fog, cup
Elementals	Undines, nymphs, mermaids, water babies
Time	Twilight, dusk
Cycle of life	Maturity
Season	Autumn
Colors	Blue, aqua, turquoise, green, gray, sea green
Sense	Taste
Stones	Aquamarine, amethyst, blue tourmaline, pearl, coral, blue topaz, fluorite
Metals	Mercury, silver, copper
Vegetation	Ferns, lotus, mosses, bushes, water lilies, gardenia
Trees	Apple, apricot, birch, cherry, elder, elm, rose, willow
Animals	Dragon, water snakes, dolphin, fish, cat, frog, turtle, swan, crab
Chemical	Hydrogen

6.16 *The "Water" ad for the Martini Asti ad campaign. Design Director: Peter Jaworowski, Ars Thanea/Creative Agency.*

6.17 *The "Earth" ad for the Martini Asti ad campaign. Design Director: Peter Jaworowski, Ars Thanea/Creative Agency.*

EARTH

Earth (Table 6.4) is the nurturing quality that is represented by strength, abundance, creativity, stability, prosperity, wealth, and femininity (**Figure 6.17**).

TABLE 6.4 **Earth**

Gender	Feminine
Human element	Physical body
Physical humor	Black bile
Attitude	Despondent, irritable
Temperament	Guardian (teaching)
Creative process	Form
Consciousness	Memory
Action	To keep silent
Judgment	Experience
Jungian	Senses and sensations
Viewpoint	Past
Direction	North (south for southern hemisphere)
Energy	Receptive
Matter	Energy
Quality	Cold and dry
Symbols	Rocks, fields, soil, salt, caves, clay
Elementals	Gnomes, dwarfs, trolls
Time	Midnight, night
Cycle of life	Age
Season	Winter/Spring
Colors	Black, green, brown, russet, citrine, tan, olive
Sense	Touch
Stones	Rock crystal, emerald, onyx, jasper, salt, azurite, amethyst, quartz
Metals	Iron, lead
Vegetation	Ivy, grains, oats, rice, patchouli, lichen
Animals	Cow, bull, dog, horse, ant, bear, wolf
Chemical	Carbon

ETHER

Ether (also called Spirit; Table 6.5) is the prime and essential element present in all things, providing space, connection, and balance for all other elements to exist. Ether is immaterial, unlike air, fire, water, and earth. It is essential to your sense of connectedness and well-being, and represents the sense of joy and union (**Figure 6.18**).

TABLE 6.5 **Ether**

Gender	Androgynous
Human element	Spiritual
Physical humor	—
Attitude	—
Temperament	—
Creative process	Flow
Consciousness	Enlightenment
Action	Exist
Judgment	—
Jungian	Archetype
Viewpoint	Universal
Direction	Universal
Energy	Universal
Matter	Singularity
Quality	Being
Symbols	The slender and subtle connection: cord or rope
Elementals	Angels or spiritual guides
Time	Now
Cycle of life	Eternity, transcendence
Season	The wheel of year
Colors	White, clear, black
Sense	Higher receptions, sound (vibration)
Stones	Diamond, quartz crystal, jet, black onyx
Metals	—
Vegetation	Mistletoe, hemlock, wolfbane, nightshades, fir, coltsfoot
Animals	Dove, mythical creatures, sphinx, unicorn
Chemical	—

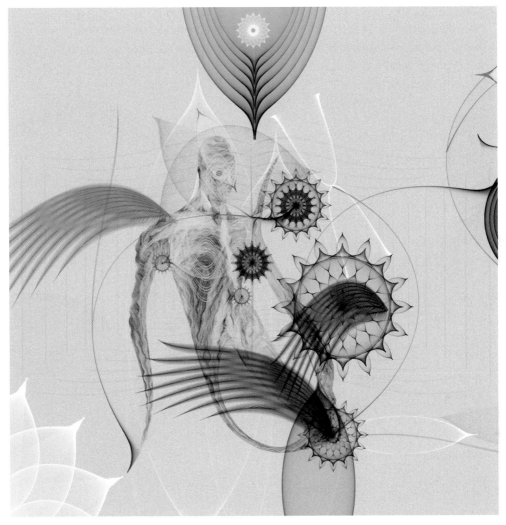

6.18 *The amalgamation of the properties of pattern, shape, and color combine to create a Photoshop illustration by Romanian digital artist Cristian Boian. Although abstracted images such as this are open to individual interpretation, there are basic elements of fluidity, diversity, unity, and separation that encompass the idea of "ether."*

Putting It into Practice

You experience life through the physical perception of sense and the inherent sense-abilities of nature. It is important to be aware of what you sense so that you are able to identify your feelings and thoughts, and their relationships to the external world. Being aware of how you personally experience the world—as well as how all people respond to its universal qualities and properties—brings depth and balance to your design by appropriately integrating nature's common sense-abilities. In the following exercises, you will experiment with color, sense, and element, and use your preferences to explore subtlety and sensuality in design.

CREATE A SENSE-ABILITY JOURNAL

Keeping a workbook, sourcebook, or illustrated journal is a habit that traditionally helps designers to design. This is a useful strategy to develop your personal senses by visualizing and organizing your thoughts and responses to the world around you in visual, written, and letterform contexts. It will help you to identify your personal inspiration and to develop your creative processing and conceptual senses while organizing your thoughts, perceptions, and aesthetics as design.

"I found I could say things with colors that I couldn't say in any other way—things that I had no words for."

—Georgia O'Keeffe

The object of this exercise is to experience the sensuality of subtlety and to create relationships in different ways between element, color, and how you aesthetically represent them in your personal design work. To demonstrate this exercise, I've provided several spreads from master calligrapher and designer Tim Girvin, owner of Girvin in Seattle, Washington. These pages are from Tim's journal *Integrations* (**Figure 6.19**) and reference his daily studies and experiences over a set period of time.

Keep in mind that Tim has been integrating word, visual, and sense for decades. It is in the practice of journaling that you become good at it. I'll provide some suggestions for you to start slowly and with support, so that you can integrate nature's sense-ability and won't feel as though you need to invent everything from scratch. If you want to jump in with your own creative process from the beginning, please do!

6.19 *Various spreads from* Integrations *showing illustration, lettering, writing, collage, and design. Designer: Tim Girvin, Seattle.*

PART I: SENSE-ABILITY JOURNAL/DESIGNED SENSES

Use a bound book specifically and only for this particular journal. A good choice for your book would be a spiral bound sketchbook, a moleskin journal, or even a book you create and bind yourself with a specially designed cover, similar to the *Integrations* cover in **Figure 6.20**. A stiff or hard-covered journal that is easy to carry is important to use as a makeshift writing and drawing surface.

Start your journal with this exercise or with other exercises in this chapter and continue it if you desire after you finish *Design by Nature*. Use it to note and explore your daily experiences. Part of subtlety is an appreciation for what you perceive as "mundane." If you look closely, you'll find the commonplace exists within your mind. Stretch it to see the extraordinary within the simple. Use your journal as a reference or use it as an event or timeline to observe your growth as an observant designer.

1. Take a walk in nature with your notebook, colored pencils, paints, pen and/or pencils (use the medium you prefer but bring along supplies that you can integrate color with). It's handy to use a backpack or other hands-free item for storage; this lets you easily collect found objects in nature and gives you a way to store them for later use.

2. Choose a sense you would like to explore—sight, touch, taste, hearing, or smell—and intentionally focus on just this one particular sense for each walk. Your thoughts or external events will tend to make your mind wander. Continually bring your focus back to your chosen sense. For example, if you've selected sound, naturally you'll be using sight, too. Other senses will come into play. Continue to come back to the primary sense you are working with. Listen beyond louder noises: If you're in a city park, listen to soft sounds close to you instead of the loud sounds that carry from a distance. Listen for the subtlety in natural sounds. Find alignments between sense and design. Silence is like white space. Reverse your normal tendency to hear (or sense) the overt. Find sound within silence. What does it sound like? Is it abstract or have a shape? Does it remind you of something from your childhood? Note what you become aware of.

3. Take a moment to stop and sit. Reviewing your notes while still paying attention to the selected sense, write about what you experienced and how it made you feel. You can use singular words, a poem, a haiku, or a few sentences. Stay present with the sense so you can capture it as accurately as possible.

4. Draw what you hear (or feel, see, taste, or smell). If you don't know what it looks like, draw what you imagine it to be. This can be abstract and colorful. Integrate it with your writing. Tim Girvin's work in *Integrations* shows several different ways of doing this. Remember to give character to your lettering as well!

6.20 *The cover of* Integrations, *a personal journal that integrates word, image, and object with feeling and sensual experience. Designer: Tim Girvin, Seattle.*

5. You can develop this particular sense after you have fully explored it in notes and drawings. Integrate any found objects from nature, ideas, or visualizations that come up later—clippings, photos, or anything else relevant to you—and create a "designed sense" collage. Pay attention to the organization of your page. Design an initial cap or experiment with hand-drawn lettering styles. Be conscious of what is most relevant to you and how you can order, position, or prioritize with color, shading, boldness, and subtlety. Remember that cool colors recede and warm colors advance, and that small relationships work together to create the whole relationship.

6. Experiment and find the best "sensual adjectives" to describe your sense. Try the same concept with several different approaches if you like. If you do this, review what doesn't change. What can you change and what will you absolutely not? Why?

After exploring each of the primary physical senses, try to find the time to take a walk to explore other sensibilities that range beyond the five physical senses. You can explore memories (what inspired them?), people or events that spontaneously come to mind (synchronicity, perhaps?), or how nature fits something together that your focus moves to (observe pattern and shape). Don't filter yourself; instead, concentrate on returning to the original intent each time you stray from it.

PART II: SENSE-ABILITY JOURNAL/SYNESTHESIA ENHANCEMENT

Synesthesia is a neurological state in which perceptual "bleeds" occur between the physical senses: A musical tone may have a flavor or color, or a number may have a particular sound. It doesn't interfere with daily life or the ability to think; in fact, many synesthetes find the sensation of crossing senses quite enjoyable. Everyone has slightly different ways of perceiving the physical world, and as a designer you help others engage their senses through your creations. This exercise explores sensory boundaries to expand your creativity. The idea is to have multiple ways to express something that explores all or most of the senses.

1. Can you imagine a number as a color? Does music have a flavor? Start this exercise by allowing yourself to sense in ways you haven't before. The more completely you involve all your senses, the more compelling your design can be.

2. Choose a line from a poem or song, or a sentence from a book you love, or write your own piece. You can also select words or thoughts from the prior exercise. Listen to music while working on this exercise and make your surroundings pleasing to you.

DID YOU KNOW? **For those who don't have synesthesia, it's very difficult to imagine what it's like. For those who do, they couldn't imagine living without it. There's a good short film by Terri Timely called Synesthesia on YouTube that provides a sense of the experience of a synesthete. Viewing it will help with this exercise by allowing you to imagine something you hadn't before.**

3. Using the text as inspiration, work with either Illustrator to create a vector illustration as in **Figure 6.21** or draw images, shapes, and colors that illustrate your image. This can be anything that "makes sense" to you.

4. When you've chosen what feels right to you, refer back to Tables 6.1 through 6.5 to see if there are elemental correspondences that are universal, or if your associations are unique to you.

I see the months of the year like a giant Rolodex, spiraling through open space. They all have colors, genders, ages, and personalities. I also benefit from having a somewhat photographic memory with directions, phone numbers, addresses, and names, because I see them as a pattern of colors. It all tastes blue to me.

—Teri Floyd, writer and synesthete

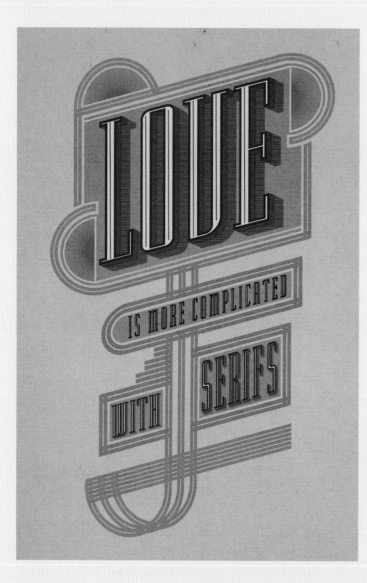

6.21 *A vectorized graphic describing the complications of love by student Mauricio Martínez/Santa Fe University of Art and Design.*

PART III: SENSE-ABILITY JOURNAL/GROW A SENSUAL GARDEN

In this part of the exercise, you will cultivate your sensual experiences as a visual narrative, as in **Figure 6.22**. Thanks to David Grey, Graphic Design Chair at Santa Fe University of Art and Design, for inspiring this exercise.

1. Choose one of the senses you have been working with. Take a few moments to reflect on this sense. What is it about its qualities that you respond to? List them.

2. Choose colors and the appropriate element to describe your chosen sense. You can refer to the color wheels and the elements tables (Tables 6.1 through 6.5) to choose from, or you can spontaneously create what feels right for you.

3. Integrate these pieces together into a poster or illustration, or as a series while it develops. You can also chart it as if it were a growing plant, from seed to bloom (refer to the Marian Bantjes illustration in Chapter 4 for an example). Remember that you are translating between a sense and the physical representation of it. Grow your design through the inherent aspects of the connective pieces.

6.22 *An illustration used for a calendar design based on earthly sensations and colors. Digital Artist: Cristian Boian, Romania.*

MOTION

THE EXPERIENCE ENHANCED

Brasil
2010 seis Estrelas

Tsevis

7

STRUCTURE

BUILDING BEAUTY

In nature, biological materials build themselves. Nature needs no support in assembling itself at the smallest scales. Molecules randomly bounce off one another while generating and being generated by the life force in a simple process of movement that constructs the world. Everything around you that appears solid and reliable is composed of particles jitterbugging at imperceptible scales. Although it's not a planned process, there are basic rules to this dance. Molecules must bind with weak bonds—or fast and temporary ones—so they can dissociate just as quickly and reassemble with other molecules. Continuous, self-acting motion is critical to nature's success of renewing itself spontaneously and continuously. Human design begins in a similar way.

ILLUSTRATOR: CHARIS TSEVIS, GREECE.

KEY CONCEPTS

- Structure and flow are inextricably related.
- Design has a basic structural vocabulary consisting of element, process, and method that is supported by principles.
- Gestalt is an approach to design comprised of five basic principles that support flow and structure.

LEARNING OBJECTIVES

- Incorporate structure and flow into graphic design messages.
- Identify and utilize design's structural vocabulary for consistent meaning.
- Integrate figure/ground, closure, continuance, similarity, and proximity into functional and aesthetic design.

A simple thought—the first step to design—works in the same way nature self-assembles through the movement of energy. Rather than moving things, you move ideas that evolve into the "things" of design. Thinking a design into being takes the integration of many elements and processes: Various physical components and procedures must be woven into the message for it to be effective. Proper sequencing and grouping between the parts must be visually described. *And* the entire structural process of design has to be supported with intelligence, creativity, inspiration, and a determined stick-to-itiveness to be appreciated as effortless and graceful. How your design holds together is based in your understanding, intention, skill, hard work, and letting go, complemented by a smidgen of luck—otherwise known as the synchronicity of connections that aren't understood at all.

This chapter looks at the structural aspects of elements as the nuts and bolts—or building blocks—of design. You'll learn how the parts are assembled and can be structured to flow as a continuous and integrated piece of designed communication.

Structural Flow

The structure of design is based on how the parts are related in the most intentional of ways. It's true that overly structured design can be stiff and unappealing, but no design works without some degree of structure. Being wildly creative and personally expressed doesn't guarantee anything more than personal satiation. This is art. Likewise, being completely structured doesn't guarantee anything more than a sound framework. This is engineering. True design arrives when inherent creativity and learned skills interact with pragmatic intent to visually organize beautifully designed information.

"People ignore design that ignores people."

—Frank Chimero

7.1 *"We Feel Fine" is an online database that gives a contemporary portrait of the world's emotional landscape on any given day. Human feelings have been collected from more than 12 million blogs describing everyday life in "all of its color, chaos and candor." www.wefeelfine.org (opposite). Creators: Jonathan Harris and Sep Kamvar.*

Flow was discussed as a fundamental principle of efficiency in Chapter 2 and is also critical in the practical realm of structure. Flow and structure may seem contradictory, but their cooperation is vital to fluidly move the eye through the message in graphic design, to design intuitively useful products, and to create a visceral space through which you instinctively navigate in environmental, architectural, or landscape design. It "naturally" leads the participant through information as a positive and fluid experience (**Figure 7.1**).

7.2 *An op-ed section design for the* New York Times *demonstrates structural flow between multiple complex elements to provide visual "wayfinding" to the reader. Designer: Mirko Ilic, NYC.*

Flow is a basic principle of nature's design because it is the underlying structure of workable three-dimensional space. In design it takes an immense amount of the viewer's energy to interpret information that is presented without the designer's attention to its organization. The design will be ignored completely if it's a redundant attempt at an overused technique.

There are, however, principles of flow that are consistent in their application regardless of technique. It is important to acquaint yourself with how these principles work. When you use the most appropriate structural flow for the presentation of information, you provide the service of usefulness to your audience in the same manner nature spontaneously orders its presentation for your interpretation and interaction. Energetic flow allows movement around physical structures in space or flows the eye through words and images across a page. The op-ed page for the *New York Times* in **Figure 7.2** demonstrates structural flow with typographical relationships, white space, and use of visual elements and sizing to distinguish sequencing order and importance with a relaxed and intuitive continuity. Expanding upon the rudimentary basics with the proper use of structural flow elevates it into a category of elegance. Effortlessly moving the eye through complex content is appealing because it emulates the dance of particulates that orchestrate the order of constructed life and builds the structure that creates flow. Different structures accomplish various organizational tasks by providing context according to need.

Structural Forms

In nature—and in the way you process information about the world—there are specific structural forms that perform functions of flow: In typical visual representations of flow, biological evolution displays as a hierarchical tree-like structure with the newest generational branch extending from the previous. Chemical elements are arranged in a periodic structure of columns or chains according to their similar properties (and as they link at the molecular level). Seasons are organized into cycles. Social networks are organized as webs. And ideas can be organized by importance, relevance, or frequency in mental maps or word clouds. Viewers assimilate order and relationship intuitively when they are guided through the content seamlessly via the use of the appropriate structural flow(s) (**Figure 7.3**).

Interpreting the relationships between various aspects of designed content gives preliminary clues as to the most appropriate flow to your design. Although the most basic of building blocks are discussed in this section, there is absolutely no reason the fundamentals can't be constructed brilliantly and creatively as

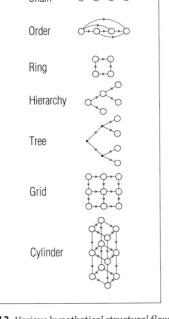

7.3 *Various hypothetical structural flows as modeled for psychological purposes. Illustration by Charles Kemp from Kemp C and Tenenbaum JB. (2008)* The Discovery of Structural Form. *PNAS 105:10687-10692. Copyright 2008, National Academy of Sciences, USA.*

Madness
Murmurs
Montage
Mobs
Metrics
Mounds

i feel so alone and this is just another time when i want to go hide where no one will ever find me

7 hours ago / from someone in henderson north carolina united states

Madness
Murmurs
Montage
Mobs
Metrics
Mounds

i love how i feel today

demonstrated in **Figure 7.4** by Jonathan Harris. Jonathan is a programming artist who combines elements of computer science, anthropology, visual art and story-telling to explore the relationships between humans and technology—and with one another. The images in Figure 7.4 are from the "We Feel Fine" Web site and its subsequent book, *We Feel Fine: An Almanac of Human Emotion* by Sep Kamvar and Jonathan Harris (Scribner, 2009).

DID YOU KNOW? **Fantasy is a dominant characteristic of creative flow because it generates more than one idea. When you are in the midst of the creative process, make a note of all your ideas, even the ones that don't appear important.**

Stand-alone illustrations, too, can be created out of structural form as demon-strated in the image used in the chapter opener by Charis Tsevis or in the illustra-tion in **Figure 7.5** for Levi Strauss. In both examples, simple relationships between size, shape, and linear sequencing have been enhanced with color and technique to compose an illusion of form. The eye is moved throughout the particles of information that coalesce as one continuous work, just as nature appears to your sense of perception.

Flow is in structure, and it is also in process. In fact, the fluid process of flow, known as a "flow state," provides much of the pleasure of the creative process.

The State of Flow

When you think of the more tangible aspects of creating functional design, you might interpret what appears solid and sound as strength. But structural sound-ness includes a fluid structure that works with and around restraints rather than against them in the same way a rushing stream finds its way around, over, and under rocks. Similar to "thinking outside the box," the box must be defined before you can move with, around, or beyond it. When you find a perfect bal-ance, you discover the openness to express design as a *flow state*. Flow state is also a description for a psychological state of focused motivation that perfectly balances energy expense with its replenishment.

Formal studies on flow were begun in the early 60s by Hungarian psychologist Mihály Csíkszentmihályi. But focused motivation has been practiced by many cultures, including within the Buddhist and Taoist paradoxical teachings of "action of inaction" or "doing without doing," and various types of Indian yoga practice. The "principle of least action" is also a term in physics. It's a simple concept with

7.4 *Examples of social networking struc-ture from* We Feel Fine *(www.wefeelfine. org), a social Web site programmed and designed by Jonathan Harris that measures the emotional temperature of the world through large-scale blog analysis. Blog sentences that contain the words "feel" or "feeling" are ordered according to the emotion expressed to give an in-depth, on-the-fly portrait of the world's emotional landscape on any given day (opposite).*

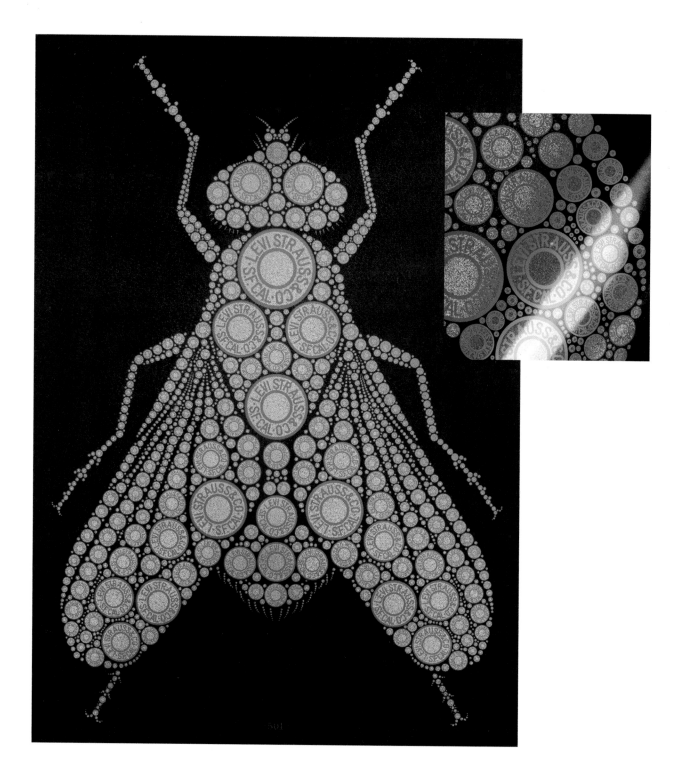

far-reaching consequences: Nature always and at every scale finds the most efficient course of action from one point to another. This occurs in the orbits of planets, the trajectory of a baseball, or a photon of light, and allows objects their own process of self-acting movement to follow the path of least resistance.

"At a meta level, design connects the dots between mere survival and humanism."
—Erik Adigard

Time dissolves when you are in a flow state; your energy is balanced and smoothly interacting with all that it encounters. You have a sense of complete focus but no sense of exertion. Effort becomes spontaneous expression—whether running a marathon or designing a logo—with maximized creative and productive results. Just as the word indicates, flow is a concurrence of diverse energies that cooperate in one smooth movement, culminating in an exceptional result. You operate as the conduit of the flow experience, not so much as the cause but as being in complete agreement with all of the circumstances surrounding the effort. This is the state everyone wants to achieve between hard work and carefree play, sexual love and enduring friendship, and material security and rich experience. Your ability to access flow allows a very personal development of individual physical, mental, and spiritual abilities that enhance every area of your life.

Aristotle said that the thing people want most in life is happiness. A life that can respond productively and cooperatively to the circumstances around it is a good life. And maybe the balance between individual gratification while serving a greater need is why design has always been the most prevalent human activity. There is a high level of satisfaction, personal growth, and contribution from the self outward that results from combining and balancing your inherent abilities with the tools and circumstances around you.

The principles in this book are principles that design a good life: balance, awareness, appreciation, and understanding. No one can tell you how to create beauty, but you can learn to recognize the principles and processes that help organize the elements of your design toward that end. When you are doing what you love, you create effortlessly, aesthetically, and productively. You are *flowing* in your own way, and it contributes to the flow of others.

For all of its continuity, flow requires structure. Structure requires pieces that when fit together create flow. These parts form the vocabulary of design syntax.

7.5 *The classic Levi 501 Button Fly. In this design for Levi's, an illustration emerges from the sequencing and sizing of shape and color as a housefly made of rivets, or a "button fly." Note the use of dirty color created with distressing to illustrate the blue collar (or blue jean) work ethic, further reinforcing the client's product (opposite). Design: Stefan Sagmeister Inc.*

THE BIOMIMICRY GROUP : GUEST DESIGNER STUDY

BIOMIMICRY DESIGN SPIRALS

The biomimicry process of consulting life's genius, described by the design spirals, can serve as a guide to help innovators use biological processes that look to the natural world for inspiration. The processes can then be evaluated to ensure that the final design mimics nature at all levels—form, process, and ecosystem. Innovators from all walks of life—engineers, managers, designers, architects, business leaders—can use biomimicry as a tool to create more sustainable, long-term-use designs.

The Biomimicry Design Spirals are tools for thinking about the basic steps that are important to biomimetic design. They can be used explicitly to guide the design process, or can be incorporated into existing design processes. The spirals should be used with the corresponding biomimicry methodologies, which include details on how best to accomplish each step in the spirals and questions to spark a deeper exploration of the biomimetic design process.

Spirals are used to emphasize the reiterative nature of the process—that is, after solving one challenge and then evaluating how well it meets life's principles, another challenge often arises, and the design process begins anew. There are two spirals: *Biology to Design* and *Challenge to Biology* (**Figure 7.6**). When working with the *Biology to Design* spiral, a designer or student would begin by observing the fascinating strategies and adaptations in nature and then consider how to apply that biological knowledge as a directive for a design project. When working with the *Challenge to Biology* spiral, a designer begins by identifying a design problem and then explores the natural world

for solutions to that challenge. In either case, designers use strategies that are related to natural principles and processes.

A biologist's methodology brings nature's wisdom not just to the physical design, but also to the manufacturing process, packaging, and all the way through to shipping, distribution, and take-back decisions. For instance, an innovator might design a wind turbine that mimics life's streamlining principles but then ask how will it be manufactured? Will the energy use and chemical processing mimic nature too? It can, with another cycle through the design method.

The following steps are used with the Biomimicry Spirals to help support the design process when emulating and integrating nature's process of design:

Identify. Develop a design brief of the need:

- Develop a design brief with specifics about the problem to be resolved.
- Break down the design brief to identify the core of the problems and the design specifications.
- Identify the function you want your design to accomplish: What do you want your design to do? (Not, what do you want to design?) Continue to ask why until you get to the bottom of the problem.

Define the specifics of the problem:

- *Target market:* Who is involved with the problem, and who will be involved with the solution?
- *Location:* Where is the problem; where will the solution be applied?

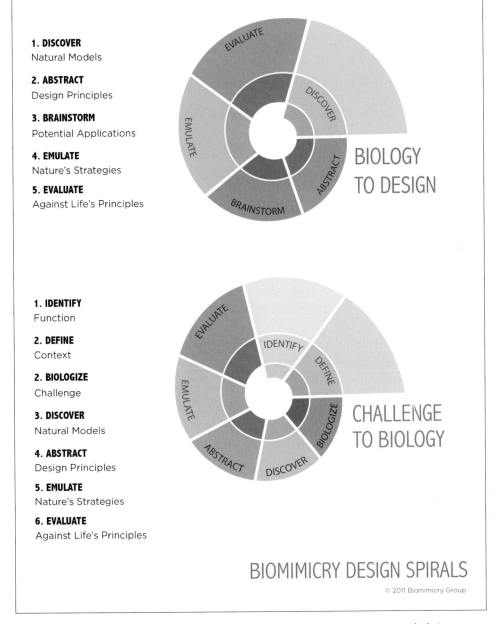

1. DISCOVER
Natural Models

2. ABSTRACT
Design Principles

3. BRAINSTORM
Potential Applications

4. EMULATE
Nature's Strategies

5. EVALUATE
Against Life's Principles

BIOLOGY TO DESIGN

1. IDENTIFY
Function

2. DEFINE
Context

2. BIOLOGIZE
Challenge

3. DISCOVER
Natural Models

4. ABSTRACT
Design Principles

5. EMULATE
Nature's Strategies

6. EVALUATE
Against Life's Principles

CHALLENGE TO BIOLOGY

BIOMIMICRY DESIGN SPIRALS

© 2011 Biomimicry Group

7.6 *The Biomimicry Design Spirals showing approaches to applying nature's solutions to specific design problems. Courtesy: The Biomimicry Institute.*

continues on next page...

...continued from previous page

Interpret. Biologize the question: Ask from nature's perspective for answers to your design brief:

- Translate the design function into functions carried out in nature. For instance, ask, "How does nature do this function? How does nature connect related things that are part of the same principles?" (Perhaps you can use a branching shape and an "order" structural flow for your design; refer back to Figure 7.3). "How does nature NOT do this function?"

- Reframe questions with additional keywords.

- Where will the design be used, and how might it be influenced by cultural perception: What is negative, what is positive?

- Define the term of the design's use. Are there any potential changes in the client's industry/profession the design could not stand up to on the horizon? Is the intended use ethical? Is it fair?

Discover. Look for the natural processes and users of those processes who answer/resolve your challenges:

- Find the best natural models to answer your questions.

- Consider literal and metaphorical solutions.

- Find the most successful adapters in nature by asking, "Whose survival depends on this?"

- Find organisms that are most challenged by the problem you are trying to solve but are unfazed by it (**Figure 7.7**).

- Look to the extremes of the habitat (or business environment).

- Turn the problem inside out and on its head.

- Open discussions with biologists and specialists in the field.

Abstract. Find the repeating patterns and processes within nature that achieve success:

- Create a taxonomy (the hierarchical system for classifying and identifying organisms) of strategies from life that accomplish successful similar designs.

- Select the champions with the most relevant strategies to your particular design challenge.

- Extract the repeating successes and principles that achieve success from your visualized taxonomy.

©LIPOWSKI/WWW.ISTOCKPHOTO.COM

7.7 *A Yemen chameleon that camouflages itself according to external directives.*

Emulate. Develop ideas and solutions based on natural models:

- Develop concepts and ideas that apply the lessons from your natural teachers.
- Look into applying these lessons as deeply as possible in your designs to mimic form, function, and the ecosystem:
 - Find out details of the morphology (the form and structure of organisms or processes that share characteristics with your design and their specific structural features) to mimic form.
 - Find out details of the biological process to mimic function and the ecosystem.
 - Understand scale effects.
 - Consider influencing factors on the effectiveness of the form and process for the organism.
 - Consider ways in which you might deepen the conversation to also mimic process and/or an ecosystem.

Evaluate. How do your ideas compare to life's principles, the successful principles of nature?

- Evaluate your design solution against life's principles.
- Develop appropriate questions from life's principles and continue to question your solution.
- Identify additional ways to improve your design and develop new questions to explore.

Questions may now be about the refinement or future of the concept:

- Packaging, manufacture, marketing, transport
- New products in the future—additions or refinements

Not all of these steps may be pertinent to your design, but this list does give you an idea of how nature works with small and detailed feedback loops, constantly learning, adapting, and evolving. You can also benefit from thinking like a biologist who looks to nature to understand it, evolving your designs in repeated steps of observation and development, unearthing new lessons, and applying these new lessons constantly throughout your own design exploration. ▪

Visit www.biomimicryinstitute.org to see more examples of nature's problem-solving strategies, and learn how they can be applied to create sustainable and healthier human technologies and designs.

Design's Structural Vocabulary

A common vocabulary is important to make concepts usable. Many terms in language have crossover meanings, and defining a structural design vocabulary is essential for meaningful consistency. The terms are relevant to all types of design: graphic (the making of messages), industrial (the making of products), or environmental (the making of spaces). The parts that construct the whole of the design are the elements; techniques and qualities give them their distinctive styles and personalities, which are created with processes and methods; and basic principles are used to support the meaning of the parts in relationship as a whole.

Before you move into how the parts of design are composed to work well, let's clarify what the structural terms mean.

7.8 *An enlargement of the illustration used in the chapter opener shows the elements of construction as shape and color. Illustrator: Charis Tsevis, Greece.*

Elements

Elements define design by describing it with the visual adjectives of line, shape, color, size, and typography. Even background components, such as texture, values (gradations or tints), and white space (emptiness) can be elements of your work. Elements are the *things* of your design—and, yes, nothing in this case would also be a "thing" (the phrase "form is emptiness; emptiness is form" is a Buddhist saying that represents the necessity of emptiness to contain form).

The form and color that make up the intricate elements (**Figure 7.8**) of the illustration that opens this chapter are based on the Brazilian flag (**Figure 7.9**). By constructing an image of the country's most popular sport using the relationships between elements—the symbol and colors of Brazil's national identity—Charis Tsevis embeds the soul of Brazil in an exuberant expression of pride.

7.9 *The Brazilian flag inspired Charis Tsevis's use of form and color in his illustration.*

RELATIONSHIPS BETWEEN ELEMENTS

The point of design is its usability value to the audience through its understanding (graphic), experience (environmental), or as a functional tool (product). It is important that the various elements of your design have relationships, or ways in which they correspond, expand, or simply support each other. Relationships that group similar concepts (visually or with text) serve as a wayfinding through the message in communication design. In the best-case scenario, designed information is presented in a way that engages the audience to expand the message into a personally meaningful relationship.

People are not designed to be spoon-fed a singular or redundant interpretation of information. They are designed to use their curiosity to interpret and understand the world around them so that they might expand upon what is already known and exist better within it. This applies to all things individuals interact with, of which design is an immense part. Relationships are more about complements between differences than they are "sameness."

Adding personality to your design elements so that there are still inherent distinctions between them is also important. This is where techniques and their qualities come in.

Technique and Quality

Technology refers to a particular way of applying human knowledge as a broad base of understanding in how to interact, do work, and problem solve in current culture. *Techniques* are introduced by technology to provide new or additional ways of carrying out a task and relate more specifically to function. Techniques can be created by drawing with charcoal, pencil, pen and ink, or painting with pastels or liquid media. In a software program such as Illustrator, the various brushes, line weights, and stylistic variations of gradation, layering, and other effects—the most basic of which are shown in **Figure 7.10**—imitate what you can achieve by hand.

7.10 *In this simple line graphic created in Illustrator, different line qualities are achieved by using brushstroke, line weight, and straightness or curves, all of which are techniques available in the program. Turn the book 90 degrees and note how vertical lines create a much different feel than horizontal lines. At a 45-degree angle, stagnant horizontal lines that contain and soothe transform into dynamic movement.*

Various techniques contain different *qualities* with which to create mood, movement, order, and other visual cues to form the foundation of the design's communication. Technology influences both aesthetic and design, and as a precept of human invention, it is limited to the range and depth programmed into the software. Even so, it is not necessarily a stagnant or mechanical process. As with all things, how you use human inventions determines the result of their actions. The ability to use technology to create visual complexities can have either good or ill effects. You've seen examples of layering run amok or other technological fumbles that are painfully overused or misused. Because layering is a function of graphics software, layering is often used as a software *technique* to achieve a designerly *quality*. The result's success is all in the mastery of how the elements are related, embellished, or stripped down to their essence.

Process and Method

Process and *method* are sometimes interchanged but have quite different meanings. Process refers to the way you go about performing procedures throughout the act of creating your design. For example, the typical design process follows the model of research, roughs, comprehensive designs, presentation, and final execution.

Methods are the ways in which you perform the task. The materials and/or software with which you create your work are the methods. They determine the types of qualities that are embedded into your design.

The traditional design process has basic steps that follow a standard sequence of a structured procedure.

STRATEGIZE STRUCTURE

Most designers begin their creative process with a design strategy consisting of steps to help give a structure to the design process. The following steps are based in traditional approaches that take some of the principles, methods, and processes you have learned in this book into consideration. But they are by no means absolute:

1. **Design scope.** Understand the parameters of the design. Define the boundaries of how the design will be used and for whom (broad audience for identity with multiple applications and long-term use versus targeted print brochure with limited shelf life, for example), and the purpose for which it is being created. Also, consider the practical aspects of time frame and budget.

2. **Investigate and research.** Explore the possible patterns, shapes, and other relevant visual information. Which have the most potential and why? Is one pattern clearly standing out, or are there others that might work? Narrow them down to what works best—in combination or alone. Be aware of structural and metaphorical relationships as you review this information. Begin to think about how they might be integrated to optimize meaning and relationship by working together.

3. **Conceptualize the design.** Integrate your thoughts as beginning thumbnail sketches to explore viable relationships between the most crucial pieces of information. What has good potential when you see it visualized? What should be tossed? Can your ideas be integrated as a seamless visual, or can you use structural flow to connect them? Visual metaphors are powerful ways to convey multiple meanings in a relationship, and flow can lead the eye through the design to cover a wider physical area of conceptual contexts that have diverse pieces.

4. **Rough it out.** Find viable relationships in your sketches that can be realized visually and create a variety of potential roughs.

5. **Test the design internally.** Develop your roughs further. Apply your own set of tests to confirm your design is ready for the next stage (refer back to #1 and #2). If the design satisfies your initial findings of scope and options, ask the opinion of someone whose design acuity you trust. This is the time to factor in feedback and tweak your design further with useful critiquing.

6. **Comp the design.** Once you've passed the internal testing stage, it's time to evolve your design into a comprehensive rough for presentation. The most relevant test before it is put into the world is always the person or persons in charge: the clients or a teacher. Not because those in charge are always right, but because they have the power to pass or kill it. If you know you have a winning design, you can back it up as to why it works: You know why you have chosen the shapes, patterns, and structural composition to match the message. Tell those in charge. If it's correctly constructed, they already know it works because it feels right. You can lead them to understanding the how and why it works to get their full buy-in when it is supported with reasoning. Humans are naturally curious creatures, and they want to know how things work. Your clients (or teacher) now have a story to back up their emotional connection. When you balance all parts of the design to make it beautiful and effective, you are rewarded with an exchange equal to your thoughtful and thorough conceptual development with a payback of positive energy: accolades, money, or a good grade.

7. **Present the design.** Show your design and guide the client or teacher through your reasoning of choices. Make changes as necessary from feedback or add your final refinements to prepare it for execution.

8. **Finalize the design.** Execute the design for production via Illustrator or whatever the relevant program is to complete it for use.

As a general rule, the standard process works fine. However, there are other ways to approach the process of design problem solving that are less linear. For example, the graphic developed by the Biomimicry Group in the sidebar "Biomimicry Design Spirals" is a biologist's approach to designing in partnership with nature.

Human evolution is at a juncture that requires thoughtful consideration of global factors that were previously less relevant, such as how visual communications are received in different cultures or how certain products or ideas can make significant impacts on the future, either in positive or negative ways. Therefore, you might want to integrate other approaches into your process that can more appropriately assess and address worldly concerns. A spiral is a perfect shape to acknowledge the layers of information that impact design and how that design in turn impacts the larger world. An approach that considers how these pieces of information continue to influence the future is a more comprehensive and sustainable model that will support design in its useful longevity.

Principles

Principles are the general underlying truths that are relevant in any culture and in any time. These are the fundamental laws, rules, or basic ethics that support change and growth in the natural world. In design, principles support the flow of elements and include balance, harmony, rhythm, proportion, unity, and order. The principles are discussed in depth in the next section, which explains good gestalt.

"Good design is obvious. Great design is transparent."

—Joe Sparano

1+1=3; The Gestalt Principles

In design, *gestalt* refers to the physical parts and their arrangements that compose meaning through relationship. The basic tenet of gestalt is "the whole is greater than the sum of its parts," or "1+1=3." Rather than registering each word, graphic, or relationship as a separate piece of information, the design is understood as a whole of interacting parts that harmonize, influence, and expand upon one other. There is no formal set of gestalt principles, but there are some generally identified rules that describe what are considered the basic principles that define "good design gestalt," or design organized through patterns. Because you do recognize patterns continually and unconsciously, how visual stimuli are organized is often ignored. Still, awareness of the principles is fundamental to the understanding of workable and beautiful design.

It is worthwhile to still your mind and concentrate on what you don't know that you know. Good design is created when awareness brings the subconscious to the forefront. When you consider all the information contained within your perceptional context, it is really quite complex: background, foreground, specific objects, relationships between those objects, the parts those objects are made up of, their colors and order—well, you get the idea. That we are able to make sense of any of this is really quite a feat. Most of it is far too detailed to register at the conscious level, but when involved in the process of intentional design, the principles must be taken into consideration and can be realized with a little effort. Your investment of effort to make the viewer's experience effortless is well worth the response to your design.

The word gestalt is derived of a German word meaning "shape, form, figure, configuration, or appearance" and is also tied to the more obsolete term stellen, which means "to place or arrange." Most simply put, gestalt is the arrangement of form in various patterns. Gestalt theory has traditionally been used by psychologists as a way to assemble an entire picture of a personality. But it has evolved into becoming relevant to anything that uses the context of basic principles to define highly detailed or complex relationships and how they are expressed as a "whole" composite.

There are minor variances to the basic principles of gestalt. In general, most people recognize the basic principles as figure/ground, closure (or completion), continuance, similarity, and proximity.

DID YOU KNOW? **Gestalt psychologist Wolfgang Metzger suggested that all objects we can perceive have a perceptual center that allows us to register them as an object. A central focus provides context to the relationships of an entity, making it a thing in its own right.**

Figure/Ground

More of an existential reality than a principle, the figure/ground relationship is the most elemental of gestalt principles (**a**). Just as you must have emptiness with which to define "thing," a figure must have a background to provide context. Distinction of form is evaluated and understood through the emptiness that surrounds it. The West, coinciding with its more literal approach to perception, typically considers the figure more important than the ground as a cultural perspective. There is much to be learned from the blank or empty spaces that surround a figure.

(**a**)

In other perspectives, as represented by the logo in **Figure 7.11** designed by Mirko Ilic for the Nadezde Petrovic Memorial in Serbia, the designer reverses the typical association and allows the ground to define the figure. This logo is expanded with other gestalt principles in a poster shown later in this section. White space lets you breathe between ideas, and empty space within a graphic can also perform double duty by providing additional tangible information as this design demonstrates and as is described more fully later in the chapter.

7.11 *Mirko Ilic transposes the typical representation of figure/ground. The figure defines ground rather than ground defining the figure in this logo for the Nadezde Petrovic Memorial.*

There are instances in design when both negative and positive space can be used toward a productive end: The most effective use is when figure and ground are represented as equal elements of meaning. This optimizes what you might consider empty—or negative—space to provide function, pushing it beyond passivity and into being an element of equalized importance with positive—or actively used—space. You can bundle an amazing amount of information in a visually simple way when you recognize empty space as having the same value as filled. This is particularly effective with logos that need to carry depth with simplicity.

Figure 7.12 shows one of my logos in which I used equal figure/ground meaning to collapse information. The logo was designed for Agricultura, a partnership of local farmers who focus on traditional agriculture and Hispanic crafts. A logo design should make the most of every potential opportunity by using every possible function it can, including those presented by the "non" parts. When you consider that a logo is responsible for carrying the entire message from the mission statement through the purpose of an entity, it makes the figure/ground principle particularly poignant and relevant.

7.12 *The logo I designed for Agricultura makes use of both figure and ground: The hand represents hand-grown, and the negative space in the palm represents a leaf. The hand's lifeline doubles as the leaf's stem, suggesting a longer life attributed to a healthy lifestyle and being conscious of the food we put into our bodies. The bottom graphic shows the logo with typographical and color applications.*

It is also quite useful to carry a complete figure/ground concept into illustration to make a statement with double impact, as shown by Israeli graphic designer Noma Bar in **Figure 7.13**.

7.13 *In this illustration by Noma Bar, negative and positive space become equal partners and maximize meaning by enhancing the viewer's relationship to the graphic. Illustrator: Noma Bar/Israel.*

Typography is an example of an element that requires a strong figure/ground relationship for legibility, with space simply being used as space, but this is not necessarily the case when type is used as an artistic form. As with any rule, it has its place, and in some circumstances is more effective when it is broken or reordered. It is particularly important to leverage consistent natural perceptions to provide context to experience. Written language is an example of a human construct that must be associated with intuitive relationships you recognize and understand for it to "make sense."

Figure/ground is also a primary principle of optical illusions that can rattle your perceptions by using visual tricks. In Lance Wyman's poster graphic for the 1968 Mexico Olympics (**Figure 7.14**), he used Op Art—a dominant style of the time— to play with your mind. The brain vacillates between figure and ground in a dance that is not dissimilar to molecules bouncing around in space.

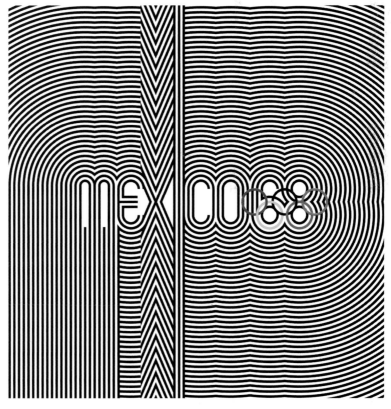

7.14 *Lance Wyman worked with illusion and principles of continuance, closure, proximity, and figure/ground to create complex effects that vibrate the brain through visual illusion in this design for the 1968 Mexico Olympics.*

Closure or Completion

You've unconsciously created closure (or completed incomplete pieces of information) of visuals throughout your life: When pieces are missing, you intuitively finish the information in your mind (this can apply to visual information, a story, or an inference of meaning). In the case of completing visual information, when part of the visual is missing, your eye automatically completes it, sending the whole visual to your brain (**b**). In the clever combination of visuals in **Figure 7.15**, Muamer Adilovic has used a car at multiple scales and rotations, along with the appropriate colors, to create a face out of unrelated graphics in a gestalt of completion.

(b)

The logo by Jeff Kimble in **Figure 7.16** was created in 1986 for a line of solar reflective glass. It still retains its power through the strong use of figure/ground relationships and by giving the viewer the satisfaction of finishing the visual in an example of closure.

Humans continually complete visuals, stories, and sentences, and simply can't help it. Completing information that is only partially available to your senses evolved from the survival instincts of your ancestors. If some small piece of evidence could be potentially dangerous, the first assumption was that it was. A sound, smell, tracks, scat, a glimpse of fur or fang—circumstances that could mean life or death—created the survival skills necessary to react instantly to potential danger. Being reactive and making assumptions are permanently encoded into your genetics, and are as much a part of who you are as breathing. You still do this today, not only as an artifact of a survival skill by completing visual information in graphics, but with basing actions on what you believe the "truth" to be. This extends into the principle of continuance, or potential outcomes based on making visual or logical assumptions.

Continuance

Continuance allows the eye to naturally flow with visual information that appears to belong together (**c**). Common direction is an important physical element of this principle. It also occurs in other ways: A story isn't finished, but your imagination flows into possible endings in your head. Or after a conversation with another person, you think you know what the other person was *really* thinking. The principle of continuation leads you into extending a picture to its logical conclusion. This is the human animal—be grateful for your intuitive nature. Your mind cannot help but make meaning because it is the pinnacle of human intelligence. The

(c)

ability to connect information and project potential outcomes has saved humans on more occasions than not in the primitive world. In the modern world, what you know and what you think flow into the inventions that create the structures that are called "reality." This is a principle of projecting common sense onto the information available so that you can weigh possibility with reality.

In design, continuance is visually represented with the same fluid conclusions set up by the visual. The poster for the Berliner Philharmoniker concert of *The Moldau* (**Figure 7.17**) literally represents the principle of continuance. It uses delicately balanced proportions of a simple color application, restrained and minimal use of line, and a perfect metaphor of ocean waves as the rhythm and flow of music.

7.15 *Expressing principles of figure/ground, proximity, and completion, this poster by Bosnian designer Muamer Adilovic uses several gestalt principles as one powerful message. The inferred outline of the various imagery creates a face and "completes" the design.*

ECLIPSE

7.16 *Allowing the viewer to complete the visual as shown in the Eclipse logo is a very effective use of closure. Not only are two pieces of visual information simultaneously suggested by the graphic, but the viewer gets the gratification of discovering each. This reinforces memory and a satisfying experience, which in turn reinforces the client. Designer: Jeff Kimble, USA.*

7.17 *Line and musical notes express continuity in this elegantly designed poster for the Berliner Philharmoniker. Design: Scholz & Friends, Berlin.*

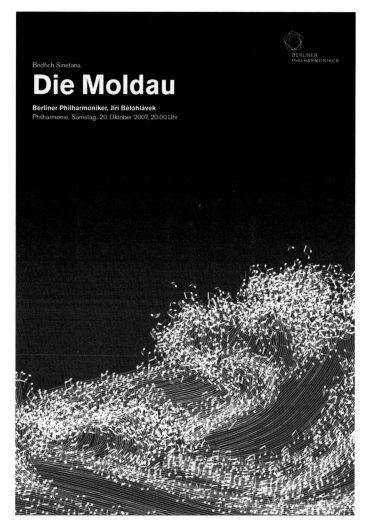

Similarity

Repetition tends to categorize information, allowing you to group by similarity (**d**). Similarity is the principle of objects sharing the same visual characteristics so that they are perceived as belonging together. This is manifested by consistent elements and/or angles of direction, or even with basic grouping throughout a composition to enhance its sense of harmony. It is often used to support the invisible underlying grid in Web or magazine layouts—and even in this book!

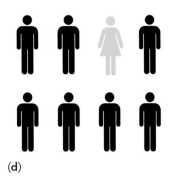

(**d**)

CONSTRUCTING EMOTION AS DIGITAL ART USING GESTALT PRINCIPLES

Created from the words to *Fearless*, a song by Pink Floyd (1971) and covered by Ambulance LTD, Robert Tucker shows elements of color, typography, and line in relationship in his Typography II poster (**Figure 7.18**). A Santa Fe University of Art and Design student, Robert gives the elements further depth by using a range of gestalt principles, including proximity, closure, continuance, and similarity. The typographical characters make up a vivid and dynamic image that is layered and distressed. This design prioritizes mood over cognitive information to become a piece of "designed art."

"I created this piece in Spring 2010 for Typography II at the Santa Fe University of Art and Design under David Grey. The assignment was to create an "experimental typography poster" using the lyrics from a song of our choosing. I chose *Fearless*, because of the simple but image-filled nature of the words. The design inspiration, however, came from the Ambulance LTD cover of the song.

The piece was initially built in Illustrator. Each word was hand-kerned, and then each letter was converted to outlines from which I cut away pieces of each letter to create varying rhythms to the piece. The background is composed of every letter from the first line of each stanza in a different color layered on top of one another.

I then took the piece into Photoshop where I applied texture and experimented with several different blend modes and transparencies until the layers looked right. The final piece was then printed on an inkjet laser poster printer at its final size of 20x30 inches."

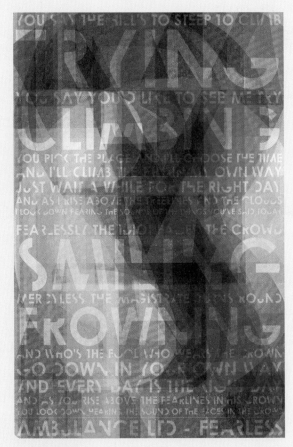

7.18 *"Fearless" by Santa Fe Art and Design student Robert Tucker, 2010.*

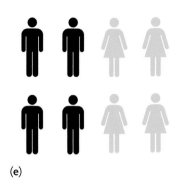

(e)

Proximity

The positioning of sets or groups gives context to their relationship (**e**). Space, therefore, becomes an element with which to determine how elements are related. Typically, you want to group similar concepts and separate disparate elements.

Subprinciples of proximity are juxtaposition, or how things are related through difference or contrast, and hierarchy, or the order established by proximity.

Designer Mirko Ilic brings order from chaos with the poster shown in **Figure 7.19**, which is based on the logo for Memorial Nadezde Petrovic. He extracts figure and ground from similarity, with a dash of continuance. This is also an excellent example of expanding the logo into designed collateral by using the gestalt of similarity to create a broader visual communication that is inextricably related to its source.

7.19 *Mirko Ilic extended his strong figure/ ground logo with the principles of similarity and proximity into this piece of poster collateral for the Nadezde Petrovic Memorial.*

8

SYMMETRY

A BALANCING ACT IN TWO OR MORE PARTS

Symmetry is the framework that underlies life's propensity of diversity and movement. These qualities must be continually balanced and ordered within the laws of time and space to work within the bounds of nature. Without symmetry, diversity and movement would succumb to inherent chaos. Movement would meander without purpose, and diversity would never settle into agreement. We're really quite organized considering the alternative!

Likewise, life cannot exist without movement propelling it onward or without diversity's genetically latent options that adjust to changing environmental circumstances. Organized complexity is a by-product of existence and is also an essential ingredient.

KEY CONCEPTS

- Translation symmetry is related to consistency through redundancy and distribution equality, and is the most simplistic of symmetries.

- Reflection symmetry shows relationships between opposites by displaying their similarities.

- Rotation symmetry is related to the balance and functionality of higher complexities.

- Tessellations bring complex and varying symmetries into agreement by creating seamless patterns from them.

- Asymmetry is related to the opportunity presented by unequal elements and the potential of future balance between them.

LEARNING OBJECTIVES

- Identify, analyze, and create designs containing translation, reflection, and rotation symmetries.

- Understand how you can use basic symmetries to support the visual message.

- Create a tessellation containing one or more of the three symmetries.

- Identify and implement asymmetry as a principle of choice and thoughtfulness rather than one of imbalance or inequality.

Designers who use symmetry—and its inverse, asymmetry—as visual principles in design establish a structure of relationship that the viewer intuitively uses to orient sequence, importance, or relationships. For instance, reflected opposites side by side display equality and balance; an image repeated in sequence conveys sameness over a broad area or expanse of time; and rotated repetitions show flexibility and accommodation in various orientations. These are concepts so basic we often don't think about their relevance, but we intuitively read them and understand many qualities about them from how they are positioned: First or bigger is often dominant; diminished visuals imply less importance or relevance. The principles of symmetry define the relationships between elements or concepts and set the stage for the message.

Symmetry is one of the more quantifiable principles of design. It can be measured and stepped or reflected into place, or rotated by degrees. Its language is mathematics. Many people are surprised to hear I am mathematically challenged because my first book was about the relationships between math, nature, and the intuitive communication of symbolism. Like many of us, I just wasn't engaged by math taught as an abstract concept. However, I've discovered that math is a beautifully simple language that happens to be linear, and it's used to describe complex relationships that are often anything but! The simple geometric forms everyone recognizes relate to deeply subliminal concepts that are intricate in detail and infinite in scope. We all have the same natural experience beneath the overlay of culture and language. Geometry—and the more ethereal application of sacred geometry—consist of universal codes used to describe relationships that words (and often cultures and religions) cannot.

Three Basic Symmetries

Symmetry has been used in art and design throughout history to create equilibrium and flow between disparate elements, just as it reconciles differences in nature. We not only experience symmetry as an order of nature, we embody *translation*, *reflection*, and *rotation* symmetries (**Figure 8.1**) in our physical selves. Generational characteristics are carried on in a line to generate new iterations of a species (translation symmetry). Our physical structure must have bilateral symmetry to support movement through space (reflection symmetry). And DNA rotates along the axis of our core makeup, making dance partners out of the actual traits we inherit and the potential traits contained within our latent genetics (rotation symmetry).

8.1 *Symmetrical structure underlies some of the most minute forms in nature, as these pollens show in rotation and reflection symmetries. Included are sunflower, morning glory, hollyhock, lily, primrose, and caster bean pollens (opposite). Credit: Louisa Howard and Charles Daghlian, Electron Microscope Facility, Dartmouth College.*

Organized information contains *value* by providing usefulness. Symmetry organizes and creates visual relationships that support a communication's message in ways meaningful to everyone regardless of who you are or where you come from. Translation, reflection, and rotation symmetry are all related, but each has a specific use as a tool to cue subtle relationships in the communication's message.

Translation Symmetry

In its simplest form, symmetry is a repeating pattern of equal elements with equal spacing in a line (**Figure 8.2**), such as a border that defines the edges of more complex patterns by holding them "in line" on a plane. This process "slides" the shape, or repeats the same figure at the same distance along a linear trajectory. Of all symmetries, translation is the most simplistic.

It correlates to our DNA: Red hair, crooked noses, big feet, and dark complexions are all genetic traits passed down the line generation after generation. This is translation symmetry in its most human form.

Translation symmetry is everywhere you look. Architects, for example, use translation symmetry to create three-dimensional support systems for their buildings through evenly spaced, weight-bearing columns or beams, as shown in **Figure 8.3**.

Translation symmetry expresses the continuity between present and future offspring, as well. Time changes between the previous and subsequent generations, but their form and function remain relatively the same. Scales on a fish or reptile (**Figure 8.4**) repeat in a tightly overlapped, replicated shape to allow for consistent flexing that gives maximum flexibility, particularly important to animals that rely on a legless body to get from place to place.

The PBS logo is a perfect example of using translation symmetry to effectively communicate some basic information about this icon of American media diversity. PBS focuses on multigenerational, multicultural educational programs delivered in an objective style, just as the repeating graphic suggests in its black-and-white linear progression (**Figure 8.5**). The network's demographics span age, gender, class, and race—a lot of territory. A simple principle can bring a lot of information into agreement in a single glance. In this case, the repetitive visual shows balance and equality in the types of programming PBS provides to its diverse audience. Good design mimics nature's patterns. It captures our interest by matching the visual message to processes in nature experienced by all the preceding generations.

8.2 *The basic order and structure of translation symmetry.*

TRANSLATION SYMMETRY DEFINED

Definition: Translation, or *slide*, symmetry moves a figure in a specific direction for a specific distance. It is based on the singular operation of repeat, or clone.

Purpose: This symmetry displays homogeny and practicality, and is useful in designs that convey equality, redundancy, or consistency within a group. In nature, it also describes generational lineage over time.

Example, Human: The PBS logo, structural column supports on a building, a stairway that provides an even progression between levels.

Example, Natural: Kernels of corn on a cob, successive waves upon a beach.

8.3 *Parc Güell in Barcelona was designed by the Spanish archi-tect Antoni Guadí and was built during the Art Nouveau period c. 1900–1914. The structural simplicity and practicality of the massive column supports are juxtaposed with flowing forms and artful mosaics common to this period. Photo: Maggie Macnab.*

8.4 *Scales on reptiles and fish, and feathers on birds, show transla-tion symmetry in a repeating pattern of consistent overlapping layers that protect the skin. In this image, fishes repeat the scale shape in a version of* self-similarity *(more on self-similarity in Chapter 9, "Messaging: A Meaningful Medium").*

8.5 *The PBS logo reinforces the media institute's mission to provide "content that values diversity and equality" to their audi-ence by using negative and positive space interlaced with the repeating principle of translation symmetry.*

8.6 *The U.S. Department of Health and Human Services logo adds a morphing effect to translation symmetry that presents a more dynamic message of common aspira-tions while implying equality.*

The U.S. Department of Health and Human Services also uses a form of transla-tion symmetry in its logo, which shows an eagle morphing into a human figure (**Figure 8.6**). This graphic evolution visually transforms a symbol of the American ideal into one of the general populace using a repeating pattern of *equal ele-ments with equal spacing in a line.*

Think about what is being represented in this particular image: Public-oriented governmental messages want to emphasize equality and status quo. The Ameri-can ideal metaphorically implies that individually we stand alone with equal rights, but as a group we become one, visually represented as being the "same" in our common ideals.

Using translation symmetry, as shown in the preceding examples, you can convey complex ideas in your design work with just a few simple yet powerful repeating elements.

To spot translation symmetry in design work, you really have to *look* for it. The effect is so subtle that it's perceived and often created on a subliminal level. In graphics, you'll often see translation symmetry used as borders because transla-tion symmetry's highly linear quality is not as engaging as more complex forms of symmetry, such as the rotation symmetry in a sand dollar or the reflection sym-metry in the MasterCard logo.

Western culture leans strongly toward individualism, so you won't find many examples of translation symmetry in the private sector. But if you *do* see translation symmetry used in a corporate logo, try to determine *why* it was used. What does the design represent at a symbolic level?

Reflection Symmetry

Reflection, or *mirror* symmetry—a more complex version of line symmetry—is a fundamental trait of all moving creatures (**Figure 8.7**). This level of symmetrical complexity introduces two-sided coordinated movement, bringing a higher order of line symmetry into play.

DID YOU KNOW? **Reflection symmetry is quite apparent in your hands, although over 90 percent of people are born with a right-handed tendency and a very few—1 percent or less—are ambidextrous or able to use both hands adroitly. The word's etymology comes from the Latin; dexter = "right," so an ambidextrous person actually has "two rights." Some of the most brilliant minds were born with this trait, including Leonardo da Vinci, Albert Einstein, Nikola Tesla, Maurits Escher, and Benjamin Franklin.**

In fact, life's journey begins with reflection symmetry. After fertilization, an egg splits in half and begins the process of billions of subsequent divisions, resulting in the mirrored symmetry of a bilateral body (**Figure 8.8**). Most animals' bodies are bilateral along a mirror line, meaning that each side of the body is essentially the same when the body is split down the middle. Whether flying, swimming, crawling, or walking, animals must have appendages of equal proportion on each side of their bodies to move in, on, or around the earth. Even animals without appendages can be split down the middle to show their inherent symmetry (**Figure 8.9**). Slithering requires it, too.

Figure 8.10 shows an ideal example of the principle of reflection symmetry. This logo design for Body Wisdom brings the name and visual together.

DID YOU KNOW? **Most of the capitalized letterforms in the English alphabet have reflection symmetry along either the vertical or horizontal axes. Can you find the letters that contain this symmetry? (Hint: All but nine are symmetrical.)**

<div align="center">

A B C D E F G H I J K L M N
O P Q R S T U V W X Y Z

</div>

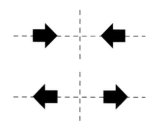

8.7 *In living things, reflection symmetry typically folds out from the center—a requirement for balanced moving about in the world—whereas a mirrored image in either direction can be used as an aesthetic design principle.*

REFLECTION SYMMETRY DEFINED

Definition: Reflection symmetry describes a figure that can be flipped over a line. If the figure appears unchanged, it has reflection symmetry—also called mirror, bilateral, or line symmetry. A line of symmetry divides a figure into two mirror-image halves and is based on the operations of duplication and mirroring. It is one order up in complexity from translation symmetry.

Purpose: This symmetry demonstrates the ultimate function of balancing movement. Two opposites in perfect balance create the ability to move forward without falling flat.

Example, Human: Body Wisdom logo, the cross symbol (**Figure 8.11**).

Example, Natural: Any mobile animal: butterflies, elephants, fish, and spiders.

8.8 *The human body has two similar sides: They are not exact replicas (have you ever tried mirroring a photo of your face—very odd!) but enough alike to facilitate effective movement on two legs. Image: Visual Language, www.visuallanguage.com.*

8.9 *Animals without legs contain internal symmetry that allows limbless locomotion by undulating their bodies, such as that exhibited in this snake skeleton.*

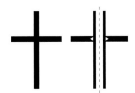

8.10 *The hands represent bodywork, and wisdom is implied with the stylized representation of an owl's face for the client, Body Wisdom. Design: Maggie Macnab.*

8.11 *The reflection symmetry of the Christian cross perfectly and precisely captures a dominant Western philosophy that is based in linear thinking, which is driven by the left hemisphere of the brain that moderates sequential tasks. For over 2,000 years, most Westerners have perceived the world through the either/or idea of opposites: heaven/hell, good/evil, right/wrong.*

JOHN LANGDON : GUEST DESIGNER STUDY

HOW TO CREATE A
HAND-LETTERED AMBIGRAM

(j)

I begin by writing the ambigram candidate word upside down.
Let's take the word ENERGY as an example (**a**). I then try to imagine
the Y as an E. Do they share any shapes or strokes? At first glance, no, they
don't. On the other hand, I can easily imagine an inverted cap G as a lower
case N. The ambigram designer must be open-minded to breaking any typo-
graphic convention, beginning with the structures. The willingness to mix cap
and lowercase forms is a fundamental requirement.

(**a**)

I've encountered the E/R combination dozens of times before, so I know that
the second E can easily become an R. When this pair is separated by other
letters, the vertical stem of the R usually has to be sacrificed. When they're
together in the middle of a word, as they are here, I keep that stroke, because it
will play the same role in both directions (**b**).

(**b**)

It is vital for the ambigram artist to understand the essences of the letters of
the alphabet. How much of a letter can be eliminated before the letter loses its
identity? (**c**) The vertical stem is a normal part of about half the letters in the
alphabet, so it is clearly not a distinguishing feature. Most of those letters are
fully recognizable without the stem, but if I can keep it, as I can in this case, it
simply makes the word a bit more familiar looking.

(**c**)

Weight variation has been an important aspect of letter design through the
millennia since broad-nibbed pens have been in use. Those variations aid
legibility significantly and can be extremely helpful in the readability of an
ambigram—as long as the traditional weight placements cooperate. Vertical
strokes tend to be heavy, whereas horizontals are lighter. But a traditional capi-
tal N features two light verticals, and a Z may have two heavy horizontals. The
heavy diagonal of an S may not work very well if you want that same shape
to function as an A, for instance, facing the other way. Those factors will often
determine whether an ambigram will be of varying weights or a monoweight
style. As a compromise, moderate weight variation frequently proves to be the
best approach.

It appears that traditional weight placement will not cause any difficul-
ties in the word ENERGY (**d**). I'll try a couple of versions with subtle weight

(**d**)

(e, f)

variation (**e, f**). But it's soon evident that a very thin stroke at the top of the second E helps the R to retain its recognizability. Yes, it's an extra stroke, vital in defining the top of the second E, but being very light, it's fairly innocuous at the bottom of the R. One principle of the way we read words is of paramount importance in ambigram design: Because we read from the top of the page down (and perhaps because we recognize people and predators from the top down), the tops of letters are much more important in identifying (and thus reading) letters than the bottoms. That means I can manipulate the bottom of a letter much more freely than the top, and that's greatly beneficial, because the bottoms of the letters facing one way are the tops of the letters facing the other way—one more reason that the extra stroke at the base of the R will not pose a problem.

THE LESS-COOPERATIVE LETTERS

Although other solutions are falling into place nicely, the E/Y is the problem. The best way to deal with a seemingly intractable problem when creating an ambigram (and in graphic design in general, I think) is to brutally force it to do what you want. By forcing a shape where an E has some Y characteristics (refer back to the second sketch) and vice versa, I can then see the beginnings of a more satisfactory solution. The two Es will not match, but because one of them is the initial letter, I can take some liberties supported by the long history cap and lowercase differences. The bottom of that initial E will have to be lopped off—as gently and tastefully as possible of course—trusting that the reader will have grasped the E-ness from the top of the letter and moved on to more familiar forms before realizing that the bottom is, in fact, missing.

(g)

My sketches convince me that the initial E will read, but I still want to make that radical surgery as subtle as I can. The weight experiments reveal that not only will a fairly extreme weight variation serve the beauty of the word very well, but that the extension of a serif on the inside of the upper-left arm of the Y, and a bit of a flourish at the end of the right arm, will provide a slight visual closing of the unnatural gap at the bottom of the E. The contrasting heavy strokes will end rather abruptly, creating the quick impression of the open space we expect at the top of the Y (**g**).

(h)

The following are process developments showing the pencil sketch progress (**h**) and a detail of the vector artwork (**i**).

The final vectorized artwork for Energy (**j**). ∎

(i)

Rotation Symmetry

Rotation symmetry contains a center point around which an image is rotated in equal degrees without distortion or change (**Figure 8.12**). This is called *point symmetry*. By dividing the number of rotations into a circle equally (any equal portion of 360 degrees), you can create two-, three-, four-, or higher point rotation symmetries.

For example, the John Mayer ambigram shown in **Figure 8.13** displays two-point rotation symmetry, or two equal elements turned 180 degrees. Designer John Langdon is a master at using rotation symmetry to create ambigrams. You've probably seen his work in Dan Brown's best sellers *Angels and Demons* and *The Da Vinci Code*. The brilliance of John's work is his ability to integrate diverse forms that not only translate visually when rotated, but also *read* in both directions. This very pleasing interplay is caused by toggling your brain and eye between word and image. (For step-by-step instructions on how Langdon creates his ambigrams, see the "Guest Designer Study" sidebar in this chapter.)

The Mercedes-Benz logo has a three-point or 120-degree symmetry (**Figure 8.14**), and the Heart Hospital of New Mexico uses four-point symmetry or a 90-degree rotation of four equal elements (**Figure 8.15**). The higher the number of rotations, the simpler the element should be for the cleanest execution. More information creates more complexity; therefore, to balance this inherent relationship, keep the single image as concise as possible so the eye can read it in multiple iterations.

8.12 *This example of rotation symmetry is based on threefold symmetry, or rotated 120 degrees each turn.*

8.13 *John Langdon beautifully captured the grace of music in this ambigram for John Mayer with a 180-degree rotation, or twofold symmetrical design. Design: John Langdon.*

ROTATION SYMMETRY DEFINED

Definition: A figure that rotates around a center point by fewer than 360 degrees without changing has rotation symmetry. The point around which the figure rotates is the *center of rotation*, and the turning angle is called the *angle of rotation*. Rotation symmetry has *point symmetry* or *origin symmetry* because the circle originates from its center point outward. The number of times it rotates around the center point determines whether it has twofold, threefold, fourfold (or more) symmetry. Rotation symmetries higher than sixfold are visually complex, thereby usually ruling them out for communication purposes (but with skill, this can be done).

Purpose: This symmetry brings a higher order of complexity to symmetry because it is based on the 360 degrees of

the circle rather than the linear aspects of translation symmetry or the bilateral aspects of mirror symmetry. It is effective in describing relationships that contain higher orders of complexity, revolutionary technologies or new systems, and less "tangible" relationships, such as those considered more mystical or universal.

Example, Human: Sun Microsystems logo, yin yang symbol (**Figure 8.16**).

Example, Natural: Most plants extend their branches in a rotational array around the center point of a stem to receive the most advantage from sunlight and moisture.

8.14 *The Mercedes-Benz logo rotates on threefold symmetry at 120 degrees each turn and was originally designed to capture three modes of transportation on air, land, and sea. The Mercedes-Benz logo is ©Mercedes-Benz.*

8.15 *I used fourfold symmetry for the Heart Hospital of New Mexico logo. The Zia sun symbol drove this choice, but a four-sided object also expresses stability intuitively and the outward direction implies radiating health, associations a cardiology hospital would want to convey. Design: Maggie Macnab.*

8.16 *In a starkly different approach to Western culture (see Figure 8.11), Eastern philosophy approaches life as a both/and paradox, embodied by the rotational yin yang symbol. Opposites are seen as intrinsic parts of the whole, or essential and equal experiences. Integration achieves balance and is related to multitasking performed in the right hemisphere of the brain.*

Tessellations

Translation, reflection, and rotation symmetry can be used alone or in combination to create *tessellations,* or repeating tiled patterns, that fill a surface by fitting together without gaps or overlaps. Tessellations are useful as backgrounds or other elements of design support and can range from being quite simplistic to highly complex. Tessellations integrate a concept at a much grander scale, and by using your own ingenuity combined with number-crunching software, you can create infinitely beautiful and complex designs. Weaving a component of the core design into the message is an excellent way to reinforce the client's brand and image (**Figure 8.17**).

Scientists and artists strive to uncover the same truths. In the early 1980s, scientists created an alloy that was neither glass nor crystal but contained a new fivefold, nonperiodic (meaning the repetitions are at irregular intervals) symmetry somewhere in between these two structures. It was named *quasicrystal* because its configuration was presumed too unstable to be possible (**Figure 8.18**).

Since then, hundreds of quasicrystals have been discovered in nature, primarily in mineral composites. Regular crystal formations are created out of molecules that fit perfectly with one another and don't have gaps or overlaps. The only shapes that can do this on the 2D surface of a plane are triangles, squares, and hexagons. A quasicrystal has five-sided molecules, and although it will never produce an exact match of itself when replicated side by side on a plane (called a Penrose tile in 2D space), it *does* when wrapped around a 3D object—in the same way hexagons combine with pentagons to form the spherical shape of a volleyball.

Art and science often intersect: At least five centuries before quasicrystals were manufactured in a lab, Islamic artists were creating incredibly intricate tiled tessellating forms, called *girih,* that follow the symmetry of quasicrystals (**Figure 8.19**). **Figure 8.20** shows the underlying structure of this tesselating pattern that includes an octagon, an 8-pointed and 16-pointed star polygon, and seven non-regular tiles.

The process of mathematical precision combined with creatively inspired design was made most famous by M.C. Escher (1898–1972), an artistic master who combined the beauty of form with the structure of mathematics (**Figure 8.21**). His extensive studies of the Moorish tessellated designs in the Alhambra inspired his elegant and highly complex artwork.

DID YOU KNOW? **www.tilingsearch.org allows you to search a comprehensive database of high-quality geometric tiling patterns and locate images by their geometric properties.**

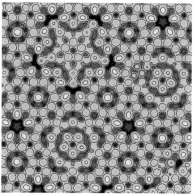

8.17 *Russian designer Igor Duibanov's logo for Amor-e-Moda has been reworked as a background pattern in a subtle and compelling way. Igor strengthened and supported his client's message by altering the logo and integrating it as a tessellating background with two contrast variations, which are implemented depending on the other colors and elements they will be used with. He also created a secondary identity image by using the triangular shape of the logo as an opportunity to create a star, implying best, special, and extraordinary. ©2010 Igor Duibanov, Russia.*

8.18 *Micrograph of lab-grown quasicrystal symmetry created with depositing silver on a fivefold symmetrical silver-copper-iron quasicrystalline surface. Credit: U.S. Dept. of Energy's Ames Laboratory.*

8.19 *A tessellating* girih *design from the Alhambra in Granada, Spain.*

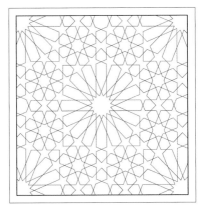

8.20 *Underlying* girih *grid to a related tessellation pattern. Credit: Brian Wichmann, UK.*

8.21 *M.C. Escher's sketch for tessellating seahorses—showing a similar symmetry to John Langdon's ambigrams—as multiple rotating images that fit seamlessly over a plane. Image: M.C. Escher's "Symmetry Drawing E11" © 2011 The M.C. Escher Company-Holland. All rights reserved. www.mcescher.com.*

Asymmetry

Symmetry is based in mathematical laws that govern nature. Our intuitive recognition of symmetry carries over to compositional design in all cultural artwork, whether magical, religious, or decorative. Almost all living things, from plants to animals, display some form of symmetry.

But there are always exceptions to the rule. In animals, one of the few nonsymmetric creatures is the sponge (**Figure 8.22**). It is one of the most primitive of all animals with a simple perforated structure that uses water to pump oxygen and nutrients in and waste out. There is no discernible symmetry in this creature—it is *asymmetric*. Asymmetry is key to the formation of life because anomalies create a tension that encourages evolving toward balance.

When something is asymmetric, it lacks balance or evenness. This can be an indication of something undesirable, such as a defect, but it can also be used as an effective way to bring attention to something, or even to release an expectation of how something should be. More common in fine art than commercial communications, asymmetry is useful as an underlying principle for messages that are left unanswered, that agitate, or that remain open to the viewer's interpretation. Imagine a bonsai tree. It is a meditation just to look at one. It is asymmetric and yet pleasing, even without visual balance. Rather than containing and directing a visual pattern of the eye, it suggests where the eye might wander. By its nature of not embodying symmetric form, the bonsai tree presents itself as receptive to outside interpretation, and this presentation relaxes the viewer to respond in whatever way is spontaneous.

Most corporate communications don't typically use asymmetry as a principle in their messaging because the point of advertising is to lead the customer toward an end purchase as directly (and cost-effectively) as possible. Still, asymmetry is useful for communications that invite the viewer to actively participate in an individual way (**Figure 8.23**).

DID YOU KNOW? **Asymmetry is sometimes used as an intentional reminder of our human shortcomings. In Native American beadwork, a spirit bead is stitched into the design (a different-colored bead within a field of same-colored beads) to open the pattern for the Great Spirit to enter. Wabi-sabi, of Japanese origin, is an aesthetic appreciation of the universal tendency to become or decay, with all of the inconsistencies and unknowns inherent to either process. All things, in all stages of their life cycle, are regarded as beautiful. (See more on wabi-sabi in Chapter 1, "Aesthetics: Enjoy the Ride.")**

DID YOU KNOW? **There are asymmetries embedded in our physical structure. We have a dominant hand and eye, and our heart and liver are positioned asymmetrically from the body's center. Both the heart and liver are asymmetrically shaped as well.**

8.22 *A meeting point for several sponge species, leather corals, and inkspot ascidian. Komodo National Park, Indonesia.*

8.23 *A Bonsai tree is intentionally sculpted by hand to look natural.*

Putting It into Practice

Begin this section by noticing and/or collecting images and objects that contain symmetry. It is not necessary to identify the symmetries yet; just look for arrangements that you intuitively know contain symmetrical relationships—for instance, a leaf, apple, logo, typographic character, book, and so on. Just hold the idea of symmetry in your mind as you look for examples in nature and human-made design. Sort the objects you find according to their symmetrical similarities.

Remember that some things contain more than one type of symmetry: Your footprints are opposites of one other and as such have reflection symmetry. Start walking and you've added *glide* symmetry to the mix. Your footprints are still reflected images of one another, but they are now staggered. It's amazing how much there is to think about with simple concepts.

Note asymmetrical items as well (a pair of scissors, a rock, a stream, a poster designed with this principle). What purpose does the asymmetry serve; what is it a result of? (For example, scissors are typically oriented for right-handedness; the functionality of their form is directly related to accommodating a natural preference.) Thoughtfully done, asymmetric design is useful to engage the viewers in a question and to elicit their personal interpretation or preference.

Although you can replicate any of the following exercises with software (additional exercises are also available on the book's Web site at www.designbynaturebook.com), it is recommended that you do at least a few of the exercises by hand, essentially replicating various symmetries on paper. This creates muscle memory, a form of physical memory that integrates a deeper understanding of the principles by engaging the mind with the physical body.

CREATING THE THREE BASIC SYMMETRIES

Creating symmetry isn't difficult to learn, even though symmetries can evolve into complex configurations. We'll start with the most basic of how-tos, and as you become more comfortable creating them, you can expand your skills by challenging yourself. For example, take a favorite design you've already created—one that you know is exceptional—and look at it carefully. Try to identify any symmetry it may contain and what symmetries might complement it, just by looking at it. If it is a truly good design, it contains intuitive bits of information that give clues to what it is representing, from the obvious and tangible graphical information to the subtler aspects of position, proximity, and symmetry. You'll be surprised by how much you already instinctively know.

TRANSLATION SYMMETRY

Hand-drawn translation symmetry is more organic in appearance and is useful for designs that demonstrate consistency but have variations on a common trait. This is an excellent way to visually convey an overall consistency with individual attention to detail.

Adobe Illustrator does not have a step-and-repeat function, but you can create translation symmetry relatively quickly in the Transform dialog box. Translated symmetry becomes a tessellation when you use both the vertical and horizontal distances to cover a plane with the clone of an original figure.

To create translation symmetry in Illustrator:

1. Select the element from which you are creating translation symmetry.

2. From the toolbar, choose Effect > Distort & Transform > Transform.

3. Enter the vertical or horizontal distance and the number of copies you want to make, and then select Preview to double-check the results. Click OK when you see the desired result. Keep in mind that software allows you to quickly make transformations, which allow for all sorts of variations that introduce more complex orders of symmetry, such as rotation and scaling (**Figure 8.24**).

REFLECTION SYMMETRY

Reflection symmetry adds one order of complexity (and interest) to translation symmetry by mirroring the image. Rather than being perceived as redundant information, it engages you by completing and balancing the whole when integrated. It also gives you the opportunity to see the image from a different perspective when side by side.

Software tools make reflection symmetry almost completely automatic.

To create reflection symmetry in Illustrator:

1. Follow step 1 and 2 in the earlier exercise "To create translation symmetry in Illustrator."

2. Key in your coordinates for your reflection symmetry. For reflection symmetry, the coordinates will be based on the number of copies you want—typically just one to create its opposite—and the direction in which it's being moved. Insert the coordinates into the X-axis field for horizontally mirrored symmetry or into the Y-axis field for vertically mirrored symmetry (**Figure 8.25**).

3. Preview your work. When it is as you want it, click OK. This mirroring function can also be done with the Reflect tool (located next to the Rotate tool).

8.24 *Use the mathematical power of software to quickly create repetitions for translation symmetry.*

8.25 *All of the symmetries of translation, reflection, and rotation can be created using the same Transform Effect window in Illustrator.*

ROTATION SYMMETRY

It's a snap to use Illustrator to create all sorts of rotations with mathematical accuracy. The tools described in this exercise are effective to build a scaffolding on which to base nonsymmetrical shapes. But be advised: Machines do not fit organically drawn shapes together, such as those shown in the hand-drawn rotations in the sidebars "Creating a Twofold Rotation for a Hand-drawn Logo" and "Creating a Fourfold Rotation (90 degrees) for a Logo Using Hand- and Computer-generated Processes." That's where nature wins in the form of human ingenuity.

To create rotation symmetry in Illustrator:

1. Select the object to be rotated, and then click the Rotate tool in the Tools panel.

2. Press and hold the Option key, and click your center point of rotation.

3. The Rotate dialog box appears (**Figure 8.26**). Divide 360 by the number of rotations you want (for instance, threefold symmetry requires 120 degrees of rotation, which is the result of dividing 360 by three rotations).

4. Check your work by clicking the Preview button, as in **Figure 8.27**. If it looks good, click OK.

5. Duplicate the action by pressing Command+D to drop the third rotation easily into place (**Figure 8.28**).

Figure 8.28 shows an example of a final threefold symmetry rotation.

Keep in mind that the higher the fold order, the simpler you want the graphic to be. This does not mean the concept has to be simple. You are using a radiating principle (the energy that drives a process) to connect all of the parts at one common joining: This is the source of the design. How the parts fit together comes from your own creative inspiration and intuition. Intention is the human equivalent of energy before it manifests. Although software is certainly useful, it does not substitute for your innate ability to work intentionally with principles that most effectively convey the message you want to create with graphics.

Always think about what you want to communicate with the graphic and how you can symbolically support the message. With the tools this book provides, you'll find the most appropriate matches of shape, principle, scale, and order.

DID YOU KNOW? **Fold order is a term used to describe higher orders of complexity in a rotational matrix, or the parts that fit within a radiating whole. The order is determined by the number of rotations an object makes to fit within a 360-degree circle.**

8.26 *What took mathematicians hours or days to accomplish can now be done in a few seconds or minutes.*

8.27 *With a few key strokes and a little knowledge, you can create the beginnings of lovely and complex rotations.*

8.28 *Threefold rotation symmetry based on 120 degrees.*

CREATING A TWOFOLD ROTATION FOR A HAND-DRAWN LOGO

I designed this logo in 1985, long before computers and software were available to designers (**a**). Using a pencil, eraser, Rapidigraph Pens, photostats, and an X-ACTO knife with several sharp No.11 blades, I created it by hand in what seemed like an endless process. The development of the logo consisted of drawing, tracing, redrawing, and meticulously peeling away emulsion from the photostat with the X-ACTO knife. The client owned an Arabian horse farm, and because breeding is the most intimate physical relationship any species can have, I began with that thought in mind. I first drew a triad of horse heads in a metaphor of close physical contact (sire, dam, and off-spring) (**b**). Even at this early stage, I imagined a figure that had no gaps or overlaps, long before I knew about tessellated shapes (although I did know about M.C. Escher's work since childhood).

Not feeling that the first design had enough potential to continue, I attempted another approach with a related concept—this time of a mare with a foal nestled into her shoulder. I immediately picked up on the opportunity of fitting two heads together along the jaw line of the foal (**c**). (Keep in mind that your first idea will often be on the right track but needs the tweaking of experimentation.)

Conceptually, the design came together quickly once I discovered the twofold rotation, although executing it was a fairly involved process (**d**).

The final conceptual touch came by orienting the heads within a circle, a concept that completes the two as one, or common parents of the next generation (**e**).

Reflection symmetry focuses on opposites cooperating, just like one foot moving with the other to get you around (**f**). This graphic shows how a literal reflection of the graphic would never work as a logo to convey the idea of two opposites—the parents—in a seamless integration. This logo is based on the concept of yin yang—something that goes beyond cooperation into supporting future life by integrating opposites as a whole.

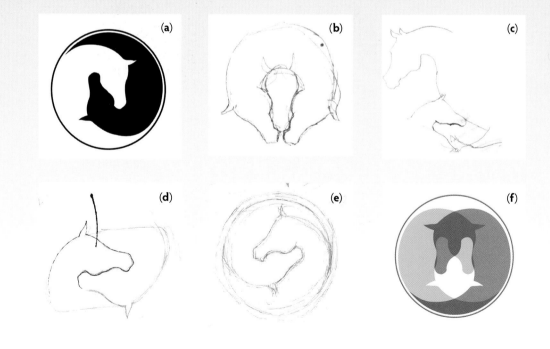

(a) (b) (c) (d) (e) (f)

CREATING A FOURFOLD ROTATION (90 DEGREES) FOR A LOGO USING HAND- AND COMPUTER-GENERATED PROCESSES

I began with a drawing I had scanned in and redrawn as a vector in Illustrator (**a**).

Using guides, I found my center point to handwork the tail shape as a pleasing interlocked shape. Because I found tessellating the graphic got in the way of the primary message (looking too much like a beach ball and distracting from the fish design), it was necessary to break apart the tail graphics. This is a rotated design—not a tessellated one because it contains gaps (**b**); it took back and forth tweaking of the drawing to make the tails work together. The fourfold, or 90-degree rotation, gives precision to the design.

The final design includes the client's logotype and color application (**c**). "Truchas" means trout in Spanish, and Truchas Hydrologic is a consulting firm specializing in generational acequia rights (traditional irrigation waterways) administration in New Mexican rural communities. The idea of community influenced my choice of a circular point-of-origin joining at the center. This represents individuals connected at the common point of a functioning whole.

(a)

(b)

(c)

CREATING A TESSELLATION

Translation, or slide, tessellations can be useful for creating borders or as background repetitions based on elements derived from or complementing the original design. In nature, important genetic traits pass along "a line." In visual communication, you can emphasize a characteristic or idea by repeating it in translation symmetry, thereby reinforcing it as *value-information* contained in the underlying design. When you ask someone to spend time with your design, something should be given in trade for it. It needs to say something. Thoughtful design catapults information into becoming a piece of communication, which is crucial to its effectiveness. The repeating information contained within trans-lation symmetry connotes something important enough to be said again, or simply states an ongoing truth of nature (such as, generations repeat themselves). Functioning as a strictly linear border, translation symmetry is called a *frieze*; as a background covering a plane, it becomes a tessellation.

You can easily create translation, or slide, tessellations by hand, and there are exercises showing how to create a tesselation on the book's Web site at www.designbynaturebook.com. It's always a good idea to know how to create by hand without complicated and expensive technology. However, drawing a tessellation is a redundant operation and is far easier and more accurate when you create it on a computer. I recommend that you experiment with the number-crunching operations available in your drawing software to experiment with multiple varia-tions quickly.

To create a computer-generated translation, or slide, tessellation in Illustrator:

1. Start with a size that gives you enough room to move across and up and down on your artboard at least four times. Be sure to make the width and height dimensions the same for a square dimension (for instance, if you are working with a graphic that is 1 inch by 1 inch, start with a document that is at least 4 inches by 4 inches). Click the Rectangle tool in the Tools panel. While holding down the Shift key to constrain dimensions, create a square. Or, click the Rectangle tool, and then click the artboard to enter dimensions manually.

 For twofold translation, the dimensions are repeated in a line; for fourfold translation, the dimensions are repeated in rows and are alternated for glide translation (the same pattern as our footsteps or in the growth pattern of leaves spiraling up the stem of a plant).

2. Create your shape with the appropriate tool. For simple round shapes, use the Ellipse tool. For more organic or complex shapes, use the Pen tool. Overlap the base square with your new shape (**Figure 8.29**).

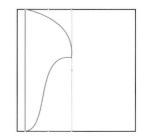

8.29 *A shape overlapping the square.*

3. With both shapes selected, choose Window > Pathfinder. The Pathfinder dialog box appears. Select Divide in the dialog box.

4. Using the Selection tool, click the image. Ungroup the image by choosing Object > Ungroup. Use the Selection tool to choose the cutout shape and delete it (**Figure 8.30**).

5. Choose Effect > Distort & Transform > Transform and enter the number of repetitions and distance for a linear design.

 In **Figure 8.31**, I've tiled the image three times for a distance of 1 inch, or the same distance as its width. I've also dropped a color into each shape for more interest.

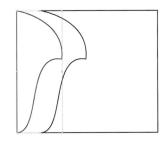

8.30 *Once you have ungrouped the divided image, you can select and delete the cutout shape or keep it to use as a colorized shape instead of empty space.*

8.31 *Use the Transform panel to create repeated shapes on a line.*

6. For a tiled tessellation, you can enter distance information into the Vertical field in the Move area. In **Figure 8.32**, I've entered 1 inch into both the Vertical and Horizontal fields with three repetitions.

 The copied row or rows are clones and can't be edited until you select the parent design.

7. Choose Object > Expand Appearance to create an independent generation of the design that you can edit.

DID YOU KNOW? **M.C. Escher didn't have the benefit of digital mathematics. He created all of his artwork by hand and figured all of the underlying gridwork with analog mathematics. It makes you wonder what a mind like Escher's could do with all the digital shortcuts we take for granted today.**

DID YOU KNOW? **Squares, triangles, and hexagons are the only shapes that have the ability of tessellation on a 2D plane. You can create threefold or sixfold orders for hand-generated tessellations just as you did in the hand-generated square dot template by marking the vertices of triangular and hexagonal shapes, and creating equidistant rows and columns.**

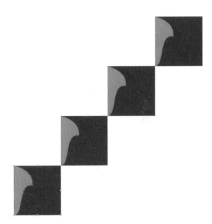

8.32 *The result of 1-inch increments input in both the Horizontal and Vertical fields with three repetitions.*

CREATING HIGHER-ORDER TESSELLATIONS

When the Moors infiltrated Western Europe with their skills in math and art, they helped to usher in one of the most prolific and creative times in human history, the Renaissance. Islamic artists created groundbreaking designs with some of the most precise and richly geometric symmetry ever used in art. Higher orders of symmetry afford infinite opportunities of organizing complex visual information. **Figure 8.33** shows an example configuration of this beautiful work, and a structural grid in **Figure 8.34** shows the multiple ways in which simple geometric gridwork can be used.

8.33 *Intricate symmetrical tessellations expressed as art. Image ©2004 Dover Publications, Inc.,* Islamic Designs *by Thalia Large and Alan Weller. Courtesy DoverPictura Electronic Design Series.*

8.34 *A common underlying geometry can create many configurations, depending on linework, fill, and color. Redrawn from "Islamic Geometric Patterns" (Thames & Hudson) by Eric Broug.*

CREATING ASYMMETRY

By its nature, this chapter is laden with mathematical precision and figuring—even if your computer is doing most of it. Because I'm a very visual person, my mind begins to do the pinball tilt when I don't balance it with a more eclectic approach to information. Therefore, I'll end the chapter with a more intuitive, hand-drawn, and relaxing exercise.

The following exercise is about seeing rather than drawing and about defining relationships while working within one whole, continuous piece. This is an exploration of information going directly from your eye and through your hand without the brain continually chattering about the "rightness" of it. It is inherently asymmetric, and by drawing "blind," you remove all self-critiques of precision and skill (**Figure 8.35**).

To create a blind contour drawing:

1. Choose an accessible item: your shoe, your hand, your face in the mirror, a jar of pencils and pens, or whatever strikes you. Keep it simple.

2. Begin drawing where it makes the most sense to you. If you're drawing your face, you might start at your forehead or the top of your hair. Look only at the object you are drawing and never at the actual drawing. Study the object and begin.

3. Do not lift your pencil from the paper, just connect the lines organically as you draw. You are *feeling* the drawing, nothing else. This has nothing to do with skill.

4. Go slowly. When you feel you've connected all the parts you want to connect, stop.

Don't judge your work. Judgments are irrelevant in this exercise. Commend yourself for having the courage to be imperfect (or asymmetrical) and for having created something driven by being completely in the moment. It is far more alive than most precisely drafted drawings. Remember that asymmetry (or imperfection) is the basis for life on earth, because it compels energy to continually strive for balance.

8.35 *Blind contour drawing allows you to have an entirely different perspective on how to create. Image: Self portrait drawn with ink by Eric M. Scott, 2007.*

9

MESSAGING

A MEANINGFUL MEDIUM

Meaning making is the constant and unconscious human activity of organizing the unending stream of information integrated and processed by your sensory perceptions. What you observe (the qualities of information), what you are taught (learned opinions and beliefs), and what you exist within (the cultural environment around you) synthesize your responses to the events of life, from the smallest to most important matters. These processes and perspectives combine to inform your interpretive meaning, but they don't necessarily have to define it. Choice is the compelling urge that pushes the human species forward. *Design thinking* interprets information to be meaningful by making it useful and beautiful. The designer facilitates the balance of perception with available choices to translate it as a meaningful experience, be it visual or visceral.

KEY CONCEPTS

- People make meaning to make sense.
- Symbols and metaphors are crucial to meaningful communication.
- Scaling and self-similarity expand design's effectiveness over time and application.
- The golden ratio is an essential ingredient of beautiful and effective designed communications.

LEARNING OBJECTIVES

- Understand the theories behind the human ability to make meaning.
- Understand the relationship between symbolizing and using metaphors, and their relevance to design.
- Understand self similarity and scaling principles, and how they relate to long-term design and application crossover.
- Appreciate the phi ratio and the Fibonacci sequence as templates for aesthetic design.

Design personifies the genesis of your origins—energy and matter—by transforming perceptions into real-world results. At its best, the design process allows you to perceive and refine large patterns into succinct relationships. You do this when you identify the heart of the message and balance the literal with imagination as a workable solution. As paraphrased from Albert Einstein, "The problems we are facing won't be solved by the systems that created them." Thinking creatively and independently leads to solutions that can solve problems at many scales, which is why design is such a relevant and important human activity. Design thinking flexes your most practical intellectual skills by creatively imagining what doesn't yet exist. Reality is formed by the meanings you choose to make.

In this chapter, you'll learn about some of the theories of how humans came to make meaning through the discovery of metaphors and symbols, and about the *phi* ratio, a compelling proportion that most consider beautiful. Metaphorical thinking was a significant development in human intelligence that allowed people to plan into the future by relating the conceptual to the possible, which began as the creation of art. Understanding how function and aesthetic are deeply related in nature supports the best design because it emulates the experience of living.

The How and Why of Meaning

Anthropologists don't know exactly how human beings originally came to make meaning through art, but at some point in prehistory our ancestors had the brilliant idea that a two-dimensional mark could conceptually represent a three-dimensional object without the necessity of its presence. This led to imagining events that hadn't yet occurred by projecting a range of possibilities into the future. It was a crucial step to use nonlinear time as a key component of conceptual thought and symbolize ideas, things, or future scenarios (**Figure 9.1**). A circle could be the sun *or* a cycle; a spiral could express life in the form of a persistent plant tendril *or* be a series of connected, transitioning seasons that occur year after year. The highly simplified and abstracted nature of the symbol is exactly why its meaning is relatively stable anywhere and anytime. The power of a symbol is elegance at its most supreme. The human ability to make the intellectual connection between a two-dimensional mark on a surface and a three-dimensional object in reality—or in the imagination—changed everything. Design is based precisely on this ability. You must weave elements, structures, and imaginative ideas into the fundamental basis of the message you want to express in a way that at a minimum makes sense to most people, and at best inspires involvement or action.

9.1 *Variable star V838 Monocerotis (Greek for "unicorn"), a nova-like variable star, and its unusual surrounding "light echo" lies near the edge of the Milky Way Galaxy about 20,000 light-years from the sun (opposite, left). Credit: NASA and the Hubble Heritage Team (AURA/STScI). An alchemical engraving of an ouroboros devouring its own tail from an engraving by Lucas Jennis in* De Lapide Philosophico. *Published 1635 CE (opposite, right). Source: Wikipedia, Ouroboros.*

A triangle, for instance, *secures* physical structures as a support (the eaves in your roof) or *balances* them (the base of a pyramid). As a process, the triangle is symbolic of transforming a solid physicality into an energetic potential. Its shape directly addresses its ability to secure and balance physical things, as well as to symbolize the process of compressing and funneling a solid base into a new reality by converging linear edges into a disappearing point, just as the shape depicts. Symbols like the triangle carry over time and space to retain their relevance and meaning regardless of when or where they are used because they express fundamental archetypes of constructed reality.

The human mind understands the symbol as eternally relevant, which makes it flexible enough to be useful in multiple ways. It was an exponential leap in human understanding to use symbols as representations of something that didn't yet exist or wasn't directly accessible to human sensibilities. Almost everything people have invented started with an idea sketched on paper or stone. Conceptual ideas are drafted before they become real to work out the details and determine the best way to make them workable in the real world. And sometimes, beginning ideas lead to extraordinary accidental discoveries.

Establishing the foundation for structural theory in organic chemistry is one such example of an accidental discovery. German chemist August Kekulé had been diligently trying to understand the structure of the benzene molecule when in a daydream he saw an ouroboros snake eating its own tail (1864). His symbolic vision gave him an instant understanding of the structural form of this organic chemical compound. This was Kekulé's own account: "I was sitting writing on my textbook, but the work did not progress; my thoughts were elsewhere. I turned my chair to the fire and dozed. Again the atoms were gamboling before my eyes. My mental eye, rendered more acute by the repeated visions of the kind, could now distinguish larger structures of manifold conformation; long rows sometimes more closely fitted together all twining and twisting in snake-like motion. But look! What was that? One of the snakes had seized hold of its own tail, and the form whirled mockingly before my eyes. As if by a flash of lightning I awoke..." Benzene does indeed take the form of a closed ring—a hexagon with a carbon and hydrogen atom at each of its six points. The ouroboros in Figure 9.1 has long been a symbol of human myth with its serpentine movements so non-human, the shedding and renewing of skin, the lack of appendages that most other animals have, and its poisonous bite. All of these aspects of the snake make it quite provocative, fearsome, and a likely contender to represent so much more than is presented on the surface.

Symbols (first realized as images and later as the written word) support your imagination and carry humanity into the future (**Figure 9.2**). Human recognition of the power of symbols allows people to conjecture without the potential idea existing in reality. This is the basis of your ability to design a concept. But where did the idea of symbols come from? The perplexing and fascinating thread of your ability to make meaning starts with being able to think with symbols.

"The future belongs to a very different kind of person with a very different kind of mind...creators and empathizers, pattern recognizers, and meaning makers."
—Daniel H. Pink, *A Whole New Mind*

Symbols and the Natural State

Life is understood and responded to according to how you perceive the world presented around you. Prehistoric cultures that depended on animals for food and other physical necessities revered animals before higher religions evolved. Animals are "true" by consistently embodying desirable qualities, such as the fertility of a rabbit, strength of a bull, or speed of a gazelle. Animals and their inherent traits represent various ideals. By honoring the animal through a totem or amulet, its status was elevated as a power symbol. The totem is one example of exalting the animal into sacred status by physically representing the essential powers of that animal in art. **Figure 9.3**, by Hawaiian illustrator and designer Ben Everett, shows the qualities of the "wise Owl, who speaks through cunning Fox, who whispers to Bear, who gives force of transformation to Eagle by turning him into Man, who must pick up the paddle and ride with Orca on the Ocean of life."

Designers still use animals today to instill various "powers" in advertising, only now animals' qualities are more about self-gratification than honoring their inherent characteristics. Revisiting the animal symbols mentioned earlier, some current-day animal "power symbols" include the Playboy bunny logo (implying sexual gratification rather than fertility), the power of the bull as represented in the caffeine-laced Red Bull energy drink that provides a temporary burst of adrenaline (rather than actual sustained muscular power), and the Chevy Impala that flies down the road with the speed of a wild animal of prey (this one still holds as a means of escape). Mythology is very much alive today; its use has just been commercialized to fit the bottom-line objective.

9.2 *This rock art is from Skavberget, a small island off the Norwegian Lapland coast, showing a figure—possibly a shaman—holding a drum that overlooks a small channel through the fjord to another island. Locals say the reindeer crossed here twice yearly during migrations in earlier times. One could surmise that the shaman figure was placed here to watch over the herd and protect them from being swept away during the crossing. The date of the rock art is unknown but may be as early as the Bronze Age, when the precursors of the modern Sámi people lived in this area (opposite). Photo: ©2000 Mike Williams, Wales.*

9.3 *A modern animal totem designed and illustrated by Ben Everett, Hawaii.*

The forces of nature were also embodied by the polytheistic gods and goddesses (for instance, the Roman and Greek gods and goddesses); all had human fallibilities, strengths, and personalities that complemented their particular traits. Later, the idea of monotheism, or one god, integrated all possibilities into one.

"I believe in God, only I spell it Nature."

—Frank Lloyd Wright

Long before humans had religions that synthesized nature into a formal concept of "god," man went inside himself to connect with the unknowable forces as one, standing alone and ready to face whatever came. Man—and woman alike—ventured within to discover the symbols with which they could construct reality outside of the mind and beyond the experience of day-to-day living. This is the bridge that the designer crosses.

Symbols and the Altered State

Ancient rock art around the world has abstracted drawings and paintings (pictographs) and rock carvings (petroglyphs) that contain common geometric patterns of grids, concentric circles, spirals, zigzagging lines, dots, waves, and other similar forms. They are the predecessors to the more complex symmetrical and tessellating patterns discussed in the previous chapter, and are the very same shapes you use today as background patterns and borders.

All humans see these shapes within the mind because they are part of the neural activity that connects eye to brain, along with various superficial "floaters" that randomly come in and out of view on the surface of the eye. These optical patterns and shapes are called *phosphenes*. The process is known as *entoptics*, a Greek word meaning "within the eye." Internal visions applied as external markings are proposed by some anthropologists as the possible beginnings of all art. This makes sense when you think of similar progressions: Children begin drawing the same abstracted shapes before they have the skill to control what they draw and "make pictures" (or "make meaning"). I remember seeing these shapes at night when pressing lightly on my eyeballs decades before I knew there was a word for it (don't all kids do this?).

Several years ago, South African anthropologist David Lewis-Williams looked at prehistoric art and drew similarities between the abstractions created by the organically generated visuals in your mind and *form constants*, the images you

complete from abstracted shapes to make sense to you (via the "completion" of gestalt). This experience is universal and has been categorized as three consistent progressions. *Stage one* is the spontaneous visualization of entoptic forms (the neural transmissions that occur behind the eye, "floaters," and other organic phenomena). These images are visualized primarily by themselves and are of their own making. The rock art in **Figure 9.4** is an example of the abstracted geometrics that occur during this stage. In *stage two*, the person experiencing the entoptics

phenomena moves on to make sense of the images with "iconic" elaborations, or culturally known forms. Scientists think this may be one of the things the mind does during dreaming. Although much of the dreaming process remains elusive, scientists know that dreams are generated in or through the area of the brain that is associated with visual processing, emotion, and visual memories. Humans are compelled to make meaning of what they see and experience, even in an unconscious state. In *stage three*, the iconic forms present themselves as independent from the viewer and as having a life of their own—this is a dreaming, meditative, or hallucinogenic state.

9.4 *Petroglyphs from the Kenton Caves in northwestern Oklahoma show the geometric patterning of the first stage of the entoptic states (opposite). Photo courtesy of Oklahoma Archeological Survey.*

The visual patterns that occur in multiple prehistoric rock-art sites are consistent with how children's drawings progress and with LSD test subjects' drawings in later military experiments, which were spontaneously adopted in the 60s by the anti-war, anti-establishment counterculture of the time (**Figure 9.5**). Shamans, it is assumed, created most of the prehistoric art using the various geometric forms to initiate healing, rainfall, or in other ways benefit their community, although many tribes had initiations that probably inspired the visual recording of the experience of any tribal member. The visioners also used psychoactive drugs alone or in combination with sensory deprivation (going without food or light in the depths of a cave for several days, for example) or repetitive behaviors, such as chanting, dancing, drumming, or conscious breathing.

Delving into the deepest recesses of the mind to experience different layers of reality is not as accessible today as it was for primitive people who interacted with nature on a day-to-day basis as a matter of survival. Hence, people in modern culture who have "alternate" experiences usually do so either as research subjects, through the use of drums, or by using psychoactive drugs.

The most interesting question of all still remains: How and why did humans start using the symbol as a proxy to both strategize and make a bridge to the future, thereby creating the immense complexity of civilization that surrounds us today? Lewis-Williams thinks that those who experienced mental imagery during states of altered consciousness projected the image during a trance or in flashbacks onto their surroundings. They traced the image on a wall or other surface to "fix" the image. Rather than creating realistic depictions of their environment, they wanted to capture images from the world of altered consciousness. (Coso Shoshones believed that if they forgot their visions, they would die or couldn't cross between worlds—memory is crucial to visioning.) This process describes a possible purpose that led humans to symbolize in the first place and connects directly to the intangible, intuitive nature of who we are. The individuals who drew what they envisioned were "making real" what they saw in their imagination.

9.5 *A late 60s Zap "AOM" comic strip by Rick Griffin, a well-known illustrator from the San Francisco Bay Area. Rick's art was influenced by the south-western archeological digs he went on as a boy with his father and his attendance at Chouinard Art Institute, the predecessor to CalArts, Illustration: ©1968 Rick Griffin. Permission of Ida Griffin.*

In design, effective visual metaphors compress information into a symbolic representation of meaning without the need for verbal explanations or decorative descriptors. Symbolic language is the cornerstone of effective design and is the result of countless prior generations who experimented with what reality is and how to best live within it.

The Symbolic Metaphor in Design

Design metaphors relate more than one idea in a single visual context. Metaphorical design is a method I've used for almost 30 years to create effective logos. The most enduring and memorable branding designs condense the message to provide more interest and information than a superficially repetitive or trendy design. As visual puns, metaphorical designs can be surprising and fun—and encourage memory retention and recall. They are low-maintenance, hardworking bits of information that carry a lot in a small space, just like the archetypal shapes do. They are useful in all sorts of designed communications—editorial or poster illustrations are examples—and several were shown throughout this book. Metaphors compress information while retaining the ability to "unpack themselves" and expand as you realize the complexity contained within the simplicity. The logos shown in **Figures 9.6** and **9.7** are examples of providing the most value out of the least material, a basic maxim in nature.

All you need to create a visual metaphor is a similarity between two or more visuals or ideas—a blending of line or shape to express more than one idea—and the removal of any information that doesn't serve the communication. Although it is easier said than done, it is not that difficult to do when you strategize what you are looking for. All you need is a pencil, a piece of paper, a mind set on making it work, and a little ingenuity. Begin by finding the commonalities. Then ask: What is essential to the communication? What can be removed? Toggle between these ideas and watch a shape begin to emerge as your intelligence and talent go to work!

Metaphorical design is flexible enough to work in different situations by "scaling" in duration and across media and application by combining and condensing several concepts into one succinct visual. "Speaking" with visual metaphors provides a tremendous service to your clients by making their message accessible to their audience.

9.6 *A metaphorical logo expresses more than one idea consolidated into a single graphic. Mike discovered his "hook" when he doubled the fish hook as the "U" character of the client's name. The fishing line was integrated as a further embellishment to reinforce the client with greater memory retention. Design: Mike Erickson.*

9.7 *A pun of word combined with image gives the Elefont logo design particular impact to make it memorable. You will never forget how the negative shape of a trunk created the lowercase "e," or how each piece of information returns you to the design just as the trunk spirals back into itself. Happy opportunities taken at every turn. Design: Mike Erickson.*

LIZ COLLINI : GUEST DESIGNER STUDY

ARTIST : LONDON

Discovering the essence of form can take on many styles and be realized through any discipline. British artist Liz Collini describes her process of drawing the soul out of the printed word by connecting it to the invisible threads of its making.

"I have always been intrigued by classical inscriptions and other texts cited in public spaces bearing an apparently inherent right to exist there. As an artist who explores the systems underpinning written language, I wanted to find a way to disturb the aura of anonymous, authoritative privilege carried by the printed word (**Figure 9.8**). Working with digital text was unsatisfying—it seemed to arrive too easily, prepacked from another place with little human trace. On the other hand, I found working with metal type too slow and rule-bound. As a reaction, I began to try redrawing digitally generated text, reconnecting it with its historical, man-made antecedents (for example, the inscription on Trajan's column in Rome in **Figure 9.9**).

My real interest lies in the fragility of language underlying its veneer of strength and certainty—for example, in double meanings and multiple interpretations of the same simple word or phrase. I usually take a long time deciding which words I will draw because the process is time-consuming and laborious. Although the shapes and structures are becoming ever more familiar to me, I always start each letter as if it is the first time I have drawn it. I work with open lettering, sometimes with the body text shaded to help reading, but in a way that suggests a framework around and through which meanings can flow. The resemblance to plans and blueprints is a happy coincidence with the way that I think about the written word—that it is a signifier of absence. The things of which we write are elsewhere, displaced, in the same way that a plan is a suggestion of something yet to come but that is not actually present. There is a similar aesthetic thrill to be found

9.8 *A detail of Liz Collini's artwork showing the intricate interlacings of the underlying shapes of the letterforms she works with.*

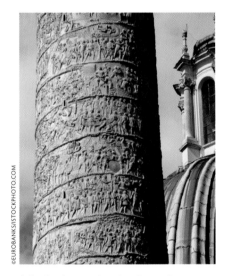

©EUROBANKS/ISTOCKPHOTO.COM

9.9 *This freestanding, hand-carved monument was built to commemorate the Roman emperor Trajan in the first century CE. Descriptive bas reliefs spiral up the column immortalizing his victory in the Dacian Wars.*

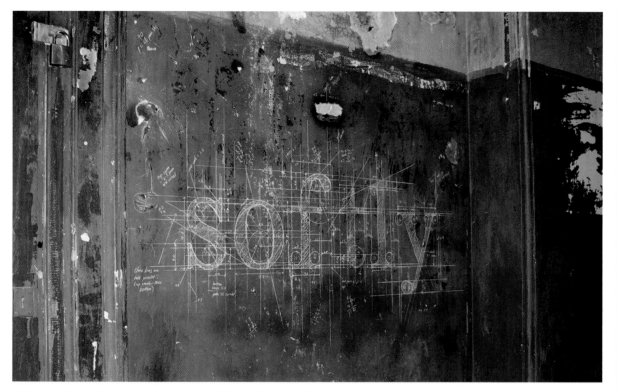

9.10 *One of a pair of temporary drawings installed in the basement of Victorian Town Hall in London.*

in underdrawings of great works or the little mathematical notes left by builders (often discovered when wallpaper is stripped away [**Figure 9.10**]).

Because my interest is in language rather than type, I only draw Times New Roman. This is the default font on many computers, and to my eye, has a sense of timelessness and seriousness; for many years, the British newspaper *The Times* was known as the newspaper of record. What results is the rather accidental output of a process of mapping and trial and error. The underlying structure of language becomes literalized in the drawings. There are overlaps between hand and machine, word and image, and structure and chaos. There are two voices at work: the authoritative voice of the Times New Roman text and the anxious and self-critical

annotations of my own attempts to re-create something as accurately as I can, and yet, constantly failing. The measurements are necessary to help me find my way around each letter. Time becomes embedded in the work. I like the words to float unanchored in a space, free of context, because this creates an uncanniness such that the work reflects back to the viewer something familiar yet strange. Sometimes I draw directly onto walls as temporary installations. These are hugely satisfying because they carry in them the seeds of their own erasure, yet always leave a trace behind.

I see my work as a form of reclamation of the material from the virtual. Someone once described it as a place where text and image 'collide and bother one another,' and I can't think of a better definition than this." ■

Scaling Across Time and Space

Scaling and self-similarity essentially have the same meaning: Nature's most basic templates are reused and are applicable in other sizes, complexities, and dimensions. Circular shapes—the basic template for microscopic cells to macro-cosm galactic planets—are examples of a self-similar principle that carries across scale. Because the circle is the archetypal shape of inclusiveness, self-generating organisms, such as a cell or planet, express their embodiment through this shape. Nature uses redundant shapes and patterns that may be completely different in some ways but still retain the fundamental characteristics of their symbolic expression. The micro at its most simplistic evolves into macro-complexity by scaling into other versions as needed (**Figure 9.11**).

Maximized efficiency of scale is also essential to design: Branding must have a core context of visual and message to be effective in a variety of applications over time. Think of enduring brands, such as Coca-Cola, which has survived two world wars (and multiple lesser ones) while remaining one of the most popular soft drinks on the market during immense cultural and technological changes over more than a century. How did the company do this? Coca-Cola has a strong central message of *refreshment*—or relief from daily stresses that have significantly increased since its inception—and a wordmark that has been used consistently while the world around the brand changed. It's a simple formula that balances the established classic with exciting innovation, and it takes diligence and discipline to achieve.

As in nature, visual communications that *scale* remain more consistently relevant to the audience than those that don't. By weaving a thread of connection between the design's physical expression and its core purpose, the design becomes scalable by addressing more than one solution at a time. And although self-similarity has "sameness," it is not confined by it: It naturally extends into the world by being part of what's around it.

©ALKALYNE/ISTOCKPHOTO.COM

9.11 *A fern frond unfurls as a living example of self-similarity and scale. The spiral shape is used in the Māori tribal artwork of New Zealand (called a "koru" or "loop") where these plants are prevalent. The spiral symbolizes perpetual movement outward, and the inner coils return to their point of origin, symbolically expressing spiritual and physical recurrences.*

Designs That Scale: Spanning Culture, Trend, and Time

Scaling supports a company's brand to transcend being "just another business" by becoming a symbolic expression of an organization's personality and purpose. This is particularly essential with the density and immediacy of digital connectivity around the world. An identity has a short window of opportunity to create

a relationship with viewers because of the vast amounts of information in their visual periphery. It must equate to something more than the noise that surrounds it, or it is lost. In addition, if the reach of the company needs to go beyond the local community to network internationally through the Web, as many do today, it must also be understood by a variety of cultures and languages. If you can key in on the essentials of an organization or business in a way that aligns intent with purpose and present its image in universally understood terms of aesthetic, accessibility, and interest, you have made the very most of your design's ability to do so. By communicating the essentials of an organization's externalized presentation, there is agreement and truthfulness between essence and expression. Alignment implies balance and helps to establish a relationship between the sender and the receiver, because the message intuitively translates as trustworthy and opens the door to receptivity. In terms of being the central component of a universal brand, a memorable logo captures and distills the most vital components of an organization's message, such as those demonstrated in **Figure 9.12**. It then embeds those components in a way that is universally understood but at the same time is totally unique to that organization. This is a crucial attribute of a symbolic logo that resonates around the world.

Effective visual communications need more than just superficial decoration. The inherent truth of the company or organization's communication must be displayed consistently from the core of how it is symbolized throughout the parts—from the logo and core message to the collateral materials it is applied to. Integrity is necessary for an effective message and reinforces it by remaining "true," or staying consistent with the message throughout the various forms of its transference. The alignment of visual to symbol and word to message creates the power of integrity and momentum to carry a communication over trend and time.

The example in the next section is a rarity in terms of a brand's duration by successfully expanding the company's image across tremendous cultural change and over a relatively long period of time.

LONG-HAUL BRANDING INTEGRATION

An example of long-term brand integration—or the scaling of a product through time and trend changes—is evident in the nearly 140-year history of successful marketing by Levi's. The history of Levi's began with Levi Strauss, a young German immigrant who came to San Francisco during the gold rush, bringing his family's wholesale dry goods business to the West. After two decades, it became evident that one of the most essential needs were durable work pants that could weather mines, all-day horseback rides, or wading through rivers while panning gold.

9.12 *SwanSongs is a nonprofit in Austin, Texas, started by a local musician. The organization enhances and supports the dying process by playing the patient's most beloved musical requests in life's final stages. The founders chose a perfect name to facilitate the visual; it was clear to me that a swan was embedded in the treble clef as I began work on the project. The philosophical as well as visual metaphors are relevant between music and transformation. The heart recognizes universal truths as images more directly and simply than the mind does words.*

LYNN DOWNEY : LEVI STRAUSS & CO. HISTORIAN

THE INVENTION OF LEVI'S 501 JEANS

May 20, 2003, marked the 130th anniversary of a historic event: the day that Levi Strauss and Jacob Davis obtained a U.S. patent on the process of putting rivets in men's work pants for the first time. It is the birthday of the blue jean.

How jeans were invented is quite a simple story: After emigrating from his native Germany, Levi Strauss spent a number of years in New York learning to become a dry goods merchant. At the age of 24, he moved to San Francisco in 1853 to open a West Coast branch of his brothers' wholesale dry goods business. Over the next 20 years, he built up his successful San Francisco business, making a name for himself as a well-respected businessman and a local philanthropist.

9.13 *Levi's originated the idea of copper rivets at stress points for more durable pants—an instant hit. Photo by Hangauer/Kissinger.*

One of Levi's many customers, a man named Jacob Davis (originally from Latvia), made his living as a tailor in Reno, Nevada. The wife of a local laborer asked Jacob to make a pair of pants for her husband that wouldn't fall apart. While trying to think of a way to strengthen his trousers, Jacob hit upon the idea of putting metal rivets at points of strain: pocket corners, base of the button fly, and so on (**Figure 9.13**). Because these riveted pants were an instant hit, it didn't take Jacob long to begin to worry that someone might steal his great idea. So, he decided to take out a patent on the process but needed a business partner to help get the project rolling. He immediately thought of Levi Strauss, from whom he had purchased the cloth to make his riveted pants.

He wrote to Levi suggesting that the two men hold the patent together. As an astute businessman, Levi saw the potential for this new product and agreed to Jacob's proposal. The two men received patent #139,121 from the U.S. Patent and Trademark Office on May 20, 1873 (**a**). The iconic Levi's copper rivets and original two-horse pocket label have been in use since the late 1800s and are nearly identical to the current-day Levi's brand labels.

(**a**)

The merged companies opened their San Francisco factory with Jacob Davis in charge of manufacturing. Soon thereafter the first riveted clothing was made and sold. The first jeans were made out of denim because denim was the traditional fabric for men's workwear. Within a very short time, all types of working men were buying the innovative new clothing and spreading the word (**b**).

(**b**)

(**c**)

Although denim pants had been around as workwear for many years, it was the act of placing rivets in these traditional pants for the first time that created what is now called jeans. The word jeans was coined around 1960 when the baby boomer generation adopted that name for its favorite pants.

Holding a patent on the jean-making process meant that Levi Strauss & Co. was the only company allowed to make riveted clothing until the patent went into the public domain in 1890. From 1873 to 1890, the only riveted clothing in the world was made by Levi Strauss & Co. When the patent ran out, dozens of garment manufacturers began to make the riveted clothing, which were just imitations of the original.

So, the next time you see someone wearing a pair of Levi's jeans, remember that those pants are a direct descendant of that first pair made back in 1873. Remember also that it was two visionary immigrants—Levi Strauss and Jacob Davis—who turned denim, thread, and a little metal into the most popular apparel in the world (**c**). ∎

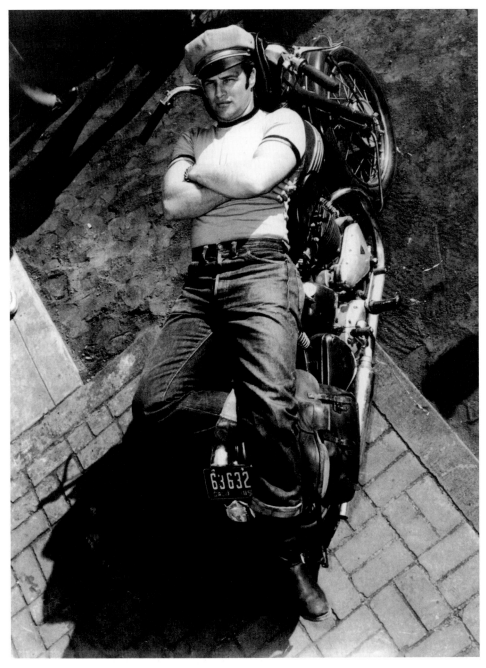

9.14 *The essential accoutrements of attitude in American counterculture: Marlon Brando in rolled-up Levi's, T-shirt, and biker boots in* The Wild One *©1953, renewed 1981 Columbia Pictures Industries, Inc. All Rights Reserved. Courtesy of Columbia Pictures.*

9.15 *Levi's clothing on a psychedelic hookah-smoking caterpillar in a 1970s television spot. Credit: Chris Blum, Art Director; Heidi Endemen, Artist.*

One of Levi's most successful marketing strategies has been to embrace fun and style as well as practical durability. Since at least the 1950s, Levi's has been adopted by the counterculture as a symbol of personal freedom (**Figure 9.14**), transitioning the brand from workingman attire into "everyman (and woman)" attire. Levi's response to its customers made the brand more inclusive and created a statement with more reach—and market share. Levi's has smartly picked up on integrating young appeal with ideal into its advertising campaigns consistently over the last several generations (**Figure 9.15**). Whether you were heading west to join the gold rush in the 1800s, hitting the open road on a motorcycle 100 years later, or protesting in the streets or with street art—searching out freedom was and is a universal activity that will never go out of style as long as people continue to choose their future. Freedom requires enduring effort along with the right presentation. Don't forget the durable pants to match your enduring passion!

As well as using alternative messages and styles to flow with the tide of changing generations, Levi's supports local artists and initiatives, such as the street-art piece shown in **Figure 9.16**. The Levi's Hokusai wave was created by Jay Jay Burridge in London's East End and lasted a mere 36 hours. Jay says of this work, "Levi's approached me with an open brief for some alternative billboards based around its 'Live Unbuttoned' campaign. The first batch of artworks were giant butterflies or Button Flys made out of real 501s that were dotted around London perched up high on the side of buildings and others displayed in taxidermy cases and frames. One of the locations was a 3m x 6m billboard site on Old Street just under the rail bridge, a location fast becoming synonymous with alternative advertising and art installations. This site was selected for the second *wave* of artworks based on *The Great Wave Off Kanagawa* by Katsushika Hokusai, probably the most iconic Japanese woodblock print and an inspiration to many people.

I simply re-created it with Levi's 501 jeans in place of the blue water and thick EVA foam sheets, which formed the background—and most important, the white frothing crests of the wave—thus giving it a 3D curve that literally appears to crash over the heads of passersby. Reminiscent of a surfer riding in the curl of a wave, people walking past look and feel as if they are momentarily engulfed within a mighty force of nature.

I predicted that the artwork might not last long with light-fingered people helping themselves to a pair of pants or two. We were prepped to make daily repairs, but we were not prepared when someone took the entire artwork—including billboard backing—in one go and loaded it onto a flatbed truck."

ARTIST: JAY JAY BURRIDGE, 2009; PHOTO: DELE AJAYI

9.16 *A piece of street art commissioned by Levi's in the East End of London.*

9.17 *The inspiration for the Levi's "Live Unbuttoned" campaign. Original woodblock print by Katsushika Hokusai, created during the Japanese Edo period between 1826–33.*

Jay based his artwork on the classic piece of art in **Figure 9.17**, which is related to a common aesthetic and the beautiful proportions that most people find pleasing. All things in nature are connected, even if the connections seem imperceptible. You respond to the invisible forces and relationships that bind you into the world and lead your imagination beyond what you know.

The Hidden Relationship

Many symmetries are easy to find and identify in nature and in human design. But there is one universal structure that is so ubiquitous and subtle that you often don't know you're experiencing it. What you do know is that it "feels right." Feeling your way toward good design is the way many designers design, and there is nothing wrong with working around the edges until you discover the fit that works. But it is far more productive for your understanding of good design—and your time—to be conscious of how to compose a layout from the inside out that contains visual harmony and grace. Design is more productive when the viewer is receptive to it. A "natural fit" helps your design to accomplish this goal.

"When you get free from certain fixed concepts of the way the world is, you find it is far more subtle, and far more miraculous, than you thought it was."

—Alan Watts

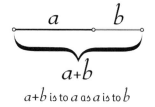

9.18 *The mathematical ratios that create the proportion called* phi.

This "natural fit" is based on a prevalent tendency in nature called phi (fi): The simple ratio of one quantity to another, as shown in **Figure 9.18**. The ratio has a mathematical value of 1.6180339887… and continues on indefinitely (but is usually rounded to 1:1.618). It is an irrational, or nonrepeating, mathematical constant, or a number that spontaneously generates itself—and therein lives its deep connection to nature and is why human sensibilities find it so pleasing. It contains the natural language of relationship that references life's regenerative process. Your brain understands this language immediately and intuitively.

The phi formula can be created as a visual geometric structure and applied to your graphic design to create the same pleasing patterns of relationship.

DID YOU KNOW? **You can download a free trial of PhiMatrix, a design and analysis software application for Windows and Mac. The software's grid system overlays any image on your screen to identify or apply phi proportions in various grid styles, as well as user-defined ratios. You can get it at www.phimatrix.com.**

The Hidden, Seen

Phi's proportions can be visualized in the *golden ratio*—also called the golden rectangle, spiral, section, proportion, or mean, along with many other descriptive names. The golden, or divine, proportion underlies many proportional relationships that occur in natural forms but whose structure is for the most part invisible. It is visualized as a logarithmic spiral (discussed in Chapter 4, "Patterns: Nature's Dynamics" and Chapter 5, "Shapes: Nature's Vocabulary") and is drawn out of the golden rectangle, the angular geometric construct of the linear mathematical formula (**Figure 9.19**). The rectangles successively rotate into smaller versions of one another in an endlessly repeating pattern of self-similarity. It is the regenerative motion of the ratio's proportional relationships that are so compelling: This visual relationship is a metaphor of the ratios that allow life to continue through self-generation. The curve of the logarithmic spiral displays self-similarity in the same way generations of a species extend into the future: As the spiral's size increases, its shape remains proportionally the same. Size is a visual metaphor for measuring time, and self-similarity is the metaphor for the consistencies contained within different generations' characteristics. Also called the equiangular spiral, this shape is found in the shell of the chambered nautilus, the horns of rams, seed heads (**Figure 9.20**), pinecones, hurricanes, nano-structural relationships and spiral galaxies, and throughout the proportional relationships within your body.

The aesthetics of the golden ratio have been used throughout human history in design. It was at the forefront of design most recently during the Renaissance, although the age of its knowledge is from time out of mind. Like many pieces of hard-won human wisdom, it has simply come in and out of focus as human knowledge tends to do. When the common becomes obscure, human intelligence plummets. The "golden" number was written about by Euclid in *Elements* around 300 BCE and by a contemporary of Leonardo Da Vinci's, Luca Pacioli, in *De Divina Proportione* in 1509.

Another mathematician, Leonardo Pisano Bigollo (born 1170 in Italy), made the Fibonacci sequence popular after studying under the most astute Arab mathematicians of the day. He is often credited for the sequence's invention, but it was the simplicity and efficiency of Hindu-Arabic numerals that taught him—and European culture in the Middle Ages—a new and more elegant way to understand math.

The Fibonacci sequence is defined as follows: If a square is added to the long side of a golden rectangle, a larger golden rectangle is formed. This ratio forms the foundation of the Fibonacci series of 0, 1, 1, 2, 3, 5, 8, 13, 21, 34, 55, 89, 144...;

each number is formed by adding the previous two numbers together. These numbers create a Fibonacci spiral, a slight variation on the golden spiral. This sequence is yet another metaphor for the continuation of life. It also illustrates the proportion's deep tie to the appeal of gestalt as 1+1=3, or that two, when combined, produce a completely new and independent third, which in turn combines with another and so on as the dance of life spirals into a sequence of similar generations recurring over time.

9.19 *The geometric ratios of* phi *as the golden rectangle and the golden spiral.*

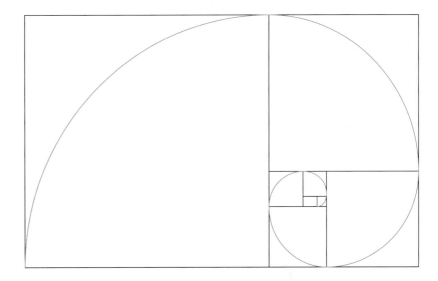

9.20 *Seed whorls, such as these in a sunflower head, display another version of the golden mean by tightly packing seeds as two opposite spirals entwined within the circular shape of the flower. This displays a Fibonacci sequence relationship.*

In the golden ratio breakdown of the Apple computer logo in **Figure 9.21**, various Fibonacci relationships are shown as the underlying circular components of the template. This gives you an idea of the many ways the golden ratio influences design and can be used as angles, arcs, or curves.

DID YOU KNOW? **You can download a free Mac-based widget to help you figure out golden ratios as columns for laying out your designs at www.goldenratiocalculator.com.**

Figure 9.22 reveals the underlying golden ratios within the water forms of the classic original Hokusai print Jay used as inspiration for his stunning piece of hybrid street/advertising art for the Levi's "Live Unbuttoned" campaign discussed earlier.

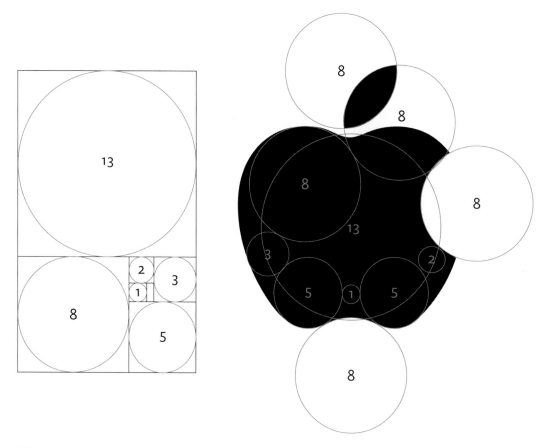

9.21 *The golden ratio embedded in the Apple logo design. This graphic has been recreated from one circulating on the Web. There are several associations to the golden ratio, but the Apple logo is not proportioned perfectly with this ratio. Notice there is not a perfect fit for the number 13 and 2 circles.*

If you think design is a job, you're missing the point. You might have guessed that by now. The human species is in a unique position to influence its future. What you create has the potential to move mountains in the most literal sense. The process of design isn't about your clients, your teacher, or your bank statement. The process of design is about understanding your intimate relationship with nature firsthand to learn how to live better within it. You are at the center of this relationship. Everyone is counting on you to design the future into reality. Following nature's lead allows you to create within a beautiful, workable, and sensible framework. Isn't it a comfort to know you don't have to figure it out all by yourself?

9.22 *Hokusai's wave with the golden spirals that underlie its aesthetic.*

AFTERWORD

Taking on the task of writing a book about nature's relationship to human design was nothing less than daunting. I've learned a lot in the process. I have always sensed the power of nature's subtle truths, many of which were revealed more deeply during the writing and development of *Design by Nature*. For all of our human ingenuity, I very much believe that anyone can approach design with a perspective that includes nature for better results on every level: Your design will be lovelier, more functional, and more satisfying to create without endless training or how-tos. You already know nature in your heart because you are nature. Most people simply have a case of modern-day amnesia caused by the out-of-sync human systems that we are brought up in. The most evident truths can be easily forgotten when the deepest connections of our existence are not honored. This is not a sensible way to go about life or design.

Most important, perhaps, is the aspect of generating creatively from your true self. It is a deep need of the human psyche to interact with and discover through what nature has to teach us. Everyone has the ability to apply themselves with the unique characteristics and circumstances that make them up. Although structures can be put in place and procedures can be taught, how you relate to your creative self is between you and nature. Design is the opportunity to express yourself in an individual way while creating something that can serve all who use it.

Ask questions of nature. Nature has every possible answer. You simply need to listen. This book is a reminder that there is no system more powerful, more creative, or more truthful than nature. Acknowledge it. Appreciate it. Use it. It belongs to you, and you belong to it.

CREDITS

Page 2, © Andy Goldsworthy

Chapter 1, Aesthetics: Enjoy the Ride

Page 2, opening image: A cover design by Kenya Hara for *A Book*, demonstrating the ethereal substance and aesthetic of blankness. Art Director: Kenya Hara; Illustrator: Yoshitaka Mizutani; Publisher: Asahi Shimbun.

Page 8, Figure 1.2, Full-body tattooing image; image in the public domain; sourced at www.visipix.com.

Page 13, Figure 1.7, Joel Nakamura, joelnakamura.com.

Pages 14 and 15, Figures 1.8–1.10, Art Direction: Stefan Sagmeister; Design: Richard The, Joe Shouldice; Photography: Jens Rehr (unless otherwise noted); 2008.

Page 21, Figures 1.14 and 1.15, DIN 1451 © DIN Deutsches Institut für Normung e. V.

Page 22, Figure 1.16, Pottery and Photo: Robert Compton.

Page 23, Figure 1.17, Art Chantry, art@artchantry.com.

Page 26, Figure 1.20, Tamotsu Fuji for the MUJI Advertisement, 2003 "Horizon" Poster; Project Name: MUJI Advertisement, 2003 "Horizon" Poster; Art Director: Kenya Hara; Photographer: Tamotsu Fujii; Client: Ryohin Keikaku Co., Ltd.

Page 28, Figure 1.21, Project Name: MUJI Magazine Advertisement, 2004; Art Director: Kenya Hara; Photographer: Asuka Katagiri; Client: Ryohin Keikaku Co., Ltd.

Page 28, Figure 1.22, Project Name: MUJI Magazine Advertisement, 2006; Art Director: Kenya Hara; Photographer: Asuka Katagiri; Client: Ryohin Keikaku Co., Ltd.

Page 31, logo c, Designer: Bruce Edwards EVP, Creative Director, Fame; Client: Minnesota Zoo.

Chapter 2, Efficiency: Go with the Flow

Page 34, opening image: Actual kimono fabric swatches from the 1900 Oko Isho-Kagami fashion catalog, which was organized to show color and fabric texture for customer decision making and purchase. Woodblocks and publisher: Honda Ichijiro, Japan. Esther and Hannes Keller Collection, www.visipix.com.

Page 36, Figure 2.1, José R. Almodóvar Rivera, Scientific Instrumentation Specialist, University of Puerto Rico Biology Department, Mayagüez Campus.

Page 49, Figure 2.8, Credit: Dr. Rex Jung, University of New Mexico Department of Neurosurgery/Albuquerque.

Page 51, Figure 2.10, Art Director and Designer, George Lois.

Page 51, Figure 2.11, Design and illustration: Ellen Lupton; Photography: John Dean; Client: Sheila Kinkade and Richard Chisolm.

Pages 52 and 53, Figures 2.12–2.14, Erik Spiekermann.

Pages 54 and 55, Figures 2.15 and 2.16, Debbie Millman.

Pages 56 and 57, Figures 2.17 and 2.18, Samurai Guppy Logo copyright © Glitschka Studios.

Pages 58 and 59, Figures 2.19 and 2.20, Name and Identity: Social. Bar: Good Godfrey's. Hotel: The Waldorf Hilton.

Page 61, Figures 2.21 and 2.22, © 2011, Ayumi Sakamoto.

Chapter 3, Nature's Ethics: Everyone's Business

Page 66, opening image: *The Story of Stuff* exposes the connections between environmental and social issues, and calls for everyone to create a more sustainable and just world. An enormous viral hit, the online video has over 12 million views and inspired a front cover story in The New York Times. See it at www.storyofstuff.com. Produced by Free Range Studios. Used with permission from *The Story of Stuff* project.

Page 72, Figure 3.3, "DYLAN," 1967, by Milton Glaser.

Pages 75–77, Figures 3.4 and 3.5, DensityDesign Research Lab, Politecnico di Milano, INDACO Department ©2009 Density Design.

Page 81, Figure 3.8, Gurujot Singh, 2010.

Page 82, Figure 3.10, San Francisco News-Call Bulletin photo, October 28, 1964.

Page 86, Figure 3.13, Ken Cool, Ken Cool Design, Boston, USA.

Page 86, Figure 3.14, Lyn Irvine, Juppin Designs, juppin@yahoo.com.

Page 86, Figure 3.15, Habib Khoury.

Page 86, Figure 3.16, Samuel Toh.

Page 86, Figure 3.17, Brian W. Jones.

Page 87, Figure 3.18, Maggie Macnab and Joel Nakamura, joelnakamura.com.

Page 89, Figures 3.19 and 3.20, Banksy; Image Courtesy of Pest Control Office.

Page 90, Figure 3.21, LUDO, www.thisisludo.com.

Page 91, Figure 3.22, Photo © Jaime Rojo.

Page 91, Figure 3.23, LUDO, www.thisisludo.com.

Page 101, Figure 3.30, Robert L. Peters, FGDC.

Page 102, © Andy Goldsworthy

Chapter 4, Patterns: Nature's Dynamics

Page 104, opening image: "Flow" is a self-maintained, public lighting system that operates on the principle of a vertical wind turbine and solar power, using locally sourced materials and labor. The lamp's design follows the patterns of nature and makes optimal use of available energy, resources, and materials, and decomposes with minimal waste. Designer: Alberto Vasquez/ Hungary, igendesign.wordpress.com.

Page 106, Figure 4.1, José R. Almodóvar Rivera, Scientific Instrumentation Specialist, University of Puerto Rico Biology Department, Mayagüez Campus.

Page 108, Figure 4.2, "Influence Map" Poster, 2006; Design & Artwork: Marian Bantjes; Client: Self (for Milton Glaser's summer class); Medium: Vector Art.

Page 110, Figure 4.3, Graphic by David M. Hillis, Derreck Zwickl, and Robin Getell, University of Texas.

Page 113, Figure 4.6, *La Grande Bibloethèque*, 2006 (cut Tyvek) by Béatrice Coron (Contemporary Artist) Private Collection/The Bridgeman Art Library.

Page 113, Figure 4.7, *A Web of Time*, 2010 (cut Tyvek) by Béatrice Coron.

Page 115, Figure 4.8, José R. Almodóvar Rivera, Scientific Instrumentation Specialist, University of Puerto Rico Biology Department, Mayagüez Campus.

Pages 125, 126, and 128; Figures 4.19, 4.20, and 4.23; José R. Almodóvar Rivera, Scientific Instrumentation Specialist, University of Puerto Rico Biology Department, Mayagüez Campus.

Pages 132 and 133, Figures 4.27–4.29, Alberto Vasquez, www.igendesign.hu, alberto@igendesign.hu.

Page 134, Figure 4.30, Alberto Vasquez, MOME Project, www.igendesign.hu, alberto@igendesign.hu.

Page 137, Figure 4.31, Natural Process "Clouds" abstraction and pattern, Erick Ferrer González, Graphic Designer, México.

Chapter 5, Shapes: Nature's Vocabulary

Page 140, opening image: A preliminary sketch by architect and futurist Buckminster Fuller for his book, *Synergetics*, (Macmillan, 1982). "Synergetics" (a term Fuller coined) is the study of systems in transformation that emphasizes total system behavior that cannot be predicted by the behavior of its isolated components, including humanity's role as both participant and observer. Courtesy: The Estate of R. Buckminster Fuller.

Page 154, Figure 5.7, Thorleifur Gunnar Gíslason, www.thorleifur.is.

Page 166, Figure 5.22, Thorleifur Gunnar Gíslason, www.thorleifur.is.

Chapter 6, The Elements: Nature's Sensuality

Page 168, opening image: Technology can create subtle beauty as effectively as nature—when the right artist is involved. Digital artwork by Cristian Boian/Romania, www.be.net/boiancristian/frame.

Page 172, Figure 6.2, Mauricio Martínez, MM Graphic Design, www.mse-mtn.com.

Page 178, Figure 6.7, Project Title: King Pigeon Yoga, Organic Poetry Posters; Client: King Pigeon Yoga / AC Berkheiser; Location: Brooklyn, NY; Art Direction and Design: Mark Brooks, www.markbrooksgraphikdesign.com.

Page 181, Figure 6.10, David McCandless & AlwaysWithHonor.com.

Page 185, Figure 6.12, Mauricio Martínez, MM Graphic Design, www.mse-mtn.com.

Page 185, Figure 6.13, Tommy Cash Sørenson (tommycashdesign.com).

Pages 186–189, Figures 6.14–6.17, Client: XRS/Bacardi & Martini Poland; Creative Director: Peter Jaworowski; Digital Art: Peter Jaworowski; Agency: Ars Thanea.

Page 191, Figure 6.18, Digital art by Cristian Boian, www.be.net/boiancristian/frame.

Pages 193 and 194, Figures 6.19 and 6.20, Integrations Journal—Tim Girvin.

Page 196, Figure 6.21, Mauricio Martínez, MM Graphic Design, www.mse-mtn.com.

Page 197, Figure 6.22, Digital art by Cristian Boian, www.be.net/boiancristian/frame.

Page 198, © Andy Goldsworthy

Chapter 7, Structure: Building Beauty

Page 200, opening image: Poster mosaic illustration of Robinho (Brazilian national football team star), which was inspired by the national colors and flag of Brazil. Illustrator: Charis Tsevis, Greece.

Page 204, Figure 7.2, Art Director: Mirko Ilic; Illustrator: Mirko Ilic; Client: The New York Times.

Page 208, Figure 7.5, Creative Director: Stefan Sagmeister; Design: Richard The, Joe Shouldice; Design Company: Sagmeister Inc.; Client: Levi Strauss & Co.

Page 220, Figure 7.11, Art Director: Mirko Ilic; Designer: Mirko Ilic; Client: Nadezde Petrovic Memorial, Serbia.

Page 221, Figure 7.14, Design: Lance Wyman; Art Direction: Pedro Ramirez Vazquez, Eduardo Terrazas.

Page 223, Figure 7.15, Design by Muamer ADILOVIC for MINISPACE.

Page 223, Figure 7.16, Art Director/Designer: Jeff Kimble; Calligrapher: Susie Potvin; Design firm: Marketing Communications Group (Toledo, OH); Client: LOF Glass (Libbey-Owens-Ford).

Page 223, Figure 7.17, Title: Note illustrations; Motif name: The Moldau – Winterdreams; Product name: Berliner Philharmoniker; Creative Director: Michael Winterhagen; Art Director: Philipp Weber; Text: Nils Busche; Graphic: Friederike Hamann; Illustration: Philipp Weber; Client Counseling: Jörg Mayer und Mandy Tschöpe.

Page 224, Figure 7.18, Robert Tucker, *Fearless*, 2010, 20" x 30".

Page 225, Figure 7.19, Art Director: Mirko Ilic; Designer: Alexander Macasev, Mirko Ilic; Client: Nadezde Petrovic Memorial, Serbia.

Chapter 8, Symmetry: A Balancing Act in Two or More Parts

Page 226, opening image: Islamic symmetrical vegetal design. Image ©2004 Dover Publications, Inc., Islamic Designs by Thalia Large and Alan Weller, DoverPictura Electronic Design Series.

Page 238, Figure 8.17, Amoremoda, 2010 © Igor Duibanov.

Page 239, Figure 8.20, Extracted from the Web site, www.tilingsearch.org, with permission to use in this publication.

Page 249, Figure 8.35, Eric M. Scott, 2007. Coauthor of *The Journal Junkies Workshop*, www.journalfodderjunkies.com.

Chapter 9, Messaging: A Meaningful Medium

Page 250, opening image: "Design Ignites Change" poster (laser cut paper). Part of a series of posters designed to promote the importance of design in development work for Academy for Educational Development (Washington, D.C.). Because of the holes, the poster changes depending on what you see through it. Design and Artwork: Marian Bantjes, 2008.

Page 256, Figure 9.3, Benjamin Everett, www.everettstudio.com.

Page 261, Figures 9.6 and 9.7, Mike Erickson, logomotive.net.

Pages 262 and 263, Figures 9.8–9.10, Liz Collini.

Pages 266 and 267, Images, Courtesy, Levi Strauss & Co. Archives.

INDEX